In the wake

Anne Nishimura Morse and Anne E. Havinga

With contributions by Michio Hayashi, Marilyn Ivy, and Tomoko Nagakura

MFA Publications
Museum of Fine Arts, Boston

Takashi Arai
Nobuyoshi Araki
Ishu Han
Naoya Hatakeyama
Takashi Homma
Kikuji Kawada
Rinko Kawauchi
Keizō Kitajima
Kōzō Miyoshi
Masato Seto
Lieko Shiga
Shimpei Takeda
Masaru Tatsuki
Daisuke Yokota
Tomoko Yoneda

In the Wake
Japanese Photographers Respond to 3/11

Contents

Director's Foreword

The memory of Japan's great earthquake, tsunami, and nuclear power plant meltdown of March 2011 continues to remind us of the fragility of society and human existence. Nothing can make up for the personal loss experienced by those directly affected, and no response, whether emotional or physical, then or now, seems adequate for addressing tragedy of such magnitude. Yet not to react at all is to ignore our connection to one another, even from the other side of the globe.

Photographers were among the first artists to respond to the triple disaster. Some were drawn to the affected area in Tōhoku because they lived in the region or had once called it home. Others took the risk of entering the contamination zone around the Fukushima plant. And some remained at a distance, making evocative images from their studios in Tokyo. The rich selection of photographs assembled in this book, and in the exhibition it accompanies, addresses universal themes such as the importance of place, humans versus nature, memory and loss, and nuclear anxiety. The artists gathered here include well-established figures as well as emerging talents, whose encounters with the disaster and its aftermath have produced images that are by turns poignant, searing, disturbing, and often strangely beautiful.

Drawing on the MFA's long engagement with the art of Japan and with the medium of photography, *In the Wake* invites viewers and readers to experience the power of art to record and reflect on historic events by creating images that express emotions beyond words.

The Museum is grateful to the Art Mentor Foundation Lucerne for its support of the exhibition; additional support was provided by the Ishibashi Foundation, Brian J. Knez, and the Barbara Jane Anderson Fund. Supporting sponsorship was provided by Shiseido Co., Ltd. Generous support for this publication was provided by the Andrew W. Mellon Publications Fund.

Malcolm Rogers
Ann and Graham Gund Director
Museum of Fine Arts, Boston

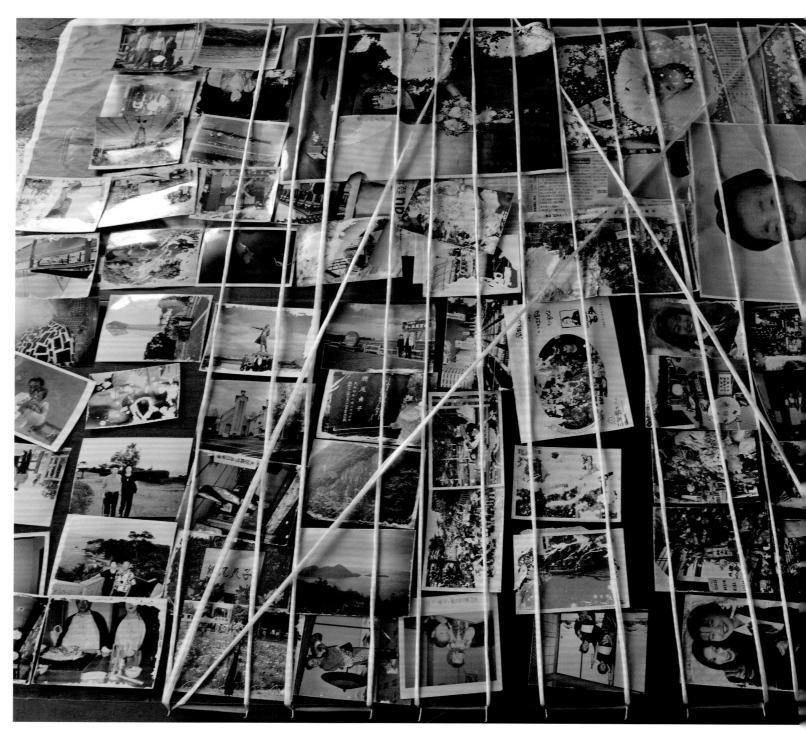

Figure 1. Lieko Shiga, *Photographs Found after the Earthquake, Presented at the Kitakama Town Meeting, Miyagi Prefecture*, 2011

At 2:46 pm on March 11, 2011, a massive earthquake measuring 9.0 on the Richter scale struck off the east coast of Tōhoku, the northeastern region of Japan's main island of Honshu. Within three minutes the Japanese Meteorological Agency issued a major tsunami alert, and as part of Japan's early warning system, NHK (Nippon hōsō kyōkai, Japan Broadcasting Corporation) activated remote cameras all along the coast. Billions of people witnessed the natural catastrophe as it began to engulf the entire Sanriku Coast over the next twenty-five minutes.[1]

News videographers were immediately dispatched to the north by helicopter from Tokyo's Narita Airport. Their footage, which captured horrific scenes of the relentless waves of black water breaching the seawalls around the city of Sendai and moving inland at speeds of thirty miles per hour, was rebroadcast in seemingly endless loops. At the same time residents of the besieged towns, such as Minamisanriku, took their own alarming and heartbreaking videos as the tsunami made landfall. Viewers all over the world experienced the disaster in real time.

In the following days the reactors at the Fukushima Daiichi Nuclear Plant, which had also been swamped by the tsunami, began to fail. Images from the site were limited and much less widely circulated than those of the initial natural disasters—partly from fear of exposing journalists to nuclear contamination but also because the Japanese government created an exclusion zone and, with the Tokyo Electric Power Company (TEPCO), controlled the dissemination of news.

Despite these restrictions, photographers and videographers from around the world have produced thousands of images of the Great East Japan Earthquake (Higashi Nihon Daishinsai), tsunami, and subsequent failures at the Fukushima nuclear facility—collectively known as the Triple Disaster or simply "3/11," after the date of the first events.[2] Some of these image makers have been professionals employed by news agencies to document the damage and recovery. The nature of their work required them to retain an objective viewpoint, as their photographic images made the catastrophe real. However, they have not remained unaffected by the human suffering around them: one group of international photojournalists produced a downloadable electronic photobook with images of the tsunami-afflicted areas whose purchase

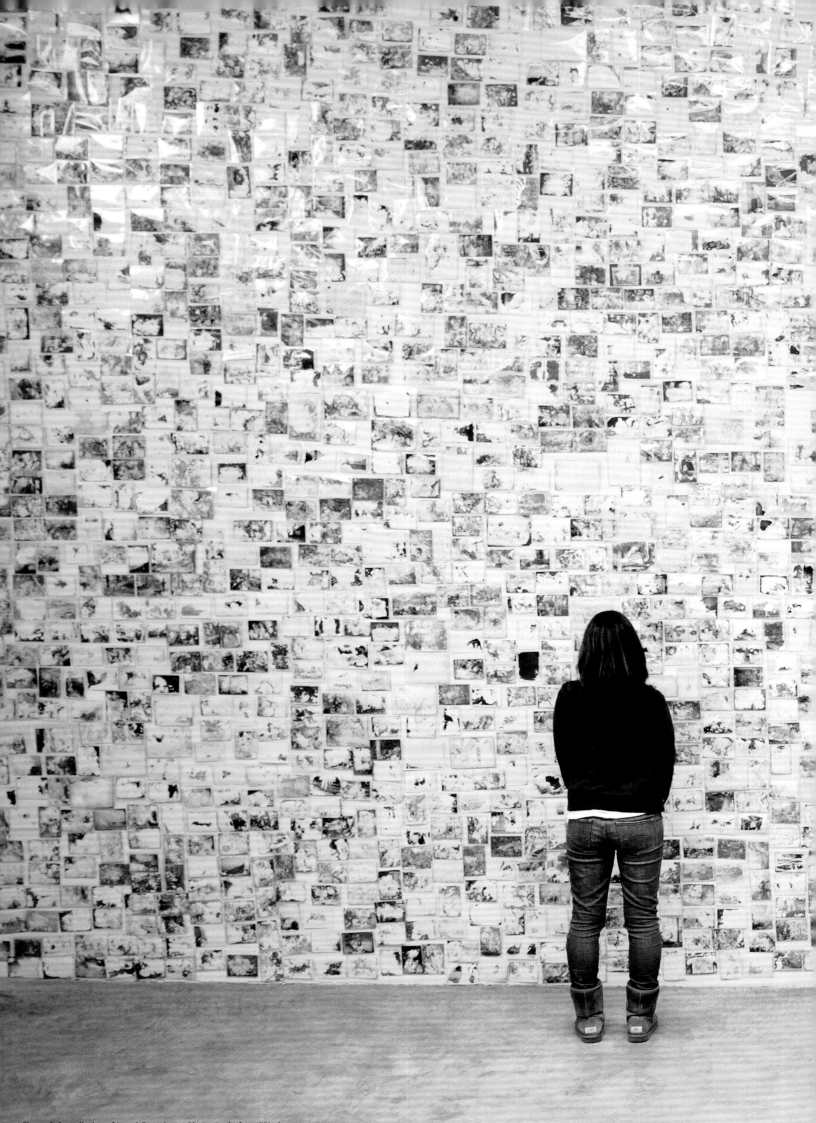

Figure 2. Installation of *Lost & Found: 3.11 Photographs from Tōhoku*, 2012

benefited the Japanese Red Cross.[3] Other witnesses ventured on their own to the area to record conditions in the aftermath. Yasusuke Ōta, who captured the surreal picture of the former TEPCO ostrich mascot wandering the evacuated streets of Ōno, wanted in particular to heighten awareness about the plight of the animals abandoned in the exclusion zone around Fukushima and to raise money for their care (fig. 3).[4]

Complete amateurs as well have taken images that can be particularly compelling, because they are unmediated; they convey the terror and also the poignancy of the experience, sometimes more immediately than the professional news photographers who were assigned primarily to document the events. One example, a YouTube video posted by a victim of the wave, had this effect on the fashion photographer Yasushi Handa: "It showed the tsunami barreling in and sweeping away his home. You could hear his cries and screams of despair. It had such a different impact because it was so personal and real." He realized that the tsunami left behind more than simply anonymous debris: "In the media coverage, reporters often used the word 'garbage,' which irked me. All these things that had been deemed 'garbage' had previously been a part of someone's life."[5]

In Tōhoku, once the waters receded, personal snapshots tucked away for private viewing—photographs of weddings, births, and school excursions—were discovered scattered among the debris. These images, as the photographer Lieko Shiga wrote, had "some ineffable power to make people pick them up, to not be overlooked."[6] Shiga was instrumental in conserving the scattered, water-soaked images from her adopted town of Kitakama (fig. 1). The Lost & Found project, under the photographer Munemasa Takahashi, mobilized volunteers to retrieve hundreds of thousands of images from the town of Yamamoto-chō (fig. 2). These photographs restored to the survivors images of lost people, communities, and ways of life, and offered a tangible way to hold on to them, if just for the moment. Photography became part of the mourning process.

In this publication, we have chosen to highlight the response of another kind of image makers, Japanese artists who work in a range of photographic media. Their varied creative practices have allowed them to step back from simply recording the disasters to reflect on the larger conceptual issues raised by creating art from such harrowing events. Reacting against the instant and repeated dissemination of images of 3/11, many contemporary art photographers waited to act—as one photographic historian writes, their "anti-reportage stance" involves "slowing down image-making, remaining out of the hub of action, and arriving after the decisive moment."[7] Rather than chronicling the onslaught of the waves, these artists examine the impact of the tsunami through the physical or spiritual traces of the communities that have been destroyed. Instead of documenting the explosions of the reactors at Fukushima, they seek metaphors for the invisible nuclear particles that contaminate the surrounding countryside and for the anxiety that continues to reverberate throughout Japanese society.

Japanese artists working in media other than photography, and those from other countries, have also responded to the events of 3/11. An example from outside Japan is a work by the Israel-born video artist Yishay Garbasz that depicts an eerily empty street in the nuclear exclusion zone (fig. 4). In Japan, the Aichi Triennale, the showcase for cutting-edge art, was dedicated in 2013 to "the socio-political repercussions and the environmental impact of the Great

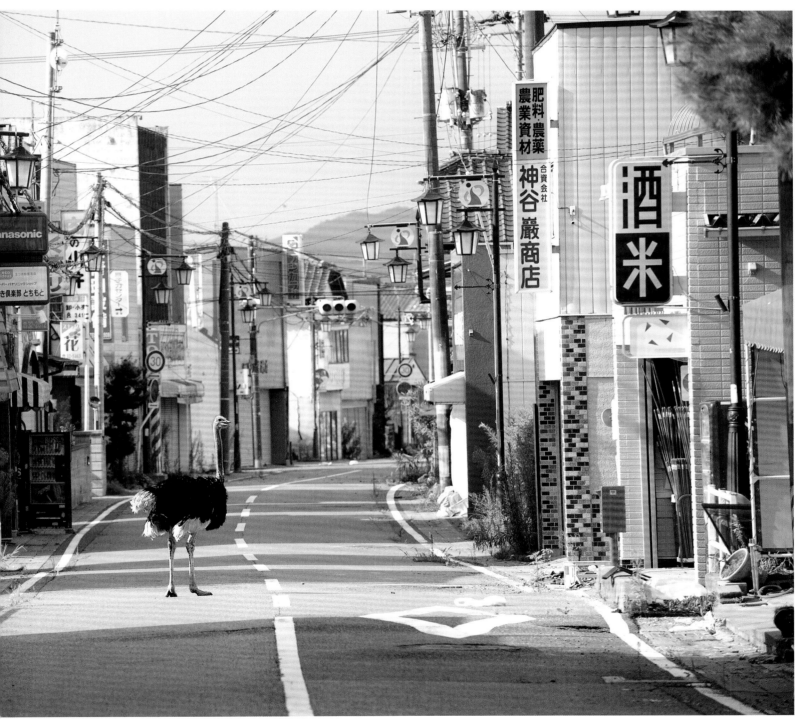

Figure 3. Yasusuke Ōta, *Deserted Town*, from the series *The Abandoned Animals of Fukushima*, 2011

Figure 4. Yishay Garbasz, video still from *Futaba, Fukushima Nuclear Exclusion Zone*, 2013

East Japan Earthquake"; the *Roppongi Crossing* exhibition at the Mori Art Museum, the triennial survey of the most recent developments in contemporary Japanese art, presented work that "reflects the social awareness that has been heightened since the Great East Japan Earthquake" that year as well. Artists as diverse as Takashi Murakami, who created paintings of the five hundred Buddhist *rakan* deities as "a prayer"; Takahiro Kondō, who sculpted a series of haunting ceramic portraits layered with metallic mist; and Kazuhiko Hachiya, the media artist who organized a group with scientists named Geiger Counter Meeting, have responded to the disasters. Nonetheless, photography has been the medium that has allowed artists to convey their reactions most directly.[8]

Since March 11, 2011, disasters both natural and man-made have continued to happen around the world. The great fear of many who experienced the Great East Japan Earthquake and its aftermath is that these catastrophes will fade from memory. In Tōhoku the endless mounds of twisted metal have been cleared away, and most of the landmarks of destruction made famous by news coverage have been dismantled. Yet recovery from the tsunami is far from complete, and the ongoing nuclear cleanup in Fukushima continues to affect not only personal lives but political developments. The photographs presented here ensure that what happened on that day will not be forgotten, while the power of their imagery invites us to contemplate, question, and yes, find profound beauty.

Anne Nishimura Morse
William and Helen Pounds Senior Curator of Japanese Art

Anne E. Havinga
Estrellita and Yousuf Karsh Senior Curator of Photographs

1 David Lochbaum, Edwin Lyman, Susan Q. Stranahan, and the Union of Concerned Scientists, *Fukushima: The Story of a Nuclear Disaster* (New York and London: The New Press, 2014), 12.

2 See Takanobu Tanaka, "NHK's Disaster Coverage and Public Value from Below: Analyzing the TV Coverage of the Great East Japan Disaster," *Keio Communication Review*, no. 35 (2013), 96–99.

3 See www.311photoproject.org.

4 Yasusuke Ōta has published two photobooks, entitled *Nokosareta dobutsutachi* (The Animals That Have Been Left Behind) and *Machitsuzukeru dobutsutachi* (The Animals That Continue to Wait; both, Tokyo: Asuka shinsha, 2012).

5 Yasushi Handa, *Mighty Silence: Images of Destruction, The Great 2011 Earthquake and Tsunami of East Japan and Fukushima* (Milan: Skira, 2012), 19.

6 Lieko Shiga, "The Spiral Shore," unpublished manuscript.

7 Charlotte Cotton, *The Photograph as Contemporary Art*, 2nd ed. (London: Thames & Hudson, 2009), 167.

8 The sculptor and painter Leiko Ikemura makes this point in "What Moves Us and What Can We Move? Fukushima and the Consequences," in *Ethics in Aesthetics?*, ed. Annett Zinsmeister (Berlin: Jovis, 2012), 179.

Araki

They say that memories fade, but it's true; you really do forget. . . .

It's the fourth year now, already. But, you know, photographs have that appeal—they're like some kind of optical illusion that makes things from however many years ago seem like just yesterday. They've got that power. Even the atomic bomb—they make it seem like it wasn't all that long ago.

It's almost as if you weren't a real photographer if you didn't take pictures of the disaster zone. But me, I didn't pack a snack and go out there; I scratched my negatives here. It's not your usual photographic realism, I guess, but for me this is realism. Normally you wouldn't damage your own photographs—you would take care of them, right? But me? I just do one after the other, as I take them every day, you know—so there are always plenty of pictures.

The only damage I suffered from the earthquake was a vase falling over and a leg coming off this guy [a Godzilla figurine]. That's it, just those two things. But then I end up being affected by the destruction from the nuclear plant and the radiation. Well, I guess I got all worked up by the nuclear stuff and the tsunami and had the urge to express something.

And then, you know what? Even out on the street I would come across scenes like a graveyard. That's what's so interesting. You don't need to force yourself to try to express 3/11. It's all already out there. Just let the breeze take you, let it flow over you, and it will just come out naturally. It's kind of amazing.

When we're shaken up by something that happens close to us, the strength to face life wells up within us. And when you've got a camera, you don't lose hope. It's like you actually get strength from it.

In the past, they've said that the camera is a phallus, but now I think that it's actually a vagina. It takes everything that's there and pulls it out. It receives and swallows up everything.

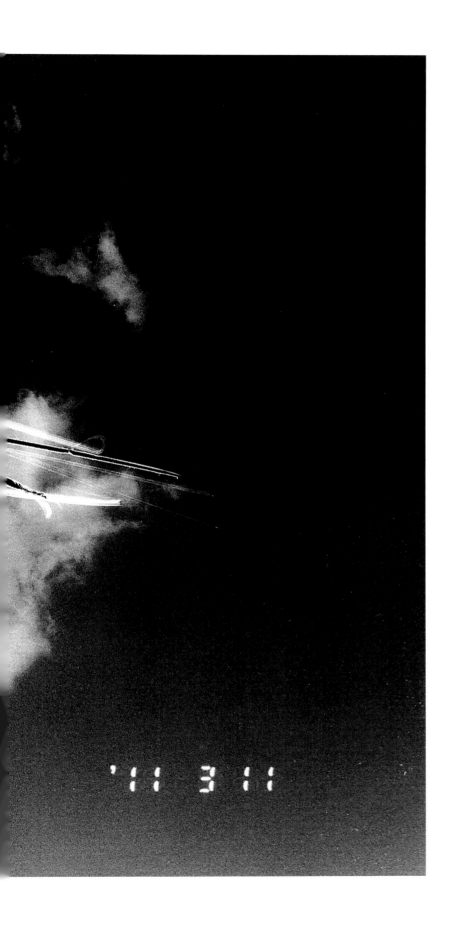

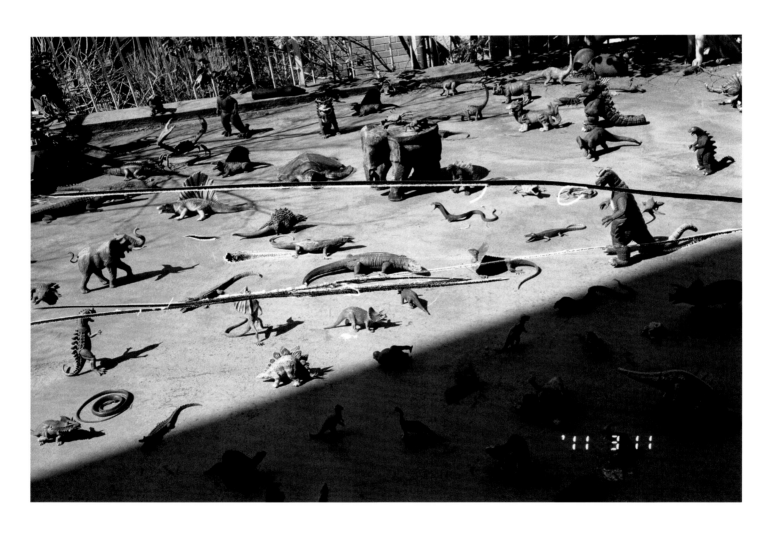

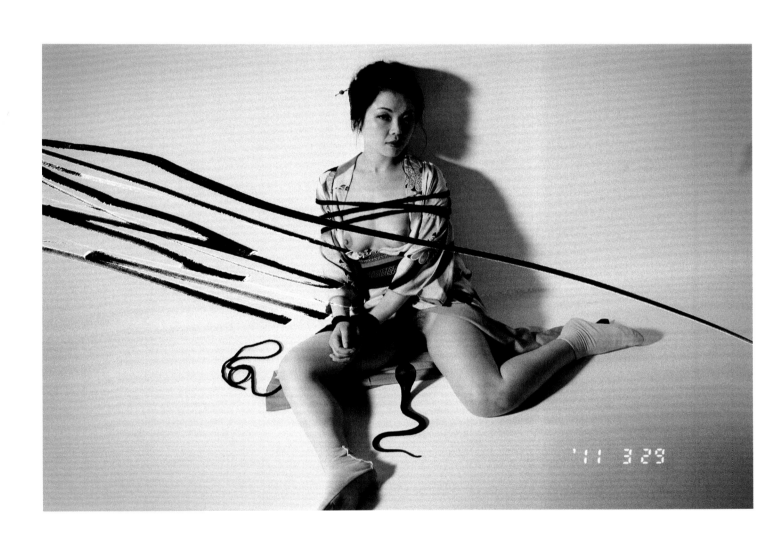

'11 3 29

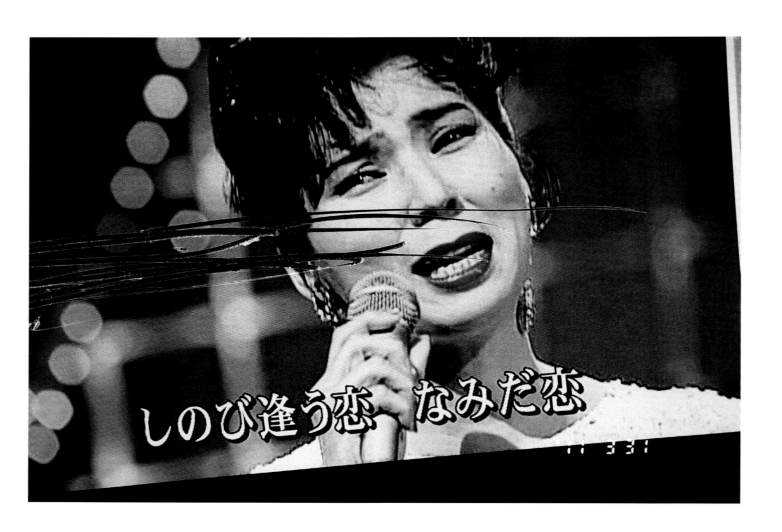

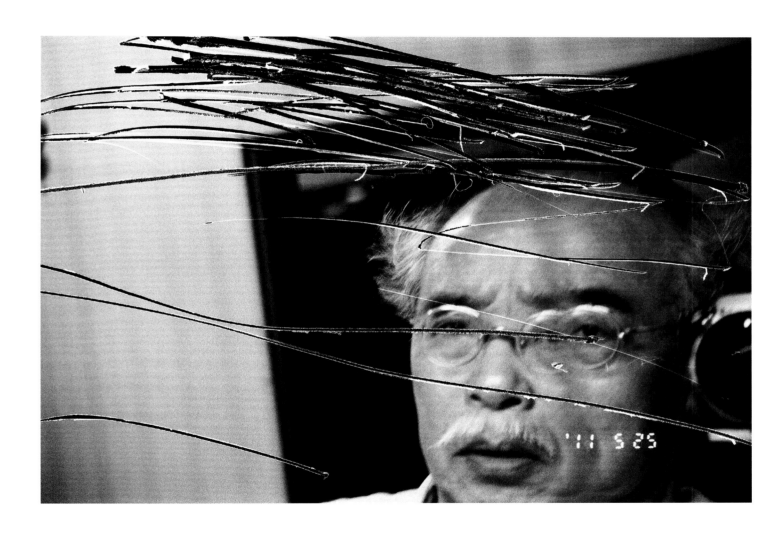

Kōzō Miyoshi

Time passed. Days passed. From the moment that unworldly spectacle began to stream, ceaselessly, across the inorganic liquid crystal displays, I no longer knew what, now, in this moment, I should do. I had always calmly decided on my own way, but now, it was as if an invisible ring of silk thread had become entwined in my consciousness, choking my thoughts. Two weeks passed in the blink of an eye. Once the ruptured highways were reopened, I decided that I must go, that I must see this reality with my own eyes. I debated whether to take a camera or not, then headed north, my mood entirely different from that of my usual trips. This project occurred to me on the way, but I hadn't yet decided whether I was actually going to photograph it or not. Ultimately, I intended to let the situation there tell me what I should do.

I had visited this region many, many times since my student days and it had inspired me deeply. In the 1980s I took a series of photographs there and wrote about what I saw: a breakwater, nets hanging to dry, a general store, a fish market, a pine grove, a shrine, an abandoned lighthouse. Now, the sights I saw and photographed and wrote about are gone. But I hope that in the near future, they will be able once again to welcome visitors.

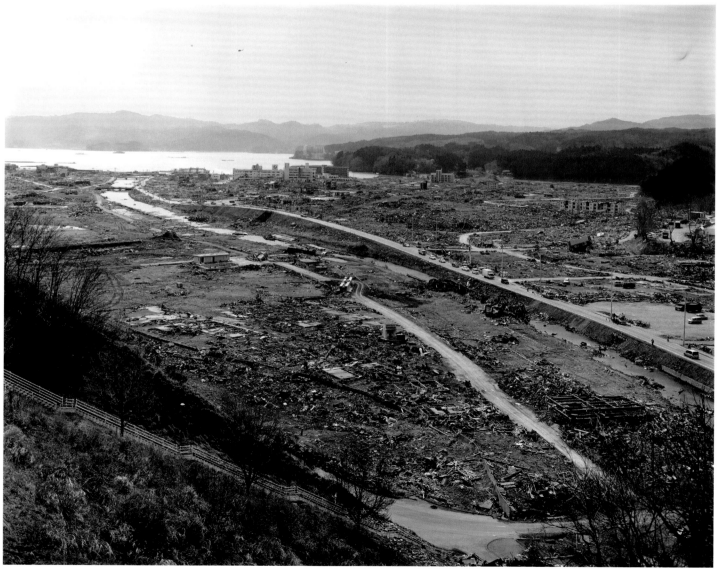

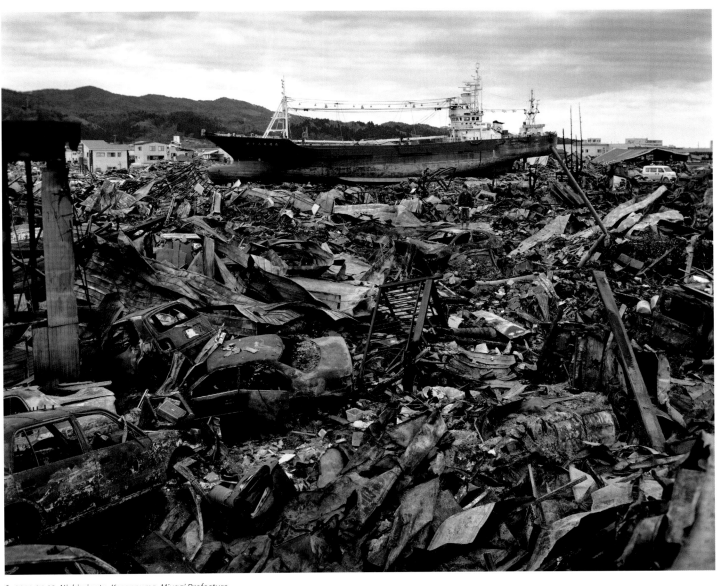

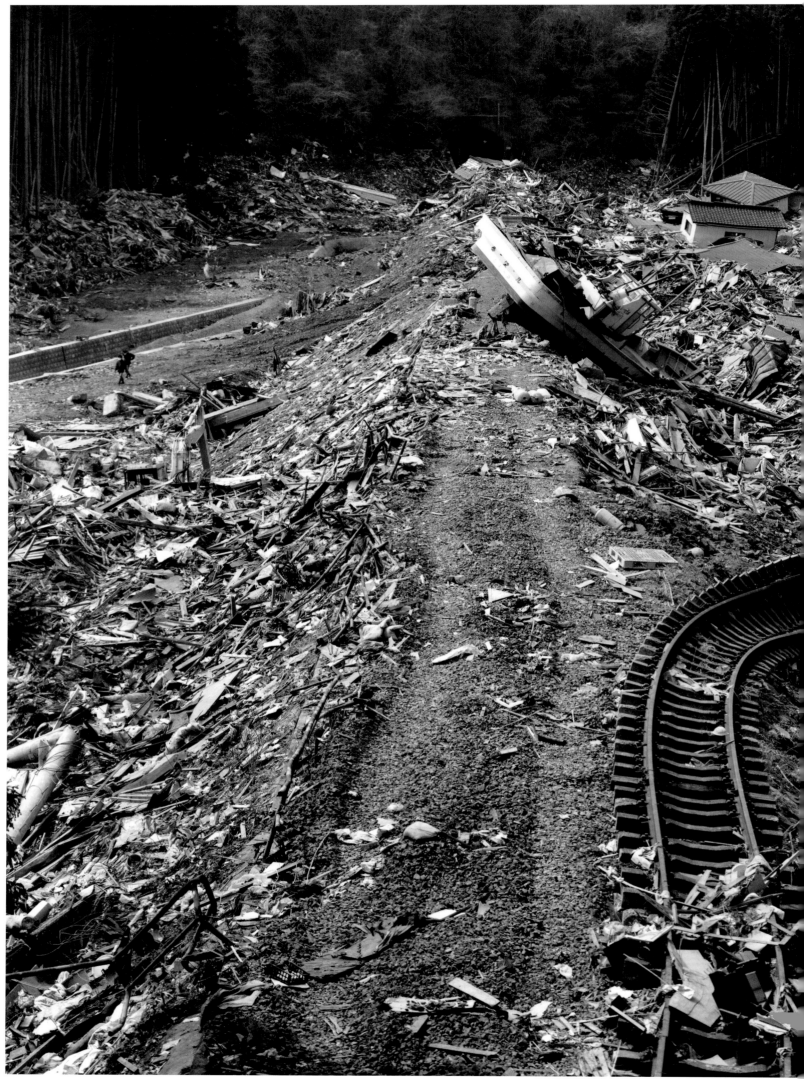

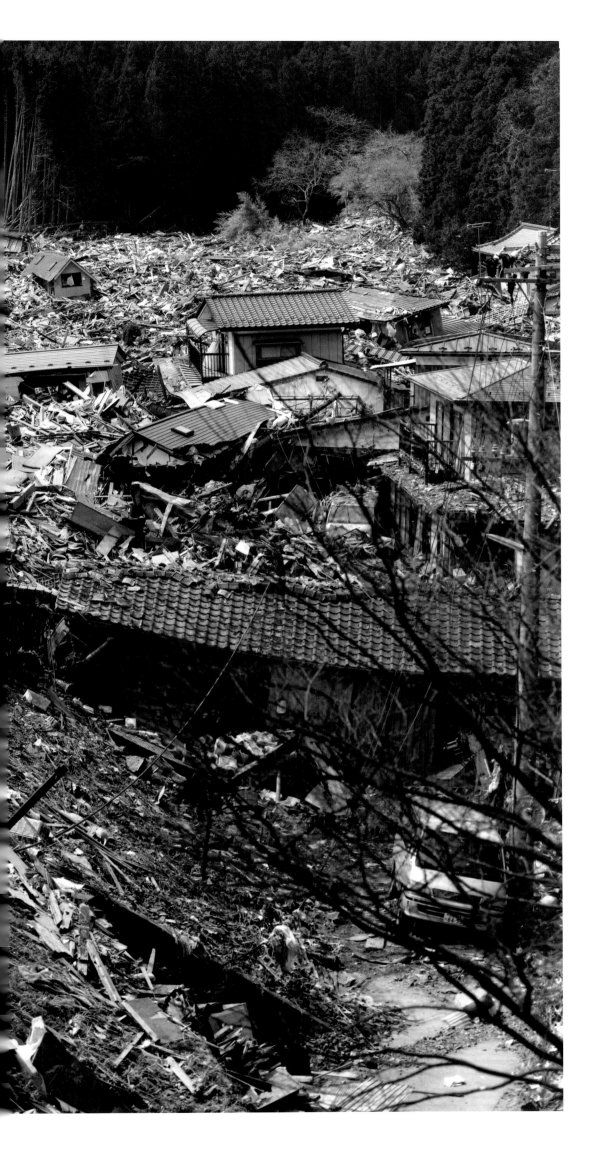

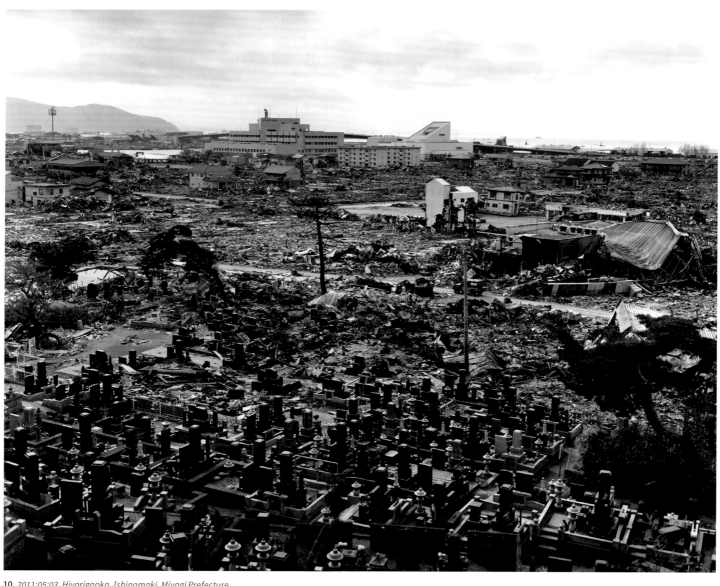

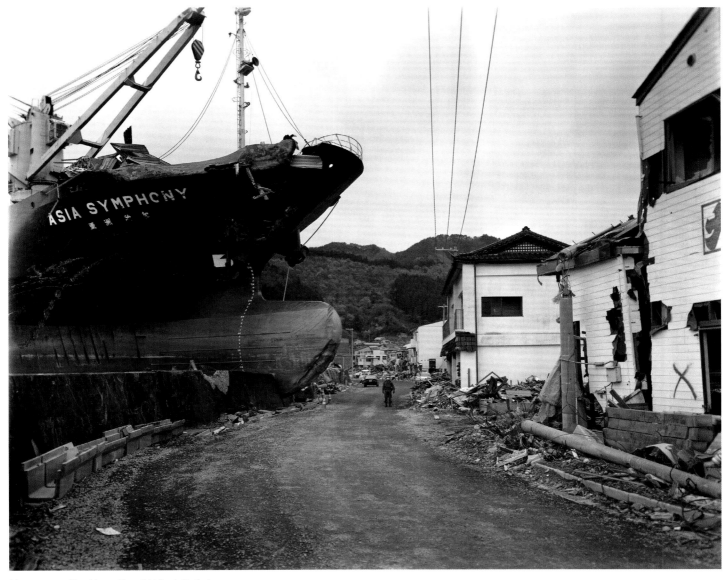

2011:05:05, Higashimae, Kamaishi, Iwate Prefecture

Kitajima

For me, the 2011 Great East Japan Earthquake and Fukushima nuclear disaster suddenly transformed the reality before my eyes into something else entirely. Photographing the ports and harbors, bays and beaches of this tsunami-ravaged coast, I realized the difficulty of distinguishing between the actuality of the predicament I saw with my own eyes and the apparent reality of the profusion of images that invade our lives by way of various media every day. Also, as I photographed the abandoned towns and villages, I could do nothing about the invisible radiation exposure but trust my dosimeter and imagine its effect. I wonder if we are not already entrenched in a world where it has become exceedingly precarious to think in binary oppositions such as victim-nonvictim, ordinary-extraordinary, fact-fiction.

In 2014, I launched a series of exhibitions and photography collections called *Untitled Records*. I feel that I must reexamine the photographs I have taken so far, and from this point forward my photos must continue to draw on those I took of the disaster area. *Untitled Records* is one way of beginning to implement this. I am planning a total of more than twenty exhibitions and publications at the pace of four per year. The locations for the photo shoots include the disaster-struck regions of Sanriku and Fukushima, of course, but extend to all parts of Japan, from Hokkaido to Okinawa.

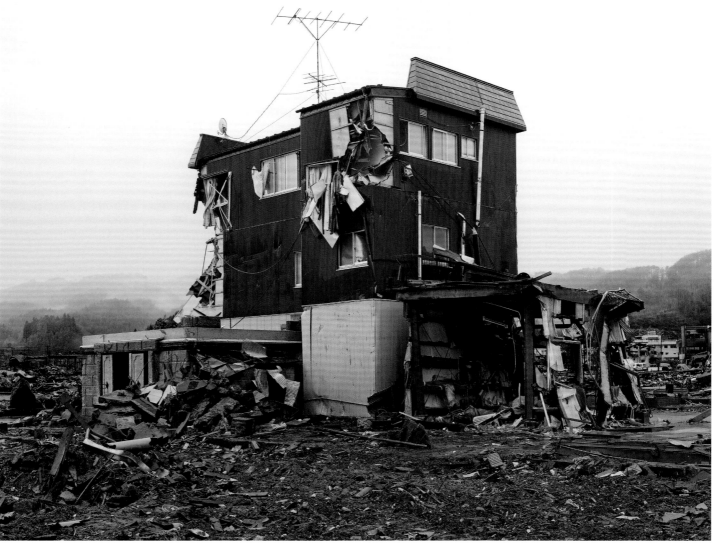

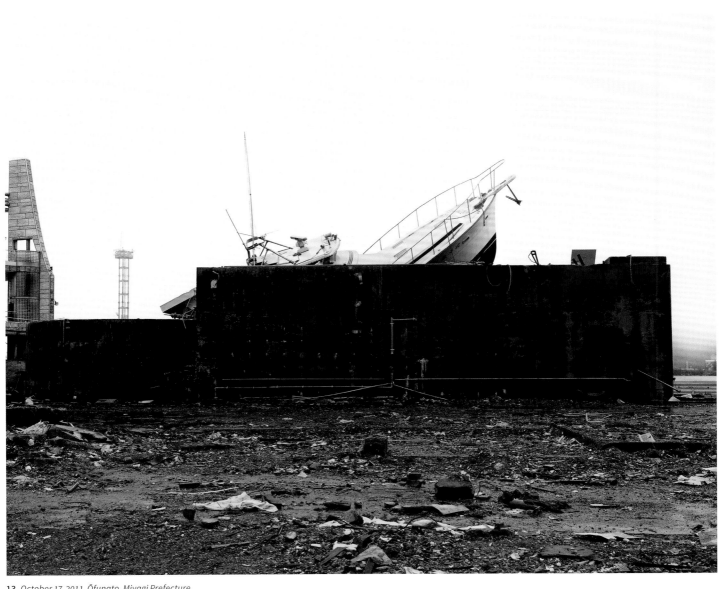

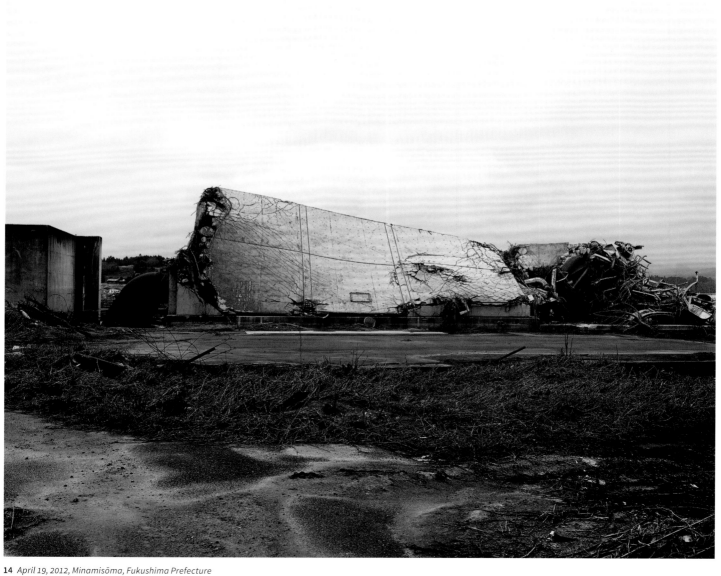

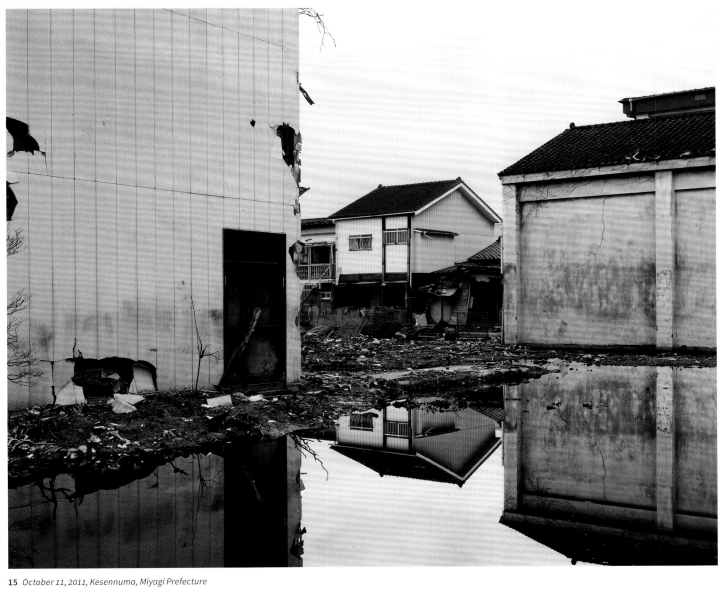

Kawauchi

April 2011. Ishinomaki. Onagawa. Kesennuma. Rikuzentakata. All these places were just so quiet. I realized for the first time how quietness connotes fear. There were no sounds. Instead, there were only fragments of what used to be part of people's lives, strewn about in piles. Against this leveled ground of rubble, the sky looked broader and more expansive than ever. Standing there for a while, I considered the smallness of my existence; so small that even a gust of wind could have blown me away. In that moment, I could also feel the reality of standing right here, in this body. To grasp that we exist, silence is necessary. And that silence involves a certain kind of fear.

In that quiet space, I saw a pair of pigeons—one black and one white. When I approached them, I noticed that they had banded legs, which meant they were domesticated. They flew away when I got too close but soon returned. This repeated several times: they flew away, circled about, and returned once more as though they were looking for their home and master. Looking at these pigeons, I thought of them as symbols of so many things, especially the dualism of our world. White and black, good and evil, light and shadow, man and woman, beginning and end.

Throughout existence there have been, and will be, innumerable incidents of delight and dread. Though I know it's unreasonable to question why happiness and sorrow repeat in turn, I couldn't help considering it while shooting. Creation awaits us after destruction. In this way, I felt that the scene before me was also a beginning.

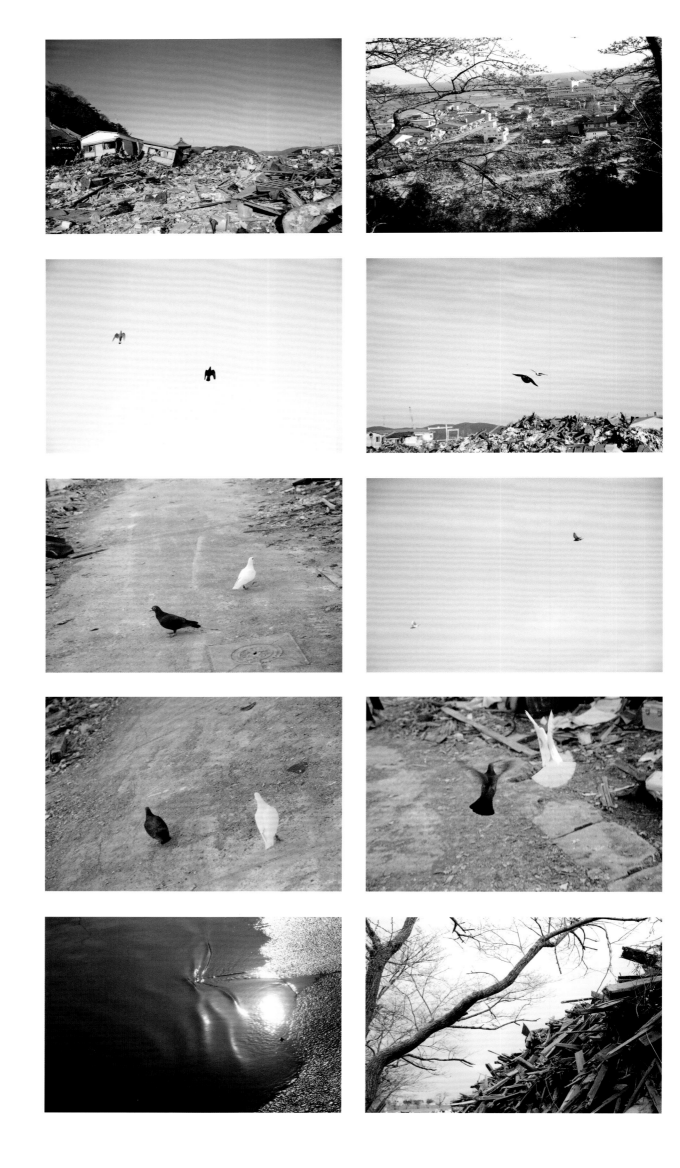

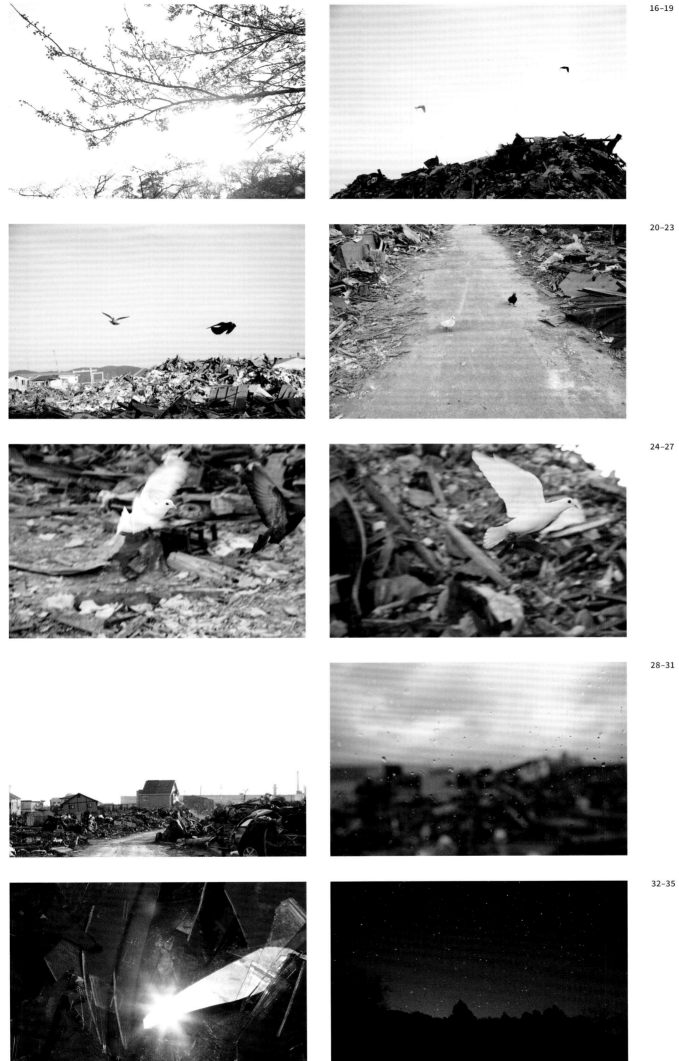

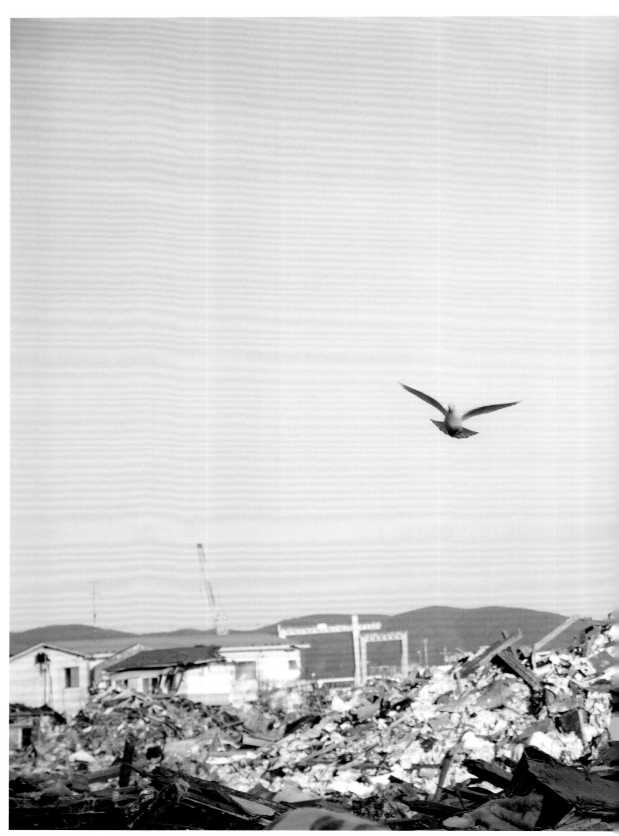

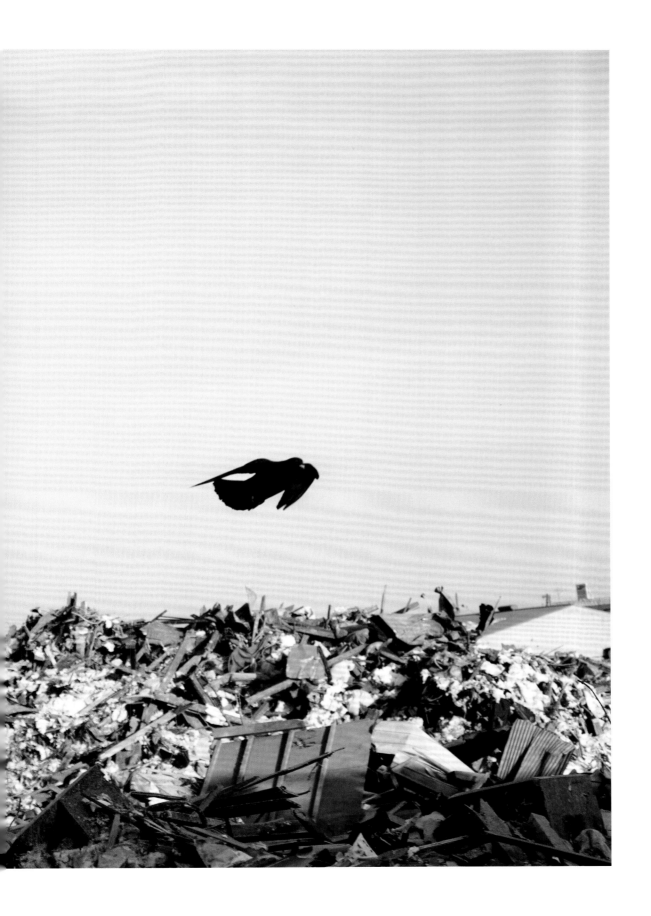

Hatakeyama

The tsunami severed time. Time before yesterday suddenly disappeared and, as a consequence, tomorrow too was gone. About all that was left were the merciless light that filled the emptiness before my eyes, the awareness to perceive it, and my own fickle memory.

With this giant tsunami—this once-in-a-millennium occurrence—time up to yesterday was erased and in its place a natural history emerged. Below the washed-out towns, the flat surface of the alluvial plain that had been there for a thousand years was laid bare. And yet, how can you say that this past of a thousand years ago—a past that none of us could know, of which no record or description remains—is anything but a fiction?

Those who survived the tsunami are now beginning to reclaim new land on higher ground. The process of carving out hundred-meter sections from the mountain, impossible a thousand years ago, is a gift of modern mining technology. The earth that is brought from the mountain every day with heavy machinery and conveyor belts is piled up daily on the low ground. In the same way, in the midst of the frustration that is the present, we too are slowly stacking up time day by day. We are creating a new past, hoping all the while that, before long, from that past a new future will be born.

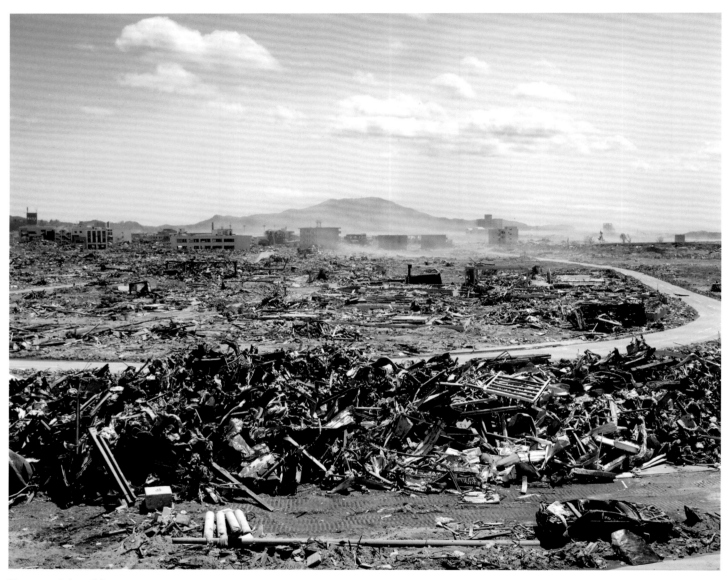

36 *2011.5.2, Takata-chō*

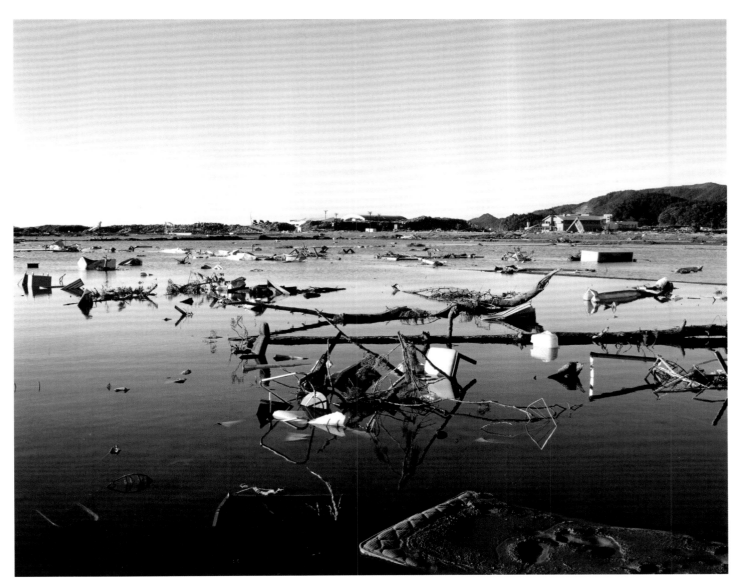

37 *2011.6.15, Kesen-chō*

38 *2012.2.25, Takata Matsubara*

39 *2012.2.25, Takata Matsubara*

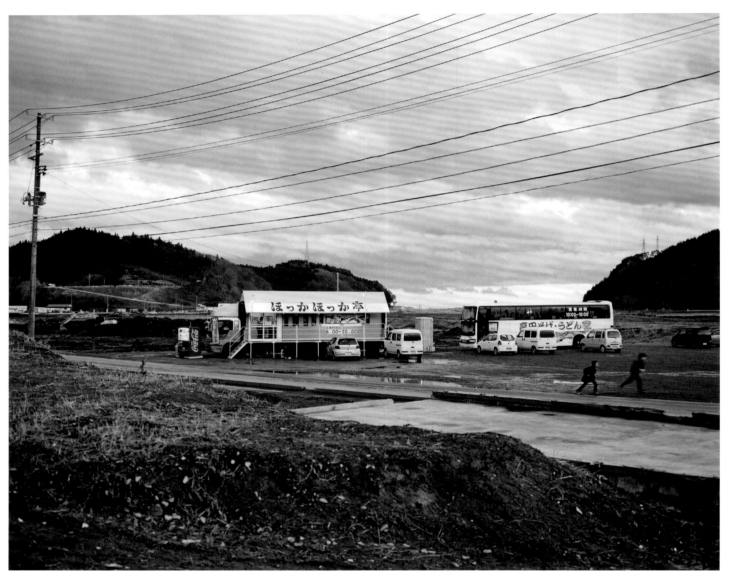

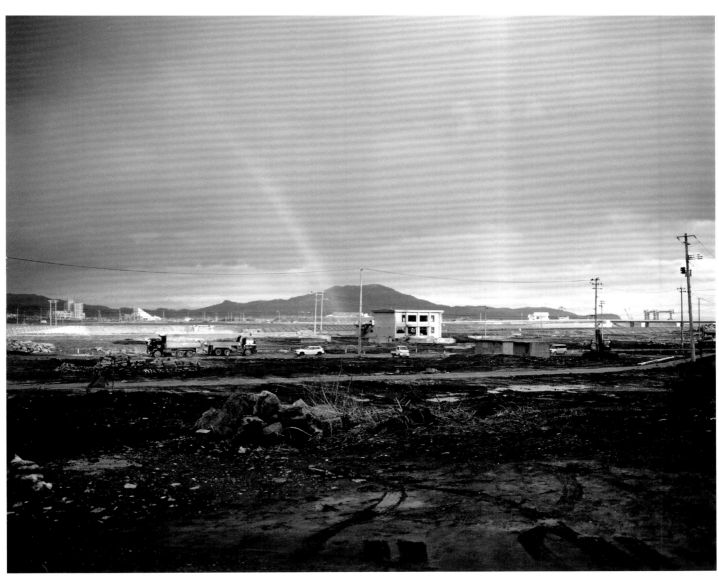

41 *2012.3.24, Kesen-chō*

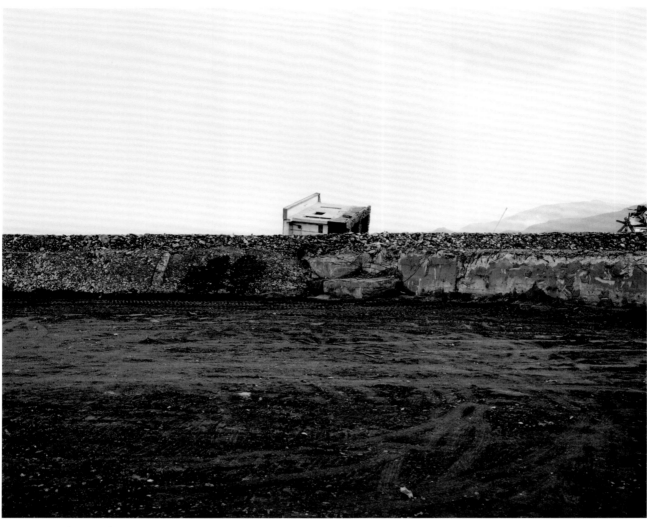

42 *2013.3.31, Takata Matsubara*

43 *2013.5.11, Kesen-chō*

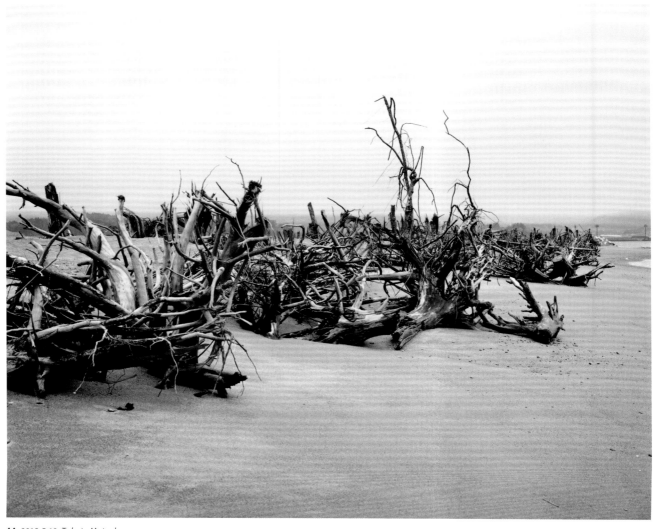

45 2013.5.14, Kesen-chō

46 2013.6.16, Takata-chō

47 *2013.6.16, Takata-chō*

48 *2013.9.25, Takata-chō*

2014.5.18, Takata Matsubara

Shiga

In the winter of 2008, I discovered a beautiful pine grove on the sea. Normally, when I feel that way about a place, I photograph it and go home, but that time I didn't take any pictures. But I didn't want to go home either. Instead of taking pictures, I felt like I just wanted to stay there indefinitely. The place enchanted me so much that it refused to allow me to take pictures in my usual way. Later, the earthquake and all those other things happened, but now I think that the reason I couldn't photograph that place was because the magical, fantastic impression I sensed in that pine grove and sea was a harmonious society. The Kitakama pine forest was linked to the far reaches of the world.

In front of the camera, the residents "performed" for me an otherwise unseen act, a role, as they do in the rituals enacted in the village. Capturing that performance was also my own attempt to gain access to the connection among us that sleeps in the inner-most depths of the earth and air of Kitakama, and to experience the faintest shadow of it. I now feel that photographs are something freed from all axes of time and that have a value that swings widely. Meanwhile, I wonder if the act of taking photographs isn't itself a kind of ritual for creating a space that is unbound by past, present, and future.

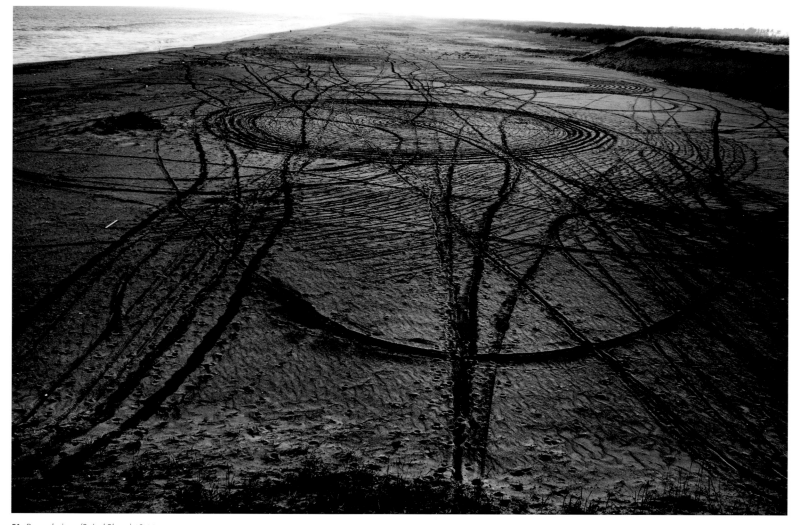

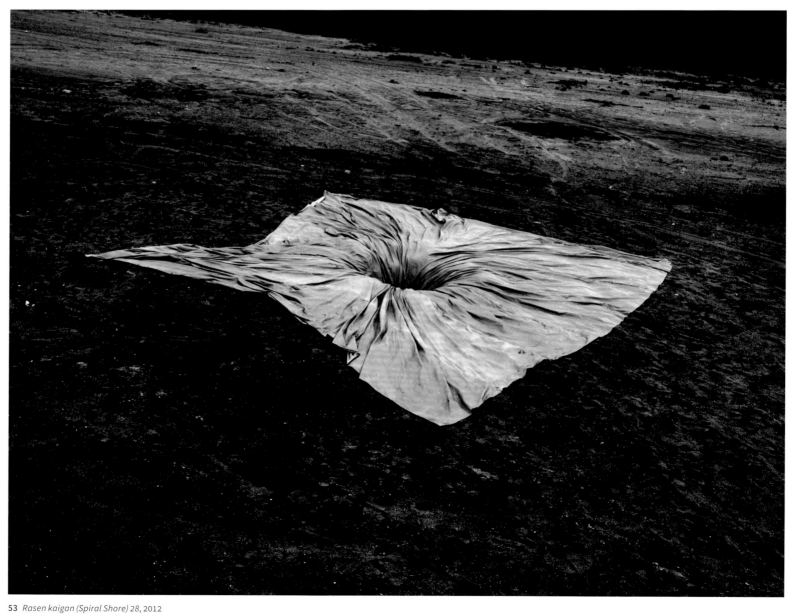

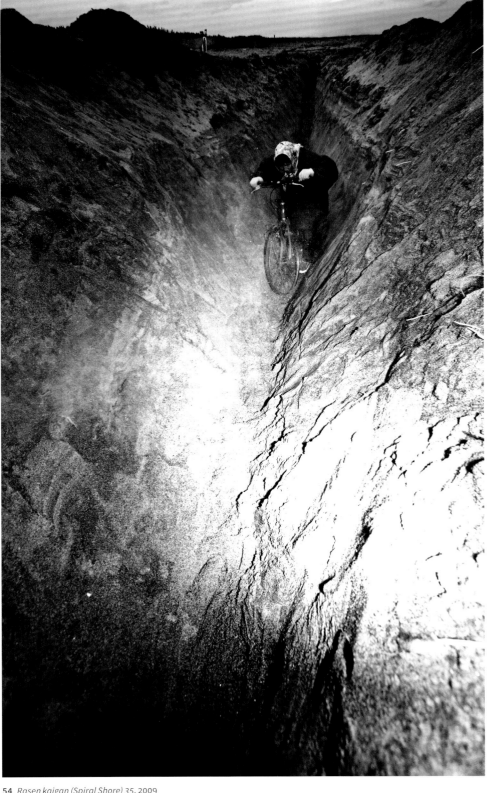

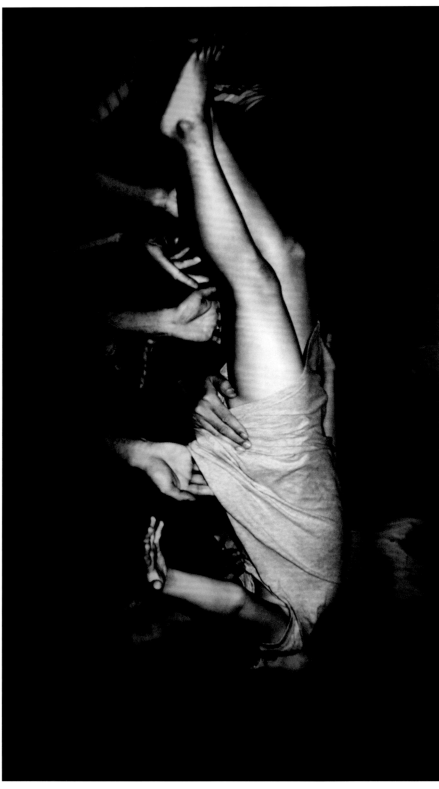

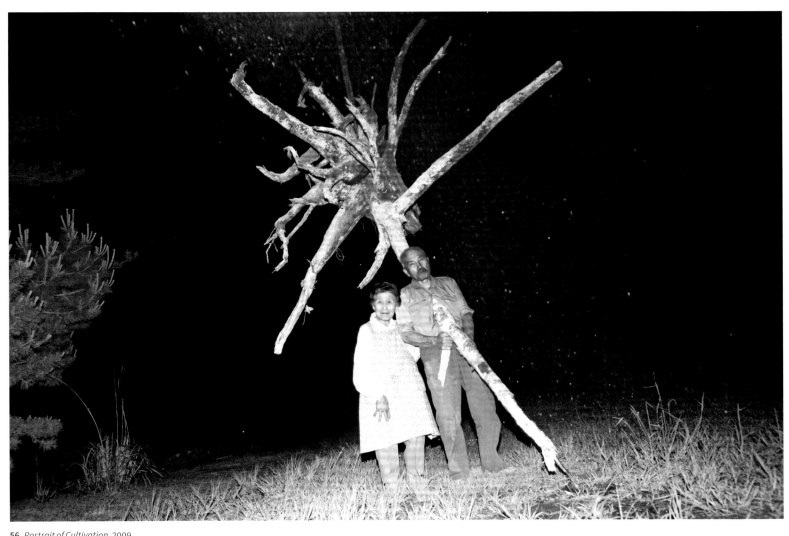

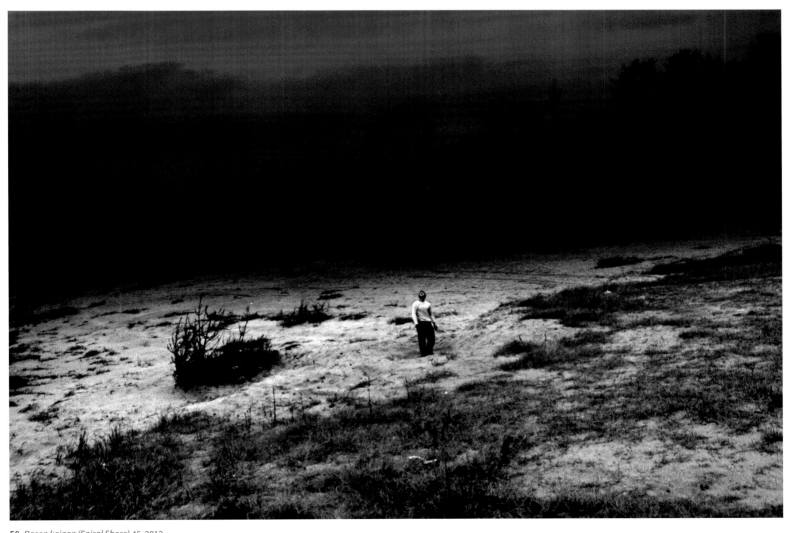

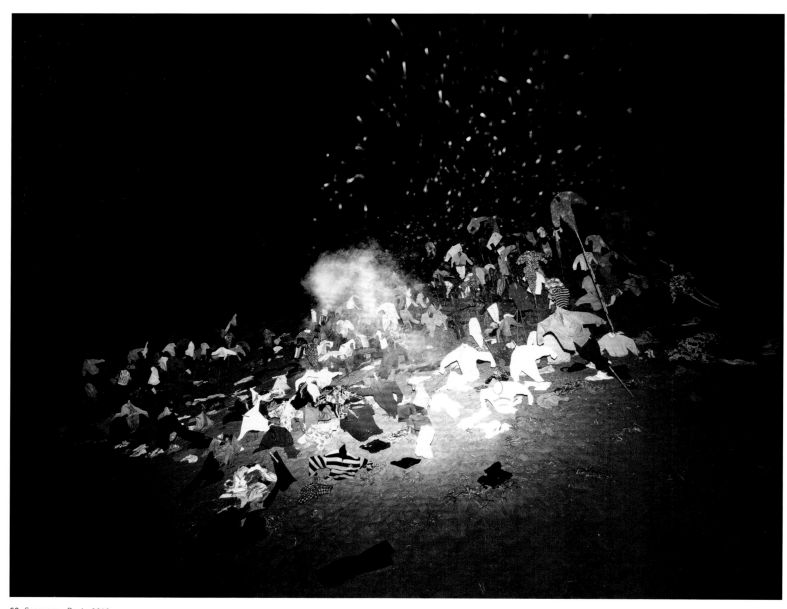

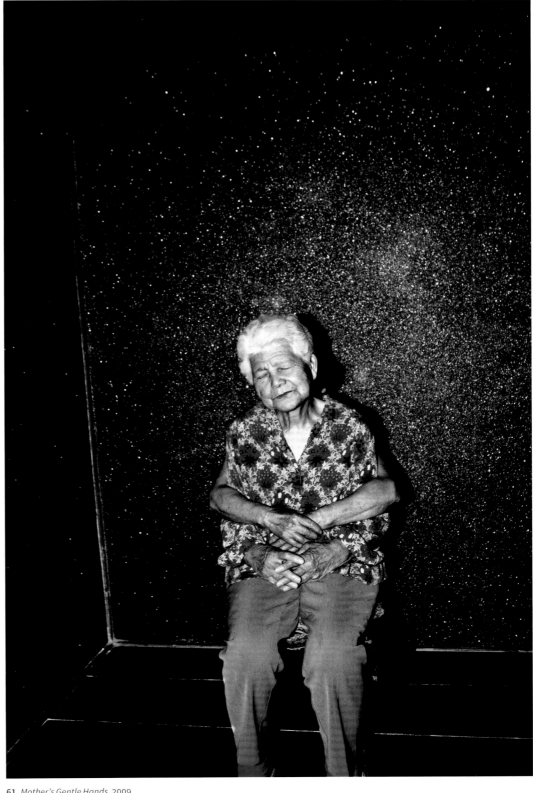

Mother's Gentle Hands, 2009

Chiyoko chan, Chiyoko chan, 2010

Han

In Tokyo, radioactivity level monitoring data is updated daily and large numbers of images have been broadcast on television. You can come across them without even trying. You can see without even going. The innumerable images issuing forth from the mass media have swallowed up our bodies like a tsunami. Two months after the earthquake, I cycled along the Pacific coast from Tokyo to Aomori. It's not as if I had a particular purpose; I just wanted to get away from that place that was Tokyo. I pedaled along, pinning my hopes on seeing the scenery of my childhood home of Aomori once again. The only place along the way that I couldn't pass was Fukushima. The area around the Fukushima No. 1 power plant was no longer inhabited; it had been reduced to a mere "landscape." And now, it feels as though Fukushima itself has become no more than an image that is gradually being consumed.

Nuclear power is intimately connected with the economy, and the government stirs up the public about it as if life as we know it could not exist without it. From now on, for the rest of our lives, we will no doubt continue to live alongside the invisible thing that issued forth from that destroyed structure. The scene of that ruined edifice is the very image of ourselves. *Life Scan Fukushima* is an attempt to reconstruct the society we live in based on existing images that have been circulated by the mass media, utilizing digital construction and composition techniques. It is a scene of the restored structure formed, like a digital photograph, from individual pixels composed of one-yen coins, the smallest unit of currency in Japanese society. I've created it with the belief that in it we will be able to see something that has been hidden from us.

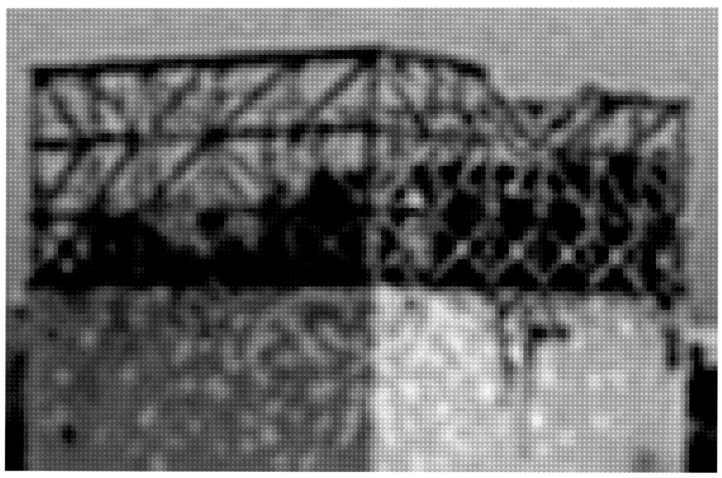

63 *Life Scan Fukushima*, 2014

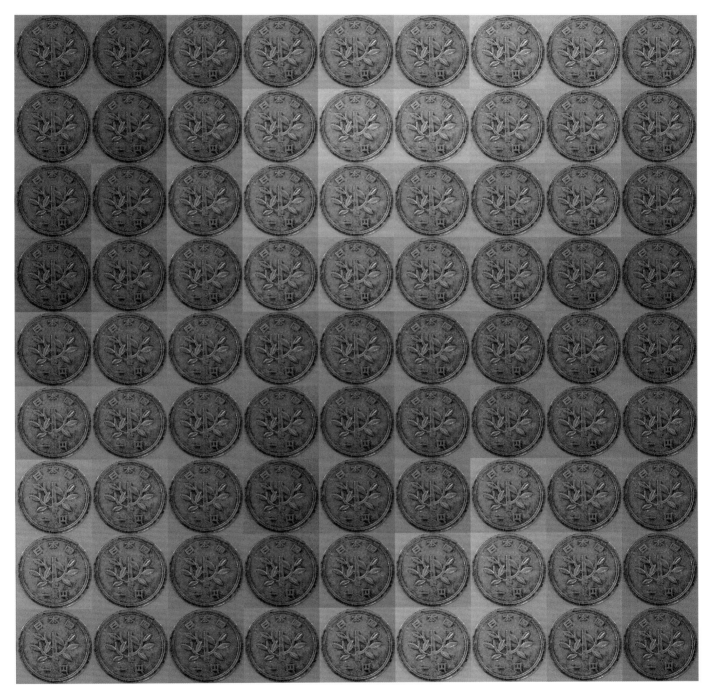

64 *Life Scan Fukushima*, 2014 (detail)

Masato Seto

Even now, the sound of their steps still rings in my ears—the crowds of people making the hours-long journey home by foot that day, stunned by earthquake tremors such as we had never experienced, even several hundred kilometers from the epicenter as we were in Tokyo.

In Fukushima, 35 kg of cesium was released onto the earth and almost all of it rained down on northern Fukushima Prefecture. They say that was about half the amount that fell at Chernobyl.

It was a week later when I set out for my family home in Fukushima. The sky over the disaster area was cloudless and only the wind cut through the deathly stillness. A breeze from the ocean danced overhead, blowing as if in search of something to stir. Slipping through a wide-flung window, it fluttered a curtain that had just started to dry. Oddly, the curtains in every window had not been washed away, and they swayed in the wind. Meanwhile, the offensive smell that wafted here and there was being swept cleanly away.

In February 2012, I had the opportunity to enter the site of the Fukushima No. 1 nuclear plant. The French minister of the environment was inspecting the grounds and I had been asked by a French news agency to photograph the visit. About twenty of us, including the minister and various embassy staff and reporters, boarded a large bus and traveled northward along the coast.

It was a warm, sunny day. We stood on a knoll that for the past thirty years had been off limits to unauthorized persons. With our bodies wrapped in white Tyvek suits and with gas masks snugly over our heads, we looked out wordlessly over the structures of the four destroyed reactors lined up below us. From the water's edge to the distant horizon, not a single cloud marked the vast sky, and the great deep of the Pacific shone a vivid blue as if to say it knew nothing. The sea of Fukushima seen through the glass of the gas mask, an invisible horror . . .

But if you saw it as beautiful, there's no doubt it was an incomparably beautiful sight. At that moment, thinking to try to capture that invisible horror on camera, I reached out to the nature of Fukushima—its mountain forests, rivers, and fields. I started photographing in an attempt to visualize the cesium that must be clinging to things everywhere, the horrific, terrifying things, but now I feel that I've seen something that should never have been seen.

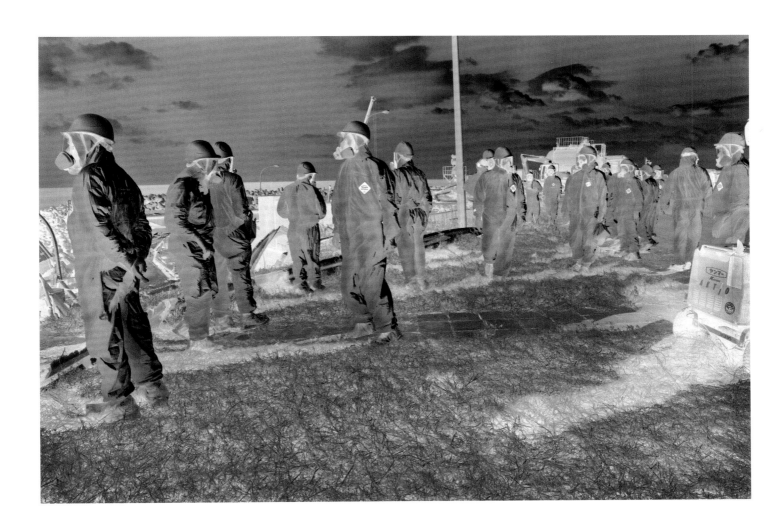

Takeda

I have always been drawn to abstract patterns formed by natural phenomena. Whether they are cracks inside a mineral or salt crystals swaying in water as they dissolve, these elemental expressions of the earth tell stories of much greater cycles of time. In recent years, I explored them through the making of radiographs. Approaching the subject through direct light felt integral to my vision both conceptually and aesthetically. These works invariably reflect my respect for and appreciation for the grandeur of nature untouched by humankind. Yet, it had never occurred to me, or been my interest, to merge my creative process with documentary photography until March 11, 2011.

What happened during and in the wake of the Great East Japan Earthquake had a strong emotional effect on me, especially as Fukushima is my birthplace. Though I was in New York City at the time, the tragedy assailed not only myself, but also the entire community with anxiety. Before the Fukushima Daiichi nuclear disaster, I did not have much understanding of radioactivity. Reliable sources of information on the subject were not easily accessible back when the world was wrapped in confusion. Seeing data documenting radiation in the air, soil, and ocean did not feel real. Therefore my natural instinct was to visualize this invisible incident in some way.

Soon after, I became aware that film and photographic paper were sensitive to radiation just as they are to visible light. On their surfaces, silver halide darkens when exposed to electromagnetic radiation. While researching the process, I learned the term "autoradiography," which is a method that uses X-ray film to visualize molecules, or fragments of molecules, that have been radioactively labeled. I tried several ways to figure out a practical production method and exposure time for applying this technique to my experiment.

I chose soil as the material to work with. I thought that any change perceived in an element as primal as a particle of earth could potentially lead to a picture of the aftermath in the most direct manner. After the soil sample had been interacting with the light-sensitive film for a month, I discovered the trace of radiation lurking in among the silver halides—a physical record of the catastrophe.

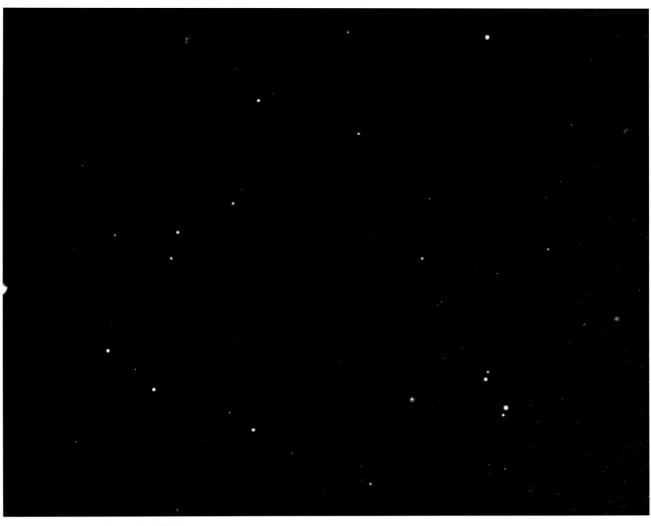

68 *Trace #3, Former Kasumigaura Naval Air Base*

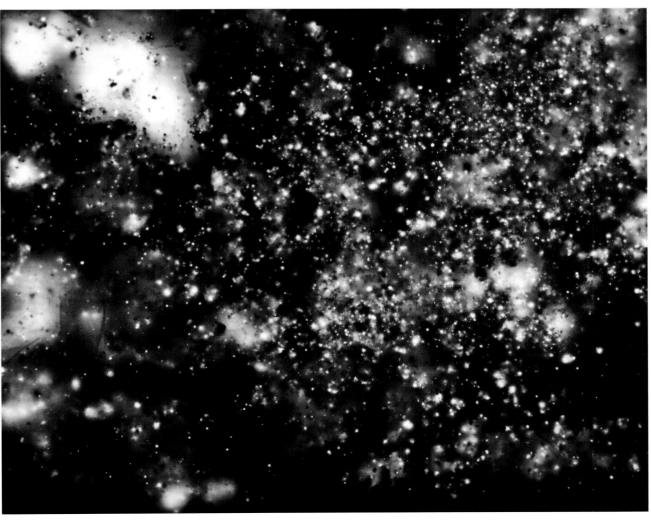

69 *Trace #7, Nihonmatsu Castle*

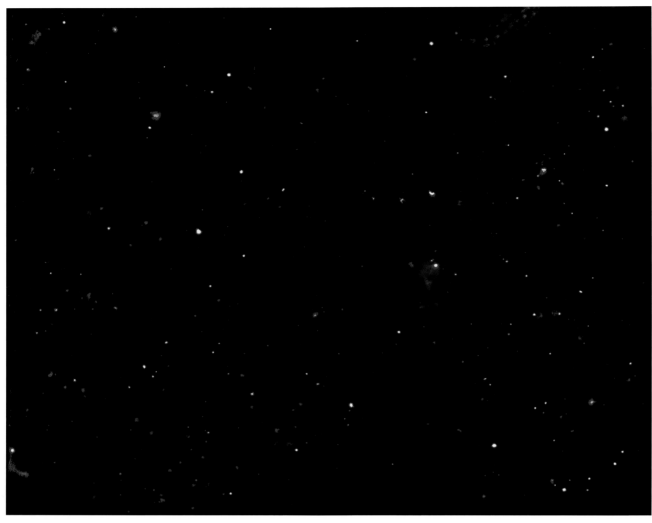

70 *Trace #9, Asaka Kunitsuko Shrine*

71 *Trace #10, Iwase General Hospital*

72 *Trace #13, Chūson-ji*

73 *Trace #16, Lake Hayama (Mano Dam)*

Homma

I believe that photographs tell their own story.

These mushrooms were all photographed in the forest of Fukushima. After the earthquake, radioactive material was detected in them and people were prohibited from harvesting and eating them.

Even though they have been affected by radiation, these mushrooms still live on in the forest.

I feel that continuing to photograph these children of the forest is the only thing I can do.

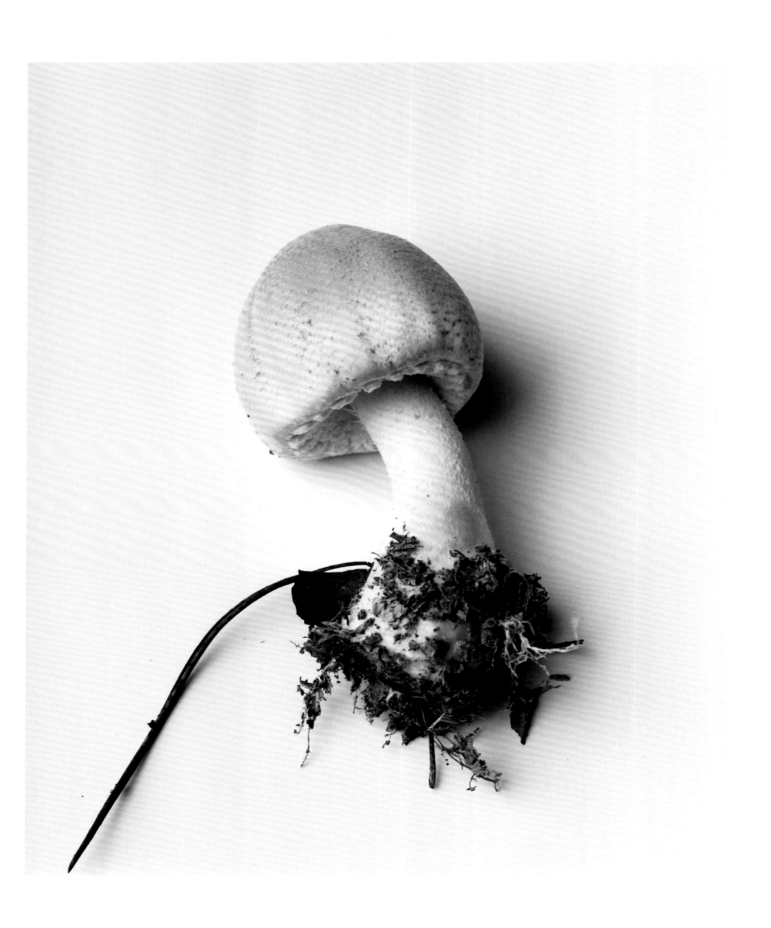

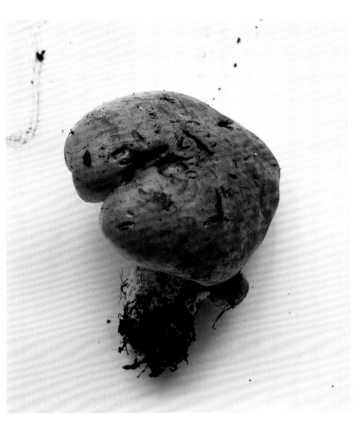
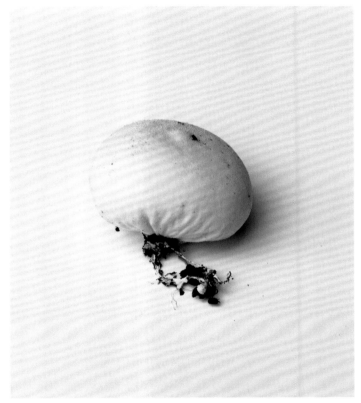
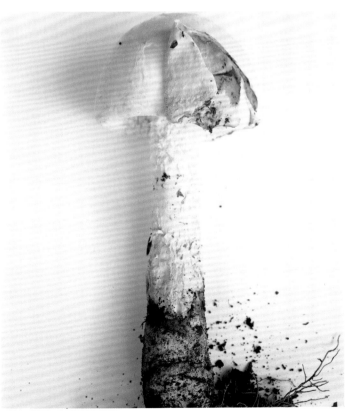
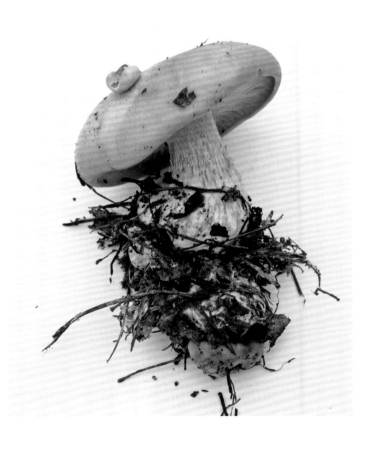

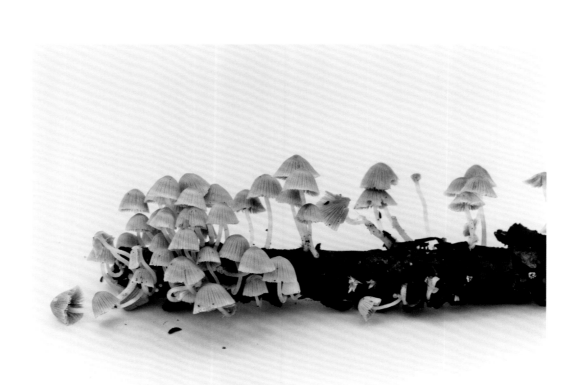

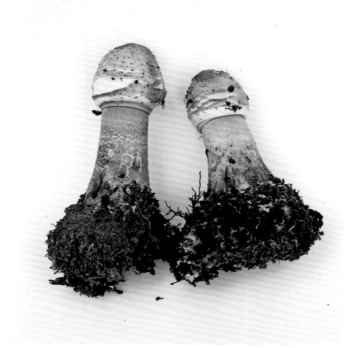

Masao Tatsuki

To be honest, I remember it only in fragments: Sitting in my room in Tokyo, sorting through the photographs I took in the Tōhoku region during the six years from 2006 to February 2011 for my photobook *Tōhoku*. Taking refuge outside with my wife, who was also at home, when the tremors from the earthquake got more intense. That the sky was blue. That after a little while the media began all at once to broadcast news of a tsunami over and over again. Even now, looking back, I can't remember it in continuous time. I was beside myself with worry, not so much for myself, but for my friends who lived in the Tōhoku region that I had so frequently photographed.

I photograph with film even now. Film is "raw." I load the raw film into the camera, aim, and snap the shutter. Everything is a moment that comes only once. The light burned onto the film becomes figures and the print is completed. It resonates with the humility I felt in taking the lives of deer when hunting in Tōhoku. And even more, it seems to parallel the cycle of life and death that has connected all living things since ancient times.

Since 3/11, I have been feeling even more strongly the desire to burn onto film these sensations and things that can't be seen with the eyes—these things that have a connection to the present and go back to distant times on the Japanese archipelago, and that we have felt but then forgotten. I have sensed it for some time now, but I think that the feeling has grown stronger because the nuclear incident opened my eyes to the invisible radioactive material that is so destructive to people's lives.

82 *Deer 3, November 2011, Kamaishi, Iwate Prefecture*, from the series *Is the Blood Still Red: 2011.11.19–20*

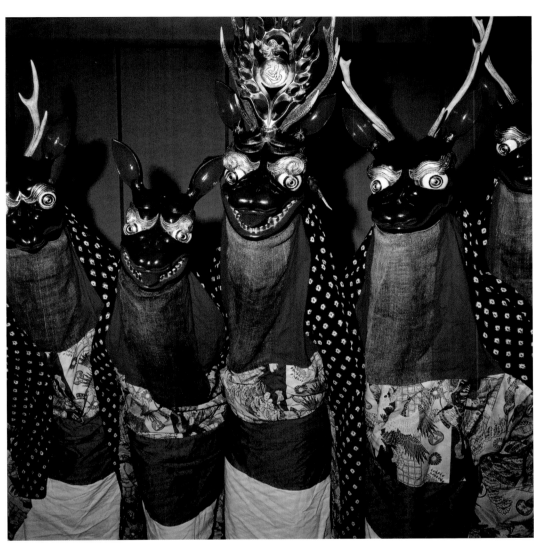

83 *Shikaodori (Deer Dance) in Natsuya Area, Kawai Village, October 2009, Miyako, Iwate Prefecture*, from the series *Tōhoku*

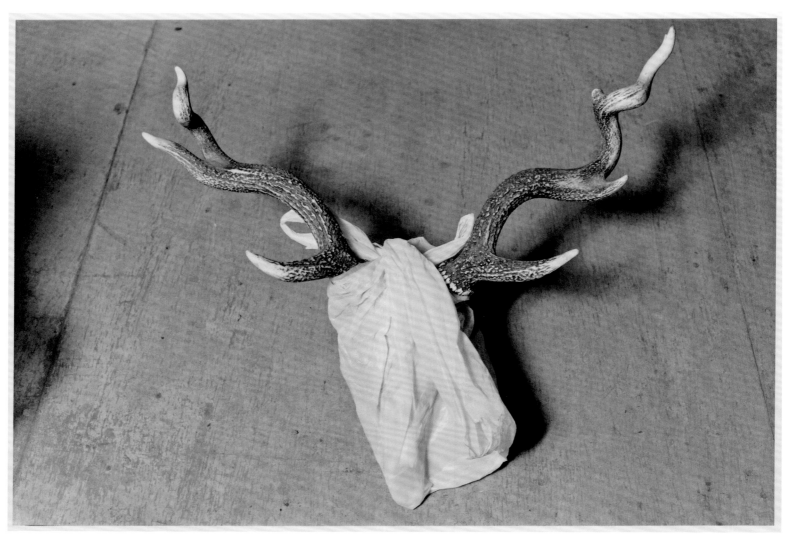

84 *Deer Skull, October 2013, Kamaishi, Iwate Prefecture*, from the series *Never Again*.

85 *Bathroom, October 2013, Kamaishi, Iwate Prefecture*, from the series *Never Again*.

Takashi Arai

When the daguerreotype, the earliest form of photography, was born in France in the nineteenth century, these irreproducible images were valued for bearing the likeness of the townspeople whose forms they captured, serving as tangible objects that remained after they were gone. Since then, have photographs, without our noticing, come to function merely as a medium for conveying meaning or recording circumstance?

The 2011 earthquake and tsunami washed away family albums, photographs, and entire households of furnishings from countless homes. Along with cash, securities, and ancestral mortuary tablets, family photos were among the most valuable possessions recovered by the police and Self-Defense Forces in their search to recover the bodies of the dead. Never before seen by the public eye, these photographs of the townspeople were now laid bare beneath the white light of the midday sun. I have taken to calling the photographs that transfer memory in this way *micro-monuments*. They are not merely a medium for negotiating meaning; these photographs have a tangible, material form and a surface that bears the physical marks of their pain.

The daguerreotype, irreproducible and etched by the light emanating from a particular place—its surface literally carved in 100-nanometer relief—is also a micro-monument.

What is a monument? A monument is an object whose surface has been marked by traces of contact with a certain event, and which arouses new emotions and recollections in each individual who comes into contact with it. The encounter is, necessarily, a personal experience and cannot be collectively summarized with a single meaning or interpretation.

They say we must never forget Hiroshima and Nagasaki, the *Daigo Fukuryūmaru*, Fukushima.... But for the vast majority of us who did not directly experience those events ourselves, this slogan is an impossible command. Nevertheless, we continue to refresh our individual experience and memory through continuous contact with monuments. We must continue to alight here on their surface. To confront these monuments is to connect with a bygone time and space. It is to lend an ear to the new tale of you and of me that is being spun from the monuments' surface. This is surely how the new twenty-first-century resistance to extinction and oblivion will once again be waged.

86 *March 11, 2011, Sample of the Fallout from US H-Bomb Test in Bikini Atoll in 1954, Collected on Japanese Fishing Boat* Daigo Fukuryūmaru *(Lucky Dragon 5¸, Todoroki Ryokuchi Park, Kawasaki*, from the series *Daily D-type Project*, 2011

87 *Study #2, A Multiple Monument for* Daigo Fukuryūmaru *(Lucky Dragon 5), from the series* Exposed in a Hundred Suns, 2014

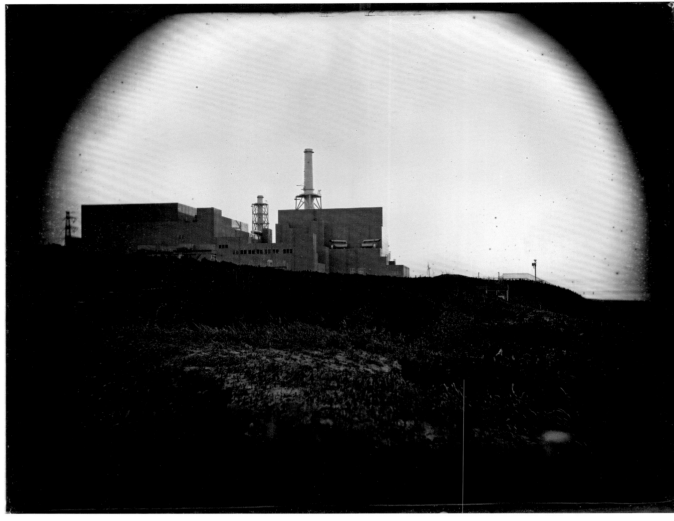

88 *April 5, 2011, Hamaoka Nuclear Plant*, from the series *Mirrors in Our Nights*, 2011

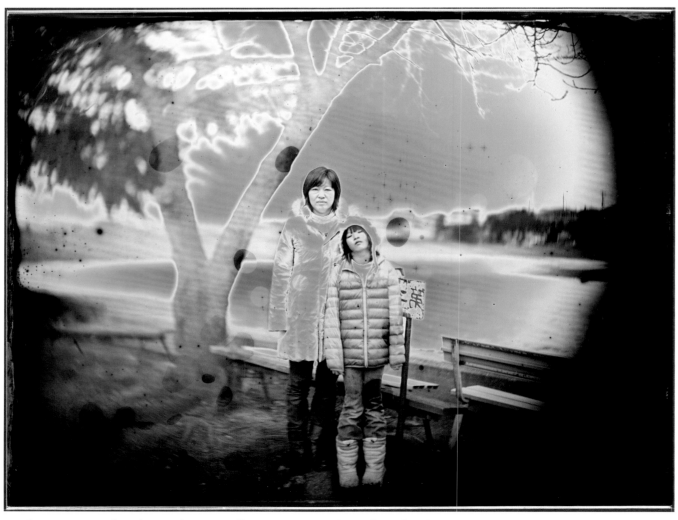

89 *February 19, 2012, A Mother and Her Daughter Evacuated from Iitate Village, Fukushima Prefecture*, from the series *Here and There—Tomorrow's Islands*, 2012

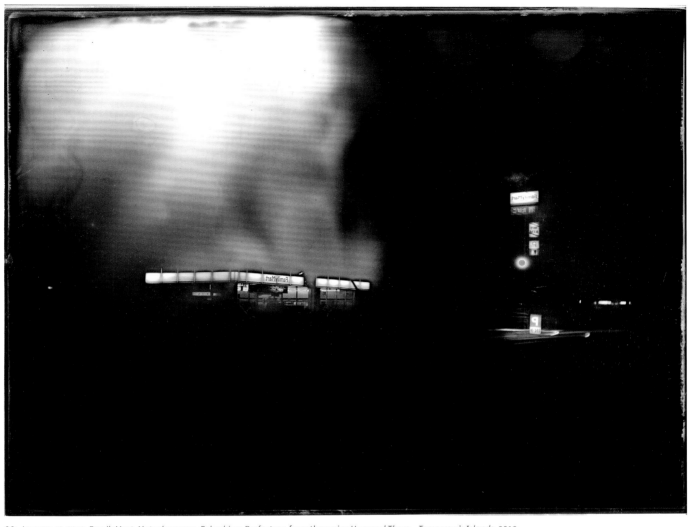

90 *January 10, 2012, FamilyMart, Matsukawaura, Fukushima Prefecture*, from the series *Here and There —Tomorrow's Islands*, 2012

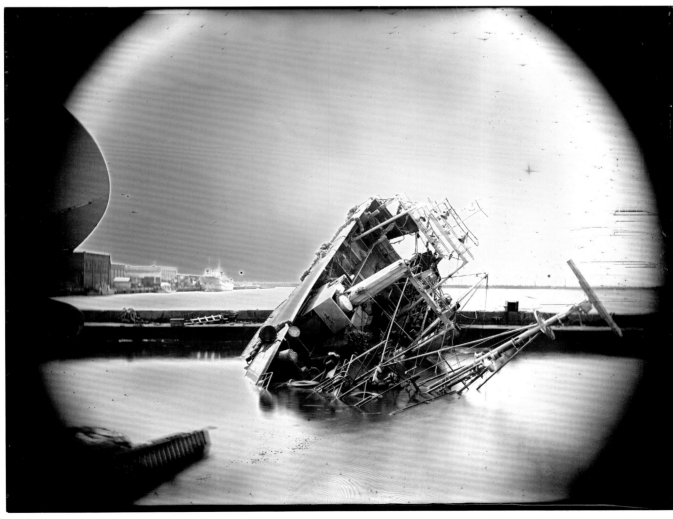

91 *April 26, 2011, Onahama, Iwaki City, Fukushima Prefecture*, from the series *Mirrors in Our Nights*, 2011

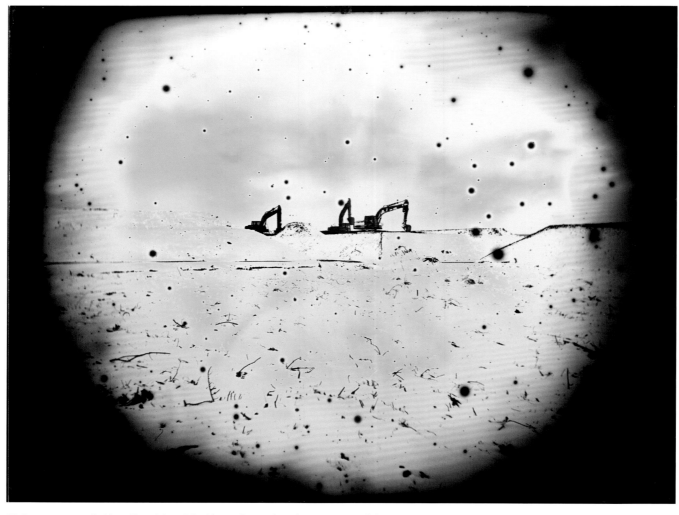

January 11, 2012, Kashima, Minamisōma, Fukushima Prefecture, from the series *Here and There—Tomorrow's Islands*, 2012

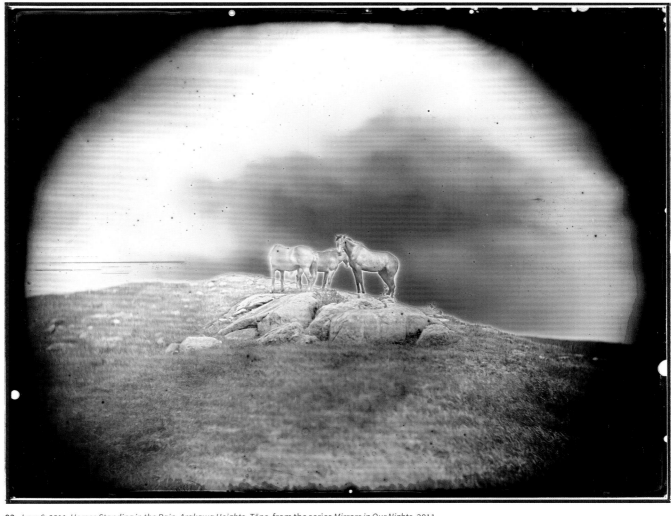

93 *June 6, 2011, Horses Standing in the Rain, Arakawa Heights, Tōno,* from the series *Mirrors in Our Nights,* 2011

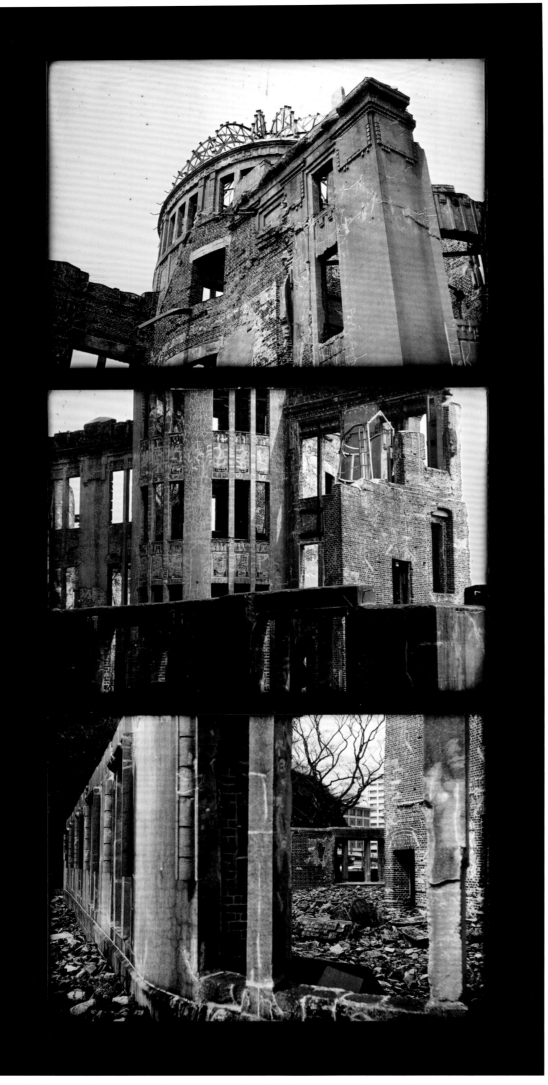

94 *A Multiple Monument for the Atomic Bomb Dome, Study, Hiroshima*, from the series *Exposed in a Hundred Suns*, 2014

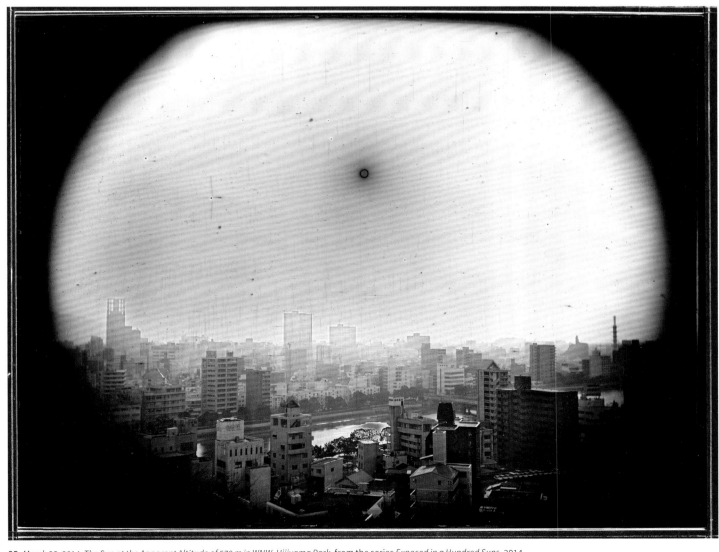

95 *March 23, 2014, The Sun at the Apparent Altitude of 570 m in WNW, Hijiyama Park*, from the series *Exposed in a Hundred Suns*, 2014

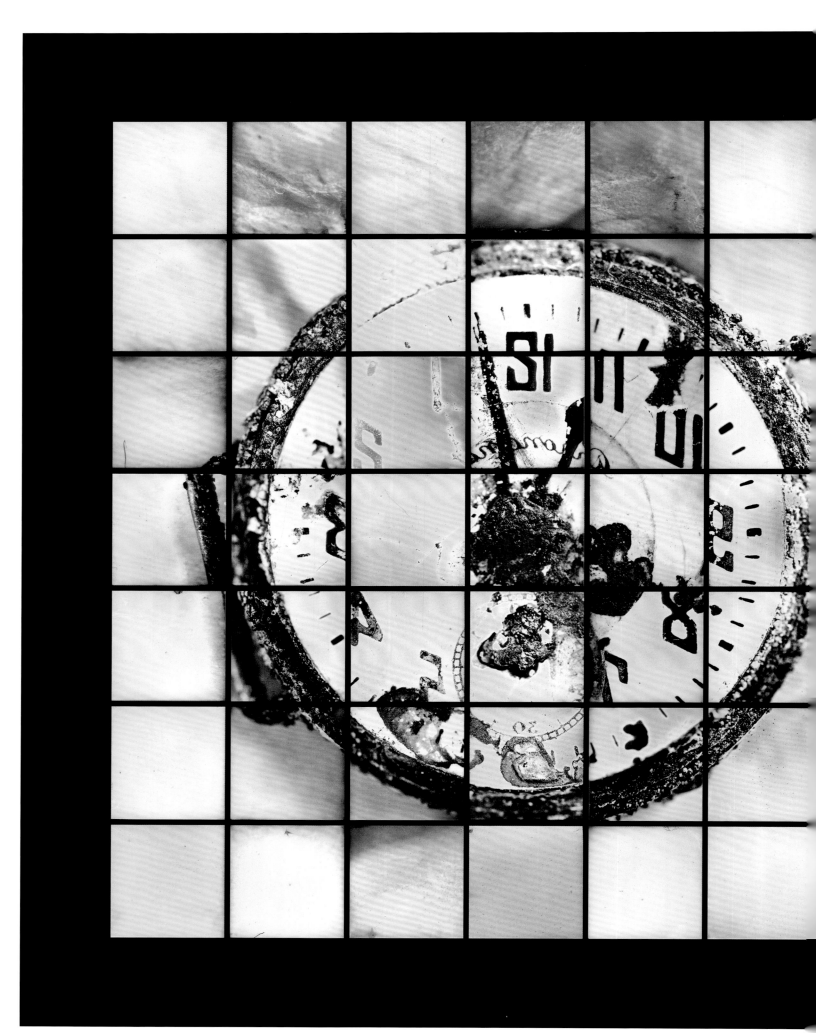

96 *A Maquette for a Multiple Monument for the Wristwatch Dug Up from Ueno-machi, Nagasaki Atomic Bomb Museum*, from the series *Exposed in a Hundred Suns*, 2014

Tomoko Yoneda

The Great East Japan Earthquake and the subsequent Fukushima nuclear power plant accident ended up shocking society once again with the invisible fear of nuclear disaster.

It became a day-to-day dread that permanently lodged somewhere in the back of our minds.

We saw—small beings that we are—that much as we might think we are all-knowing and almighty, horrible and unpredictable events can still occur; we saw in it the symbol of a large, formless presence that as individuals we are powerless to resist. When I saw the stance of our society, our nation—a nation composed of individuals that it holds under its control—in the light of this horrific catastrophe, my eyes were opened. Haven't we all been bowing to an invisible "authority" all along? I can feel a new challenge to authority budding.

Ever since the Meiji Restoration, Japan has promoted an agenda of democratization and modernization that aimed to position the nation shoulder to shoulder with the major powers of the world. With the world as its stage, it has in the past and continues in the present to endorse numerous wars and conflict. Staying here in Tokyo for a time, I have been thinking in my own way about the significance of that stance. Ultimately, to me it comes down to the larger question of the meaning of our existence. No matter how objectively we look at it, from whatever angle, isn't our whole existence here spurred on by greed?

Everything has been obscured from our view.

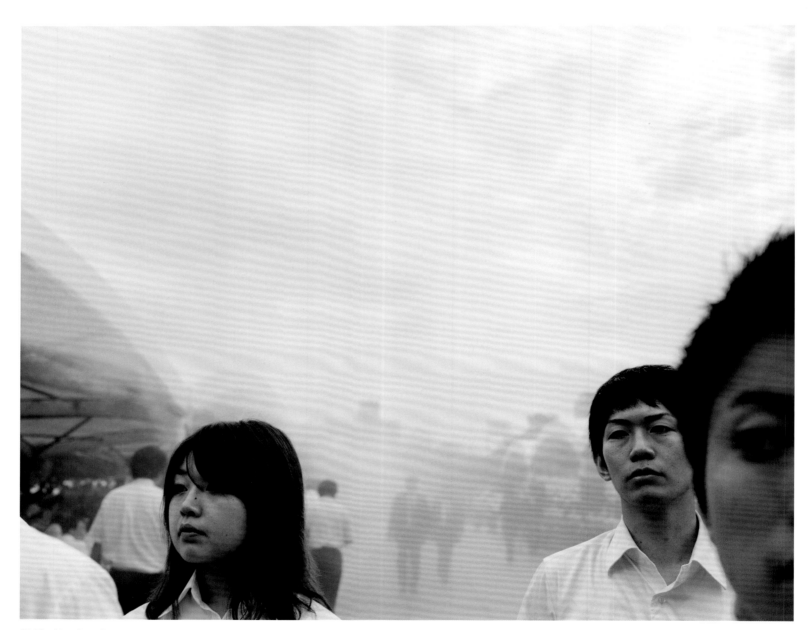

97 *Hiroshima Peace Day*

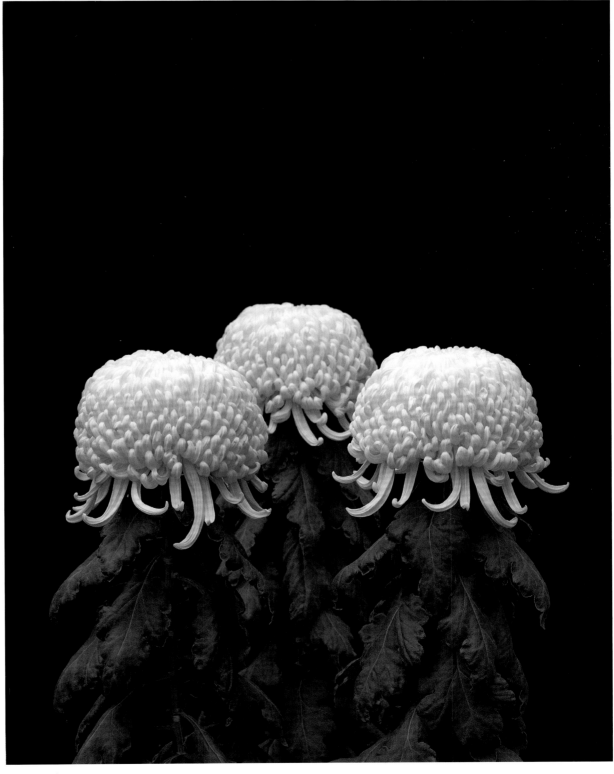

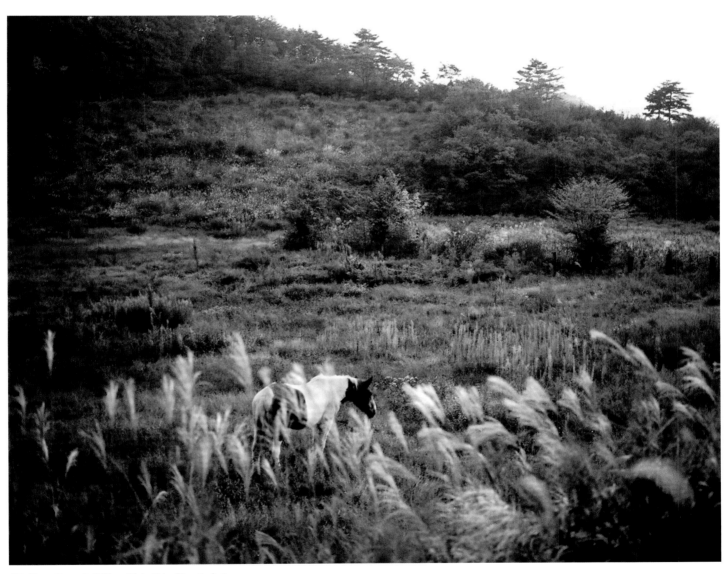

100 *Horse, Evacuated Village, Iitate, Fukushima Prefecture*

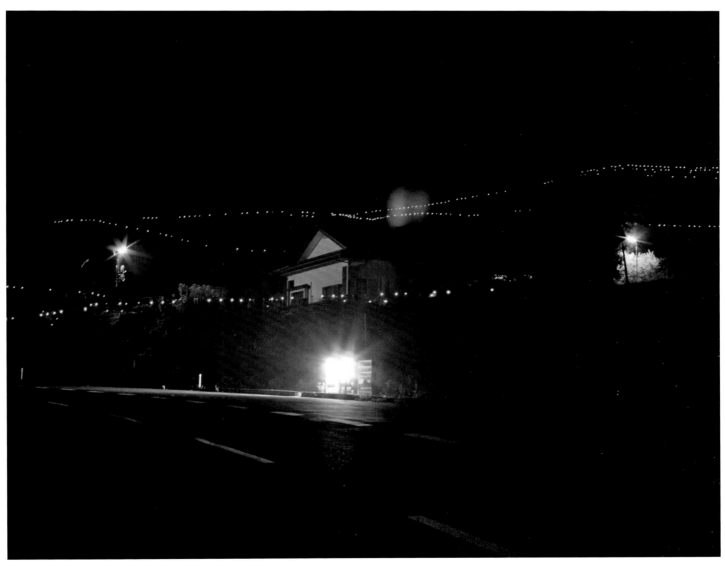

101 *Evacuated Village, Iitate, Fukushima Prefecture*

Kikuji Kawada

You know how there are times when the present gets obliterated, along with the past and the future? Take the afternoon of March 11, 2011, for example, when more than twenty thousand people disappeared in a single instant. At that time, a different curtain rose on a different scene, even though the world is always a wide-open stage.

And then came the accompanying Fukushima nuclear plant meltdown, a different kind of horror from Guernica or Hiroshima, and something that lay beyond the five senses, so it was hard to deal with. Fear was amplified everywhere.

From what you saw on TV, cars were no longer of any use. Fishing boats with their prows toward the shore were floating backward. The black tsunami swooped down like a monstrous kraken. Towns, villages, and forests swallowed up; the atmosphere contaminated; a today distinctly different from yesterday. No matter where you are, you know. Talk about safety and relief is a mundane mantra that's practically absurd.

At night, I secretly try to hear the voices of those who died in that moment. A moment in a photograph is different from a moment in words. It doesn't have ears, and it's one hundredth or thousandth of an instant, so you can't see it. There are lots of things you need to look at and listen to, all wrapped up in the time before and after the shutter snaps, but if you don't pay attention to them you don't see anything.

Human shadows attacking on the street at night, an X-ray of unhealthy lungs, a baby bat falling from the sky, a pale sun, a trembling waning moon, evasive clouds, withering seaweed, dictators and terrorists vanishing one by one. . . . More than ten years after 9/11, even more salesmen of nuclear power from this country run around the world while yet another curtain rises.

If I'm to set my sights on the "future of humanity" as an element of my photographic style, then I must seek out a heightened reality that includes both misery and sadness at the same time. No matter how hard you try, you can't consciously take that kind of photograph, not as long as the god of the unconscious fails to smile on you. I have to try to achieve a spatial remove, however slight, away from the diverse and multicolored shadow cast by future happenings and toward more comprehensive and multiple images—before, frightening as it is, the final curtain falls on this world.

103 *Morning Glow*

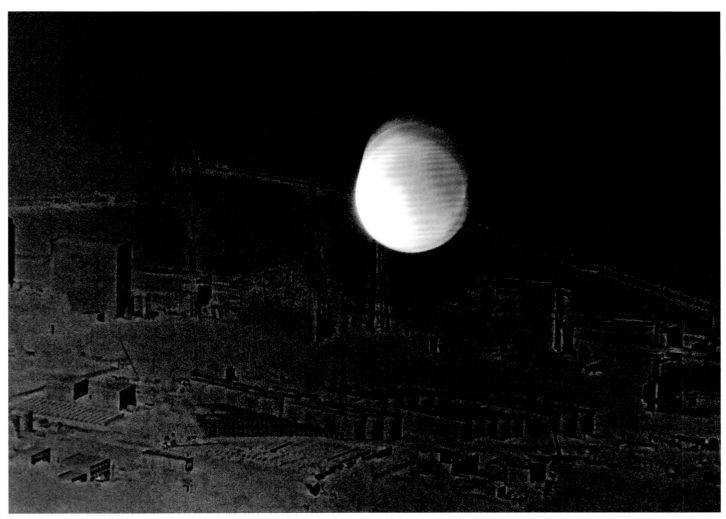

104 *Fukushima Daiichi Nuclear Power Plant—NHK BS-TV, Tokyo, Lunar Partial Eclipse*

105 *9.11, Tokyo, Chaos Cloud*

106 *Cesium Cancer Cells, X-rays, NHK-TV, Tokyo*

107 *Tokyo, Ivy Plants*

108 *Tokyo, after Typhoon*

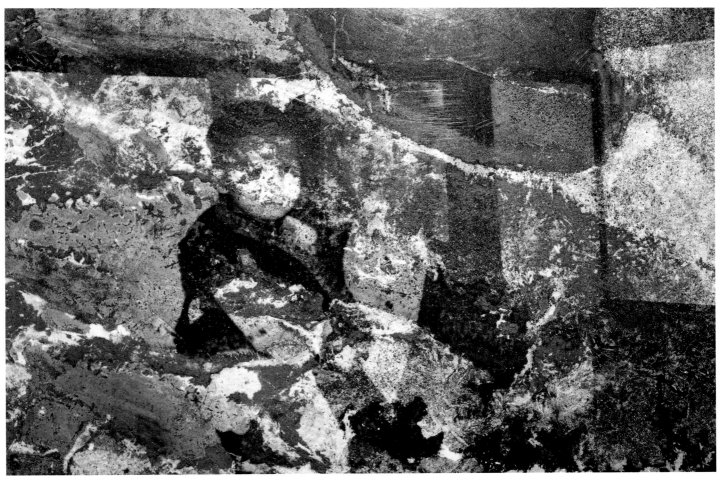

109 *Lost Child 2*

Yokota

Having experienced the end of the century as an adolescent, I heard about Nostradamus's predictions and all kinds of ridiculous stories of the coming end of the world by means of natural disaster, nuclear war, alien invasion, and so on. Seeing that kind of content broadcast on special programs on television every weekend, I scoffed at them, but at the same time somewhere deep down I probably believed them a little bit, too.

But the year 2000 arrived uneventfully, and life seemed to go forward without incident.

When I was about twenty-three, I was working part-time at a construction site when, out of the blue, I was struck by an intense feeling that maybe before the turn of the new century we *had* actually died subconsciously. We continue to live on physically, but something had ruptured in our consciousness.

If I thought about the 2000s as being a moratorium—a grace period of sorts—and that I had survived, I was able to find some satisfaction. Even if something happened, it was on the other side of the TV screen and I could think of it as having no bearing on me. I continued to produce images, unsure of how to comprehend the act of taking photographs amid this apathy toward the outside world.

But then Japan was faced with the earthquake and tsunami and the resulting radiation disaster.

In Tokyo, I lay on my sofa during the ongoing aftershocks, my gaze transfixed on footage of the tragedy streaming across the TV. "Before" and "after" scenes of townscapes that had been washed away by the tsunami played over and over across the screen.

Once something has happened, it is impossible to perceive it as never having happened. To me, if there has been anything important that has come of this tragedy, it has not been in the act of recording the changes in things that are visible to the eye; it has been in the act of thinking about my own consciousness and how it has inevitably been changed by all of this. My job is to recognize this change and make images based on that realization.

Transformed, my consciousness turned from the present to the past and altered a past that should have been fixed. The me of the present exists in a future that lies on a different plane from that past. Time, which had until now felt like a single course, has split into multiple streams.

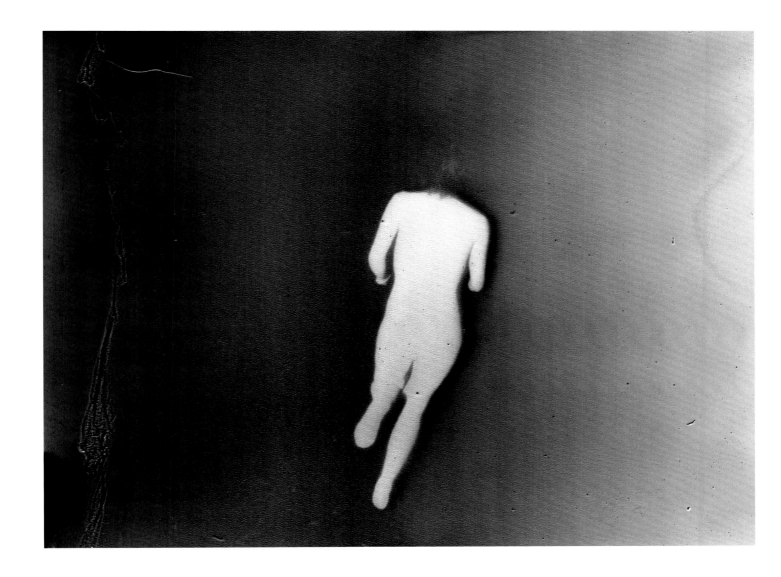

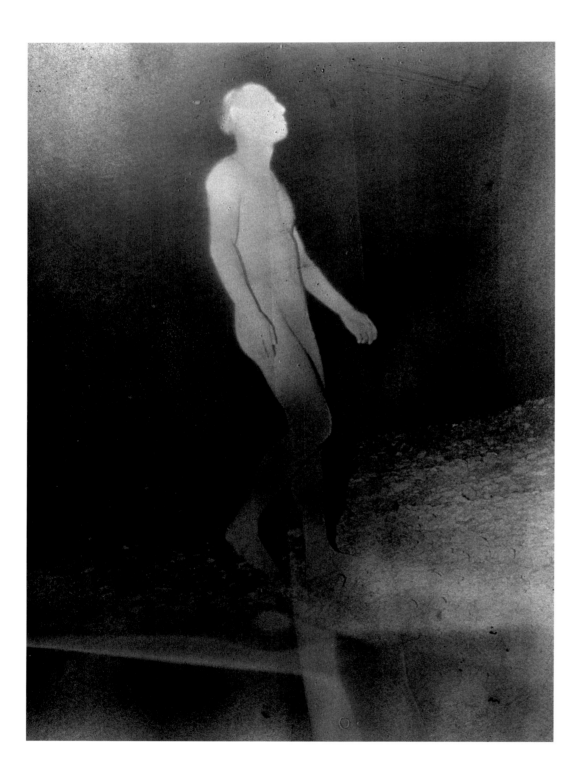

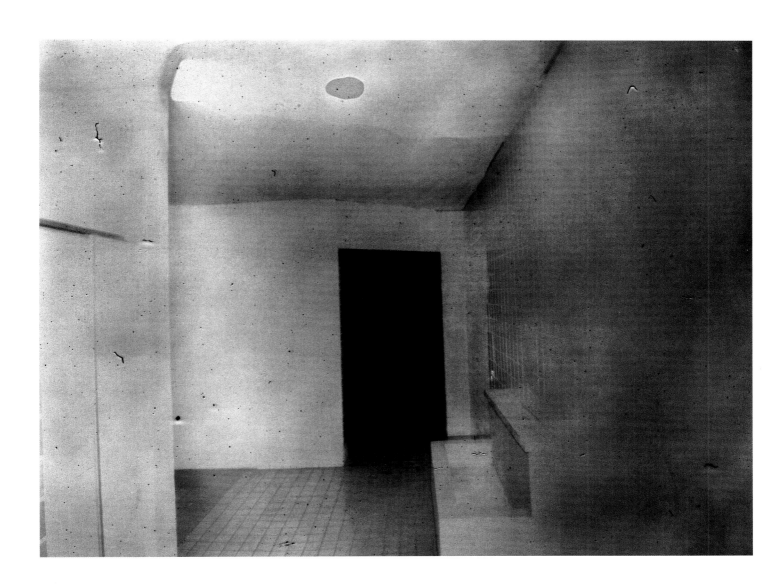

Reflections in the Wake of 3/11

Anne Nishimura Morse
Anne E. Havinga

The photographer Nobuyoshi Araki began his day by taking a snapshot of the western sky from his balcony in the Setagaya ward of Tokyo, a subject that he once described as "a window reflecting my own soul."[1] Following his longtime practice of creating a daily visual diary, Araki included the date stamp in the lower right corner of his work—this time "11 3 11" (pl. 1). He then went on to an appointment at his production studio near Waseda University, where he was when the earthquake struck. At 2:46 that afternoon, Takashi Arai was in his own studio in Kawasaki, just to the south of Tokyo, making a daguerreotype image of a petri dish containing radioactive ash from the Bikini Atoll nuclear tests. Needing a long exposure time, Arai held his hand steady for more than thirty seconds and, as is his usual practice, also recorded the ambient sound—in this instance, the blare of warning announcements (pl. 86).

The first of the three catastrophic events of March 11, 2011, the Great East Japan Earthquake, was one of the strongest earthquakes ever recorded in Japan. Its epicenter was below the surface of the Pacific Ocean, approximately eighty miles east of the city of Sendai. So great was its force that the main island of Honshu itself moved eight feet to the east, and Earth's axis shifted several inches. The powerful tsunami that followed this tremendous disruption of the ocean floor reached a height of more than 130 feet in places and traveled as far as six miles inland. The physical devastation of the scenic Sanriku Coast north of Sendai, the loss of more than eighteen thousand lives, and the displacement of nearly four hundred thousand people were compounded by the tsunami's breach of the Fukushima Daiichi Nuclear Power Plant. In the days following 3/11, as the plant's compromised emergency cooling systems failed, nuclear contaminants were released into the environment. Surrounding towns, many already seriously damaged by the earthquake and tsunami, were evacuated, forcing many more residents into exile made worse by fears of radiation exposure.

Situated on the "ring of fire," where the North American, Pacific, Eurasian, and Philippine tectonic plates converge, Japan has always

been extremely vulnerable to seismic activity. It experiences hundreds of tremors each year, many followed by tsunamis, as well as periodic volcanic eruptions. As early as the fourteenth century, Japanese artists created woodblock-printed talismanic maps intended to prevent earthquakes, but it was not until after the introduction of photography from the West in the 1850s that the aftermath of the regular physical torsions of the earth became an established subject for image making in Japan.

Today the Japanese word used for photography is *shashin*, meaning "true portrayal." During the Edo period (1615–1868) the term referred to a style of painting that conveyed the subject's "inner truth" while providing a high level of visual verisimilitude.[2] Interest in an objective rendering of external appearances had been stimulated by imported European scientific manuals, and members of the Japanese intelligentsia were eager to examine the world around them through more empirical means and to record their detailed observations. Lenses of various types—spectacles and spyglasses—enabled closer looking.[3] The introduction of the *camera obscura* in

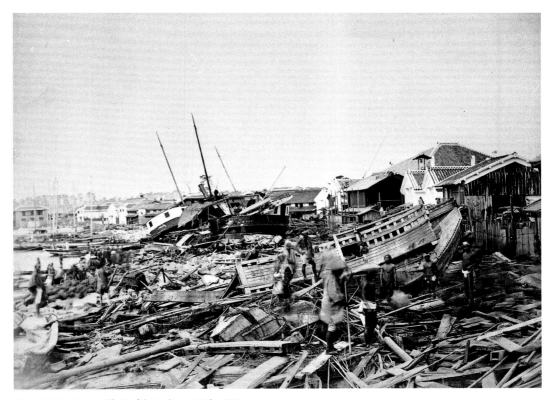

Figure 5. Felice Beato, *Effects of the Typhoon at Kobe*, 1871

the late eighteenth century, and then the daguerreotype in 1857, facilitated the production of images recording the external world.

Western photographers resident in Japan were instrumental in establishing early photographic compositional conventions. The Anglo-Italian photographer Felice Beato was one of the first to produce images of Japan's natural disasters. An image in his *Photographic Views of the Disasters after the Late Typhoon* (1871) captures a world thrown into disorder by juxtaposing building wreckage with wooden ships that had run aground (fig. 5). This iconography of disaster has continued to resonate in the depiction of the 3/11 tsunami, as seen in the numerous images of Kamaishi and Kesennuma, two of the most devastated towns, made by photographers of all kinds (pl. 8). Following other late-nineteenth-century catastrophes, Japanese photographers also mobilized to document the damage. After the 1891 Nōbi earthquake near Nagoya—which measured 8.4

in magnitude, destroyed more than 4,200 square miles, and caused some 7,000 deaths—the Boston-trained Kazumasa Ogawa collaborated with two British scientists to present a series of images by himself and other Japanese photographers in a lavish, handsomely bound album entitled *The Great Earthquake in Japan, 1891*. The collection juxtaposes richly detailed photographs of devastated traditional thatched homes with depictions of fractured Western-style iron bridges and brick factories, accompanied by a chiefly scientific text describing seismographic movements and making observations about engineering failures.

In the aftermath of the catastrophic earthquake and tsunami that struck the area around Tokyo and Yokohama on September 1, 1923, taking the lives of an estimated 140,000 individuals, photography was critical in transmitting information to the beleaguered nation. The mass media took advantage of the popular belief that photographs offered the most truthful representation of reality.[4] Japanese newspapers issued dozens of illustrated souvenir publications documenting the destruction of the touted symbols of Tokyo's new Western consumer culture—its department stores in

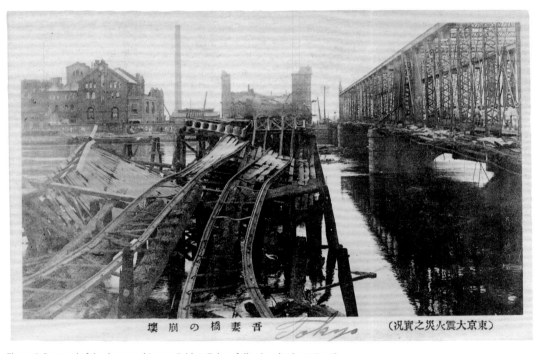

Figure 6. Postcard of the destroyed Azuma Bridge, Tokyo, following the Great Kantō Earthquake of 1923

the Ginza, banks, and train stations.[5] Postcards were produced by photojournalists and amateurs alike, some in editions of hundreds of thousands; the subjects ranged from burned-out halls of government ministries to refugees huddled in the city's parks to macabre mounds of unrecognizable corpses (fig. 6).

Since the late 1950s the most compelling photographs of natural disasters in Japan have rarely included people. Examples include Shōmei Tomatsu's series *Floods and the Japanese* (1959), of the aftermath of a typhoon in Nagoya, and Ryūji Miyamoto's *KOBE 1995 after the Earthquake* (1995; see fig. 16). Although immediate press coverage tends to focus on the circumstances of victims, seldom have such photographs remained the memorable images of the events. Contemporary photographers often find it inappropriate to draw attention to individual suffering, perhaps in part because such images could be considered an invasion of privacy. They also consider it more effective to employ metaphor when attempting to represent such overwhelming events.

One of the first photographers to engage with the 3/11 disaster by traveling to the sites of destruction was Kōzō Miyoshi. Since the mid-1980s Miyoshi had made a number of photographs of Tōhoku, including portraits of the region's traditional fishing communities (collected in the series *Innocents*, 1985, and *Shiogama Urato*, 2008). He was particularly overcome upon hearing the news of the disaster: "I, who usually keep my cool, lost everything. . . . Then there I was, telling myself to go and witness." Two weeks after the earthquake, as soon as the roads were passable, Miyoshi decided to visit the area and while there resolved to take images to be sold to raise funds for the survivors.

Miyoshi works in black and white, creating his series of images in a neutral documentary style influenced by American photographers in the New Topographics movement, which seeks to avoid emotion or even opinion.[6] Following their example, Miyoshi uses large-format box cameras, whose unwieldiness slows down the photographer's working method. While in Tōhoku Miyoshi found it difficult to traverse the debris with his large camera, so he stood where he could and recorded landscapes that had been turned on end. In one photograph of Minamisanriku, the resort town in the wooded Sanriku Fukkō National Park, train tracks bent by the force of the tsunami veer violently from their course (pl. 9). A tree-dotted cemetery dominates the foreground of the ravaged landscape of Hiyorigaoka; the resting place of the dead is ironically preserved, while the remainder of the town has largely been destroyed (pl. 10). In another photograph the 4,724-ton cargo ship *Asia Symphony*, torn from its moorings, thrusts into the town of Kamaishi (pl. 11). Left in place for months, the ship became a painful reminder of destruction to the local residents. The eerie stillness of these scenes draws attention to small details in Miyoshi's gelatin silver prints; the gray of his photographs seems to correlate with the austerity of the desolation.

Keizō Kitajima is another who went to bear witness. He first became known in the 1970s for his grainy black-and-white snapshot scenes of lurid Tokyo nightlife. When the 3/11 disaster took place, Kitajima was photographing the landscape on the northern island of Hokkaido. He had been to Tōhoku many times and was not sure he wanted to visit the sites of destruction or to photograph them. He has spoken of how the intensity of the media footage reverberated in his head, and he feared that it would influence his picture making.[7]

Concluding that the 3/11 landscape could be altered again in an instant and that he would lose the opportunity to photograph it, Kitajima did visit a month after the event. He went to a number of towns on the Sanriku coast, including Minamisōma, Kesennuma, Ōfunato, and Yamada, all of which had been overcome by the tsunami. Like everyone, he was humbled by the devastation. Kitajima's portrayal of ruined buildings at Kesennuma, where fires overcame structures that had initially survived the flooding, appears as a modern incarnation of paintings by eighteenth- and nineteenth-century European artists of ruins, beautiful and sublime (pl. 15). His rendition of a stranded boat in Ōfunato, one of hundreds that the wave deposited in the center of villages, is shown behind the remains of a wall; with little reference of scale, the photograph makes the vessel look as if it were a child's toy. Kitajima has assembled many of his Japanese landscapes, including these 3/11 scenes, into a series of booklets called *Untitled Records* that he hopes will provide "a visual document of this era: a graphic testimony that will allow us to reflect on the past and future of our time."[8] He has said that the disaster

totally changed his attitude toward his subject: "The meaning of landscape has changed. It is as if the landscape is always between disasters. Disasters will always be happening, and peace is fragile."[9]

Rinko Kawauchi is known for images that explore quiet moments of daily life and turn the mundane into the poetic, evoking the lightness of dreams and memory. Her work's personal intimacy and casual tone belie the extreme care she takes with the selection and sequencing of images; she often envisions them first in photobooks and only later presents them as individual images.[10] Soon after 3/11 a photographer friend of Kawauchi's proposed going to view the tsunami landscape, and she agreed, although doubting that she would make any pictures. They traveled to Onagawa, Kesennuma, and Rikuzentakata as well as Ishinomaki, where, standing amid the field of debris, Kawauchi found herself mesmerized by a pair of carrier pigeons. One was black and one white, and their legs had been banded, indicating that they were domesticated. Flying to and fro, they appeared bewildered, as if trying to ascertain the coordinates of the place they once knew as home (pls. 16–35). Kawauchi prefers to present this modest sequence of images as projected slides in a gallery setting.

Rikuzentakata was a small village on the Sanriku Coast, home to some twenty thousand inhabitants until its seawall was breached by a forty-two-foot-high tsunami on March 11. Since that day it has been the sole subject of the photographs of Naoya Hatakeyama. Previously he had photographed nearby lime quarries in series that explored the dynamic, cyclical relationship between nature and urban development (*Lime Hills*, 1986–91) making permanent the momentary (*Blast*, 1995). He had also followed the largely forgotten underground waterways and caves of Tokyo and Paris and studied housing estates in England and abandoned coal mine facilities in Germany. Rikuzentakata, where he first developed his field of vision in a house whose door "opened onto a panoramic view of the riverbanks beyond," was his "little corner of the world," his hometown.[11] The tender photographs that he took from 2000 onward during visits back to his mother and sisters were made for his personal pleasure and were not meant to be shared (see fig. 32).

Many of the tightly constructed arguments that Hatakeyama had made about the nature of photography were called into question after March 11—when not only was the town of Rikuzentakata destroyed, but his mother lost her life in the tsunami. Hatakeyama had once been insistent on what he described as "non-participation in the world of the subject": "Modern photography was for me supposed to be a means of stepping away from the collusion of the participatory experience."[12] Returning almost immediately to photograph the destruction in Rikuzentakata, Hatakeyama did try to preserve his detachment. The images are in a documentary style and do not indulge in dramatic effects; his camera lens through its insistence on a constancy of physical distance and scale in fact imposes an order on the landscape. However, his personal associations with the community and his own personal loss cannot help intruding on his selection of subject matter. In one photograph, for example, he captures a rainbow above the site of his mother's home (pl. 41). Hatakeyama in fact has expressed frustration that without words he cannot adequately explain his personal associations with these places; to articulate them, he now presents the images as pre- and post-3/11 slideshows.[13] The artist has said that the "before" shots "which were of no particular importance suddenly transformed despite myself into photographs to 'preserve memory.'"[14]

Hatakeyama's earlier series of photographs have been described by one critic as "meditations on the suspension of time."[15] However, the pictures taken after the disaster are definitely testaments to the passage of time; each is even labeled by the date on which it was taken. Hatakeyama first documented the ravaged landscape, then the immediate cleanup, and finally the slow process of reconstruction. Pop-up convenience stores that provided the community's needs in the aftermath of the tsunami have since been taken down (pl. 40). In a process that recalls his *Lime Hills* series, a nearby mountain is brought down so that the soil can be used for landfill near the waterfront (pl. 49). Hatakeyama watches all the changes carefully, and registers how the different phases of rebuilding make the place he so loves unrecognizable over and over again: "Nature destroyed the town, and now people are destroying nature," he says.[16] He also notes that "through a visual commentary, I am able to absorb its present circumstances little by little."[17] However, he is acutely aware of the physical and temporal distance from the pre-tsunami Rikuzentakata: "The future is closing in behind me. I try my best to feel it . . . but without being able to take my eyes off the past landscape that is receding from view and getting smaller. When I'm told, 'It's better to look forwards' I can only answer, 'Let me just walk backwards a little longer.'"[18]

Tōhoku, and more specifically the coastal village of Kitakama near Sendai, has been the adopted physical and spiritual home of the photographer Lieko Shiga since 2008. The tight-knit community of what were then just over a hundred families and fewer than four hundred residents filled her with "a feeling that I wanted to stay there forever, that I had arrived at last, that this was the place I had been looking for."[19] Local officials asked her to be the village photographer, and she became engrossed in the town's history and the residents' personal stories. Shiga was in the offices of Kitakama's town newspaper when the tsunami struck and narrowly escaped. When she returned, she found that she had lost her house, studio, cameras, and a year's worth of work, apart from some photographs that were at a Tokyo printing lab or stored elsewhere.

Despite her own personal experiences on March 11, Shiga is hesitant for the images she published in the 2013 photobook *Rasen kaigan* (Spiral Shore) to be identified strictly with the disaster. Rather she sees them as a larger body of work that explores her own internalization of the stories of the Kitakama community and that includes photographs predating the tsunami. Indeed, the images do not contain any immediately recognizable references to the physical destruction that befell the town.

Shiga is a postmodern photographer in that she uses her medium not to chronicle the subject before her lens but to create her own subjects, in images that are intensely imaginative and expressive. The phantasmagoric quality of her work has an apocalyptic tone, in retrospect well suited to what transpired on 3/11. Many of her photographs were made in darkness and exhibit an imaginative sense of color—vibrant red skies, ominous shadows, moody earth tones, harsh whites. She manipulates her images, using color filters and occasionally layering negatives to create surreal effects. In this way she combines photography's ability to capture the real world with the possibility to create a realm of fantasy.

Shiga stages her subjects, a practice that has been exploited by many photographers since the 1980s. However, unlike those who transform their own features (such as Cindy Sherman or Yasumasa Morimura), or those who create narratives from well-known stories

(Anna Gaskell and Miwa Yanagi), Shiga engages her Kitakama neighbors as performers in fantastic scenes rich with communal references. In *Portrait of Cultivation* an elderly couple poses next to the upside-down twisted root of a pine tree that had been dug up on family land, and which has been propped up so that it appears to pierce the man's heart (pl. 56). In *Still Unconcious* a young woman's body held up by many hands and tipped on its side gives the impression that she is dead (pl. 55). Through photography, Shiga has created images that seem to exist beyond ordinary time and place, and as a result they come across as laden with obscure meaning. She claims that she channeled the latent power that Kitakama itself possessed; she becomes the medium for its visualization.

The title *Rasen kaigan* comes from one image that for Shiga "expresses my present relationship to photography" (fig. 7). It shows a black shape in a whitish field of sand that is marked with concentric circles. The black shape is the artist, swinging a piece of a Kitakama pine tree and making tracks in the sand, actions that she equates with the making of photographs. Shiga comments that the faster she spun the branch, the more static she felt herself to be: "I regard this condition as a place in which past, present, and future have all ceased to exist." It is those points of stillness that became her images.

Shiga's photographs of Kitakama serve as an elegy to a community that has been dislocated. They underscore that what was lost on March 11 was not only physical structures but a rich web of societal relationships that can be found only in a particular place.

While the earthquake and tsunami left behind immediately visible devastation, the third part of the triple disaster has evoked some of the most profound responses from photographers. The popular press has used "Fukushima" as a generic term for all the events of March 2011. However, Naoya Hatakeyama has made the poignant plea that the tsunami and the Fukushima catastrophe should be seen as separate, so that the events on the coast are not subsumed by the nuclear accident.[20] Unlike the discrete natural events of earthquake and tsunami, Fukushima represents an ongoing man-made disaster. The meltdown and release of radioactive elements into the environment led to the evacuation of more than 55,000 residents of the towns of Ōkuma and Futaba and areas within a radius of 20 kilometers (about 12 ½ miles) of the plant. The Fukushima nuclear disaster has also precipitated an intense national soul-searching, for Japan has long had a conflicted relationship with nuclear energy, particularly in the shadow of the atomic bombs that were dropped on Hiroshima and Nagasaki in August 1945.

For Araki and Arai, like all of the photographers who have responded to Fukushima, the events of 3/11 cannot be seen in isolation; Fukushima is inextricably linked with Japan's nuclear past. In fact, in a 2013 interview Araki commented:

From way back, whenever August came around, somehow I could never freely shoot. So I would smash the lens. With a hammer—the lens is surprisingly hard, you know. The reason why I did that is that I still carry Hiroshima and Nagasaki with me. So when August comes, it's like an atomic bomb falls on the camera, or the camera becomes an atomic bomb—there's a number of effects.... Fukushima is the same. Since Fukushima happened, I just haven't been able to freely shoot.[21]

For the 283 images that Araki took on March 11 and during the three months thereafter, works that he included in the photobook *Shakyō*

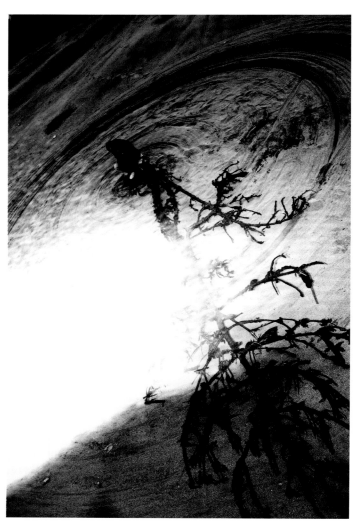

Figure 7. Lieko Shiga, *62539*, from the series *Rasen kaigan (Spiral Shore)*, 2011

rōjin nikki (Diary of a Photo-Mad Old Man), the artist expressed his inner turmoil by scratching the emulsion of his negatives with a pair of scissors.[22] The resulting jagged marks and the emotional turmoil they convey are as much the subject of the photographs as the landscapes or people portrayed.

Hiroshima and Nagasaki have long loomed over the Japanese psyche. In August 1945, when the scope of the human tragedy was still largely unknown in Japan, the nuclear bombs represented defeat and surrender in the face of the superiority of American technology. After 1952, when the censorship imposed by the United States occupation on images of the devastated cities was lifted, Japan began to identify itself not only as a victim nation, but also as the sole nation to have suffered the monstrous effects of nuclear weapons. This sentiment was reinforced in March 1954 when the crew of the *Daigo Fukuryūmaru* (Lucky Dragon 5), a Japanese fishing boat trawling for tuna in the southern Pacific Ocean, was exposed to nuclear fallout from the hydrogen bomb tests that were being conducted on Bikini Atoll. Upon returning to port in Japan the fishermen were treated for radiation sickness; the captain died six months later. The Japanese public immediately cried out for a ban on all nuclear weapons.[23]

Anxiety about a nuclear apocalypse was also expressed in films such as *Gojira* (*Godzilla*, 1954), in which a prehistoric monster, reanimated by nuclear power, lays waste to the city of Tokyo; others soon followed, such as Akira Kurosawa's *Ikimono no kiroku* (*I Live in Fear*, 1955), in which an elderly man tries to move to South America to escape the threat of nuclear war in Japan. Yet, at the same time, with the advent of Cold War politics, the United States encouraged Japan to construct a nuclear reactor before the Soviet Union was able to do so.[24] By 1956, just eleven years after the bombing of Hiroshima and Nagasaki, Japan established its first center for nuclear research at Tokaimura in Ibaraki Prefecture, and by 1958 the governor of Fukushima had requested that nuclear reactors be constructed in his prefecture in order to bolster the local economy. Groundbreaking at the Fukushima Daiichi Nuclear Power Plant took place in 1967. As the scholar John Dower has written, the bomb "became Janus: simultaneously a symbol of the terror of nuclear war and the promise of science."[25]

The 2011 crisis at Fukushima has renewed anxiety in Japan about the country's nuclear past and its nuclear present. Photographs in particular have made explicit these concerns. In his photo diary, Araki intersperses scissor-marred images of nudes, portraits of performers and artists (including his own self-portrait), and scenes of daily life with groupings of Godzilla-like creatures and an untitled photograph of umbrella-toting pedestrians that refers to the "black rain" fallout from nuclear bombs (pls. 2, 6). Arai, expanding on the theme underlying the daguerreotype of the Bikini Atoll relic that he created on March 11, has produced images of Fukushima and its residents, the Trinity site at the White Sands Missile Range in New Mexico, where the first atomic bomb was tested in 1945, and most recently Hiroshima and Nagasaki.[26]

For his images Arai has embraced the daguerreotype, one of the first photographic techniques, which involves exposing a polished silvered plate to light and was devised in France in the early nineteenth century. Like a number of photographers since the 1970s, Arai has been attracted to the daguerreotype process because it is slow and deliberate; it also produces a single image that cannot be replicated, unlike the products of negative-positive film

photography or digital imaging. The picture is captured through a long exposure; to underscore the time elapsed Arai records the ambient sounds while he shoots.[27] Daguerreotypes, which Oliver Wendell Holmes once described as "the mirror with a memory," incorporate the image of the viewer in their reflective surfaces, providing an intimate and personal experience of their subjects.[28] Arai believes that his daguerreotypes, with their own three-dimensional presence, might serve as compact monuments—like the model of the irradiated ship *Daigo Fukuryūmaru* now housed in a museum in Tokyo.[29] "I thought I could use the daguerreotype another way, as a monument to draw out more ambiguous and personal memories from a smaller community or from individual people, instead of trying to create a symbol of collective memory. Something that would appeal to the masses but still be personal, in order to prevent us from forgetting people and things."[30]

The daguerreotype technique was first adopted by the Japanese in the 1850s, during the last days of samurai rule. By using

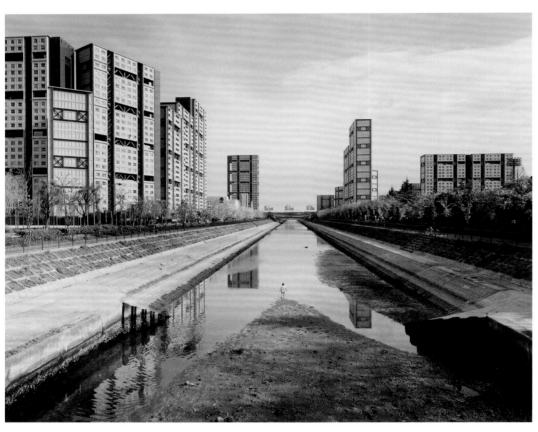

Figure 8. Tomoko Yoneda, *RIVER—View of Earthquake Regeneration Housing Project from a River Flowing through a Former Location of Evacuees' Temporary Accommodation*, from the series *A Decade After*, 2004

it to depict subjects from the famed thousand-year-old weeping cherry tree at Miharu to the controversial Hamaoka Nuclear Plant in Shizuoka Prefecture built on a fault line, Arai creates a feeling of nostalgia and thereby embeds the nuclear events of the last sixty years in the collective Japanese memory.

Since 2003 Tomoko Yoneda has taken her camera throughout the world to historically charged sites, such as sniper positions in Sarajevo and Beirut, or the railroad track in Shenyang where bombs detonated by the Japanese army precipitated the Manchurian Incident in 1931.[31] She presents the scenes in a neutral documentary style, thereby divesting the now transformed locations of their raw emotional trauma—that is, until the viewer reads the titles of the works.[32] Although living abroad in London, Yoneda has periodically returned to Japan and reflected upon moments of trauma there. In

2008 she shot a photograph of temporary housing in Kobe that had been constructed following the devastation of the Great Hanshin Earthquake in 1995 (fig. 8). Two months after March 2011 she felt compelled to leave London again for Japan. During an artistic residency in Tokyo she produced the images for her *Cumulus* series, which juxtaposes images of the observation of Commemoration Day for the End of World War II at Yasukuni Shrine, crowds participating in Peace Day at the Hiroshima Peace Park, and the evacuated village of Iitate in Fukushima Prefecture.[33]

The image of a horse grazing in a field of autumn grasses and a nightscape punctuated by the lights of street lamps and a vending machine are seemingly images of everyday life. However, the caption identifying them as having been taken in Iitate marks them as part of the contentious narrative of a town near the Fukushima reactors. The government initially refused to evacuate Iitate despite its elevated level of nuclear fallout and the protests of its residents. Surrounded by photographs of Yasukuni Shrine, Hiroshima Peace Day, and the origami crane folded by the twelve-year-old Hiroshima victim Sadako Sasaki, the Iitate images take on a decidedly political overtone, which the artist elucidates:

I am reconsidering what it means to be Japanese. Following the Meiji Restoration [in 1868] Japan turned toward authoritarianism, and even if this could be justified by the desire to stand shoulder to shoulder with the West, I have no intent of whitewashing what happened. I believe that the distortions of that period are connected to what happened in Fukushima. Disregarding the fact that we were the first country in the world to suffer a nuclear strike, the entrapment of the people who in the 1950s were seduced and manipulated by the idea of applying nuclear energy for peaceful purposes extends into the present.[34]

For much of her work in other series Yoneda has eschewed simple explanations, preferring that individual viewers have their own responses. However, she has described the image of three massive white chrysanthemums, flowers normally associated with the Japanese imperial family, as representing the "ambivalence of the Japanese people.... I'm photographing [them] as a portrait of Japanese people today."[35]

One of the challenges for photographers has been devising an iconography for the disaster in Fukushima. Radiation by its nature is invisible to the naked eye. Furthermore, access to information about the current situation and to images of the affected areas has been hard to obtain or suppressed, just as it was after Hiroshima and Nagasaki. In the days following the tsunami's breach of the retaining walls, residents in the immediate area were evacuated; but others outside the exclusion zone established by the government were merely advised to stay indoors. Japanese television crews largely stayed outside the zone as well, and thus coverage of the ongoing crisis was filtered through interviews with government and company representatives from the Tokyo Electric Power Company (TEPCO), which owned the plant.[36] Official acknowledgment of the meltdown of four reactors was not forthcoming until June of that year, leading to continuing suspicions about the true nature of the nuclear contamination.

Masato Seto is one of the few photographers who have gained direct access to the Fukushima nuclear plant. In February 2012, nearly a year after the initial meltdowns, he was asked to accompany the French industry and energy minister, Eric Besson, on a

visit to the site. Seto took a number of photographs on commission, which he turned over to the Agence France-Presse. He also took two black-and-white images of his own. Although the visit took place on a sunny day, Seto manipulated his photographs by printing them in the negative. They become nightmarish visions of the members of the Tyvek-suited and gas-masked delegation, stripped of their own individual identities, and of an eerie, luminescent screen of nuclear metering devices.

Ishu Han, a Shanghai-born artist who moved to Tōhoku when he was nine years old, has exploited the one image that has been widely circulated in the media of the deteriorating nuclear towers for his own commentary on the Fukushima disaster. Like the news photographers who could report on the plant only from outside the exclusion perimeter, Han presents a slightly pixelated image of Fukushima Daiichi Unit 1 with the metal framework of its upper walls exposed by an explosion (pl. 63). Han's digital manipulation permits viewers to examine the media image of Fukushima as if it were an organism under a microscope. Here the structural components are revealed to be one-yen coins, repeated in a digital mosaic of lights and darks—a statement on the intertwined economic interests that led to the catastrophe. This work has been Han's only printed photographic response to Fukushima. However, he has also developed an installation piece entitled *Two Safety Tapes* (2013), a tape that combines white and red, the colors of the Japanese national flag. About the piece Han has written: "the distinction in various forms of safety is questioned."[37]

Because photographers have had limited access to Fukushima Daiichi itself, their response to the nuclear disaster for the most part has not been about depicting physical damage or ruins. Instead they have explored metaphors for nuclear contamination and anxiety. The precedent for this type of response to nuclear fallout was established after the bombings in Hiroshima and Nagasaki, when Japanese photographers attached to the military or to the press recorded the damage both to humans and to infrastructure, but censorship imposed by the United States occupying forces precluded the images' circulation.[38] It was only beginning in the late 1950s that Japanese photographers brought the horrific aftermath of the bombs into focus. After visiting Hiroshima on assignment for *Shukan shinchō* (Shinchō Weekly), Ken Domon published his own collection of images of survivors in the 1958 photobook *Hiroshima*. His photographs document the victims' physical scars, but the images expose even greater psychological scars. In 1966 Shōmei Tōmatsu published images of Nagasaki in his own photobook, *11:02 Nagasaki*. Taken over twenty years after the war, the photographs again were not of the devastated landscape but of people, and of relics from the bombed city housed at the Atomic Bomb Museum, arrested in time and rendered surreal (fig. 9).

The personal "ruins" of the type that Tōmatsu first photographed at the museum in Nagasaki have continued to speak as metaphors for the human suffering wrought by the deployment of nuclear weapons. In his *Hiroshima Korekushon* (Hiroshima Collection, 1995), Hiromi Tsuchida presents articles of clothing, a lunchbox, and watches, among other items belonging to Hiroshima victims, in a neutral style and attaches brief identifying captions. The archival treatment underscores the impartial documentation, powerfully confirming the existence of lives lost (fig. 10). More recently Miyako Ishiuchi has returned to these personal relics for her own photobook, *Hiroshima*.

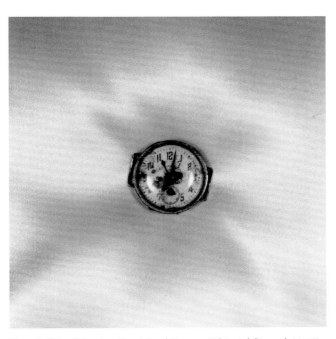

Figure 9. Shōmei Tōmatsu, *Atomic Bomb Damage: Wristwatch Stopped at 11:02, August 9, 1945, Nagasaki*, 1961

Lunch Box

Reiko Watanabe (12 at the time) was in Nakajima-chō (550 meters from the hypocenter) doing fire-prevention work under the Student Mobilization Order. Her sister Keiko (15 at the time) found this lunch box in a mud wall on August 7. The contents of boiled peas and rice, a rare treat at the time, were completely carbonized. Reiko's body was not found.

Figure 10. Hiromi Tsuchida, *Lunch Box*, 1982. Caption shown: Reiko Watanabe (12 at the time) was in Nakajima-chō (550 meters from the hypocenter) doing fire-prevention work under the Student Mobilization Order. Her sister Keiko (15 at the time) found this lunch box in a mud wall on August 7. The contents of boiled peas and rice, a rare treat at the time, were completely carbonized. Reiko's body was not found.

In response to the contemporary anxiety about radioactive contamination from Fukushima Daiichi, Takashi Homma has created his own metaphoric documents. Intrigued by the varied shapes of different species of mushrooms, for a number of years Homma has taken photographs of fungi that he harvested from forest floors throughout Japan as if they were scientific specimens. However, since March 11 the mushrooms have taken on a politically nuanced significance. Fungi absorb radiation yet continue to thrive. Thus, like much of the flora and fauna in the Tōhoku region, the mushrooms are flourishing, contributing to nature's outward pristine appearance, but belying nature's new toxicity.

The subject of mushrooms unavoidably conjures up images of the mushroom clouds identified with the nuclear explosions at Hiroshima and Nagasaki. Some outside Japan have seen these iconic photographs of mushroom clouds, taken by members of American military air crews, as embodying the sublime.[39] However, these aestheticized images, taken from a great distance by the perpetrator of the nuclear destruction, make no reference to the horrific human toll on the ground (fig. 11). Homma's mushroom photographs on first viewing can also be seen in that way, and the artist must be completely aware of the ironic disjuncture.[40]

Tōhoku has long been the subject of Masaru Tatsuki's photographs. For ten years he shot portraits of *decotora*, the colorfully ornamented trucks that converge on Japan's urban centers carrying produce and other goods from the Tōhoku region, as well as of their drivers. Just before March 11, Tatsuki was scheduled to release another photobook, entitled *Tōhoku*; he delayed production to add two pictures related to the disaster. Nonetheless, it is one of the original subjects of *Tōhoku*—the region's deer hunting—that has become a metaphor for post-3/11 Japan. The area has always been at the margins of Japanese society, and early twentieth-century intellectuals created an identity for it as the epitome of pre-modern, pre-Western Japanese values. In vivid color Tatsuki draws connections between shamanistic rituals and the annual deer hunt, with the fallen animals serving as a vital communal sacrifice. However, since the meltdowns at Fukushima the deer have been declared contaminated by nuclear radiation and can no longer be hunted. They have lost their totemic power; their horns have become mere objects relegated to storage shelves and forgotten (pl. 85).

Since the Great East Japan Earthquake, Masato Seto has returned often to visit his family in Fukushima Prefecture, nearly fifty miles from the nuclear plant. Although his previous series, *Heya* (*Living Room*, 1996) and *Binran* (2008), presented social-documentary-style photographs, Seto has since turned to the landscape as his subject. This landscape appears verdant to the untutored eye, but underneath it harbors the unseen threat of nuclear pollution: "The view was extremely beautiful. At that moment, I decided that I would take photos of this invisible terror. I thrust myself into the nature of Fukushima—its mountains, rivers and fields. I began to photograph in order to be able to visualize the cesium, or the terror, that clung to the soil of Fukushima."[41]

In three subsequent projects Seto has employed different metaphors for this contamination. The first photographs, like the ones of the nuclear power plant, he made as negative prints. In these images tree trunks appear to glow white against a black sky, as if the camera had expanded the spectrum of our normal sight.[42] In his second project, *Cesium* (2013), Seto shot richly detailed gelatin silver prints of anthropomorphic tree roots and rock formations that

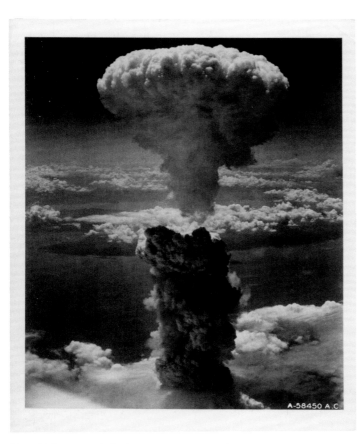

Figure 11. Anonymous United States Army Air Forces photographer, *Nagasaki, Japan, under Atomic Bomb Attack, August 9, 1945*, 1945

collectively suggest a forest bewitched by the catastrophe. Most recently Seto has explored snow, clinging to the branches of young trees and weighing them down, as a metaphor for the contaminants. Through his photographs Seto believes that he can show that which is "forbidden to be seen."[43]

Shimpei Takeda has abandoned the camera, but still has found a way to use a photographic process to make the invisible radiation contamination visible. By the late nineteenth century scientists had found that radioactivity could be recorded on photographic plates. In 1896 the Nobel Laureate physicist Antoine-Henri Becquerel discovered that uranium salts emitted their own penetrating rays that left visible traces on sensitized papers. The radioactivity created its own photogram—a medium that Charlotte Cotton has termed a "viscerally immediate way of making a representation and one that [does] not mirror human perception."[44] Since 3/11 a small number of artists and scientists has also used autoradiography to document the nuclear fallout; gloves, mushrooms, and children's shoes from the Fukushima area have all generated images.[45]

In his series *Trace* (2011–12) Takeda, unlike others using autoradiography, strove for an abstract aesthetic in images that nonetheless could provide scientific documentation of the environmental conditions in Tōhoku.[46] He created these pictures by collecting and exposing soil samples from sites in or around Fukushima Prefecture

Figure 12. Detail from Kikuji Kawada, *Chizu* (The Map), 1965

with which he either had a personal connection or that were known from Japanese history—Nihonmatsu Castle, where the shoguns fought their last battle, or Iwase General Hospital, where Western medicine was introduced in the nineteenth century and also where Takeda was born in 1982. The images produced by the irradiated soil appear like evocations of the cosmos, but the viewer is confronted with the knowledge that the "stars" are hot points created by the contamination. Takeda's captions for these works, like Tomoko Yoneda's titles for her photographs of sites of political contention or Hiromi Tsuchida's captions in his *Hiroshima Collection*, present these photograms in a neutral, factual manner, with documentation on the soil sample and a few lines about the place.[47]

Throughout his career Kikuji Kawada has reminded Japan of the fraught relationship between the nation and the nuclear age. Kawada's first major project, the 1965 photobook *Chizu* (The Map), juxtaposed black-and-white images of the ravaged walls and ceiling of the Atomic Bomb Dome in Hiroshima with those of abandoned forts in Tokyo Bay, portraits of young kamikaze pilots, and a crumpled national flag (fig. 12). In the accompanying text Kawada wrote:

A dozen years after the atomic bomb was dropped on Hiroshima, out of nowhere a giant black "stain" appeared above the basement ceiling of the Atomic Bomb Dome. Each night the "stain"—which I had seen

myself—filled my dreams with a sense of horror. An audibly violent whirlpool. Those diverse transformations threatened to completely envelop the universe of my dreams. The "stain" that began to take on the appearance of a dark cloud of drops of blood. Skeletal hands and feet burning. The blown off heads of dogs and cats. Appearing and disappearing from a crack in the wall. I don't intuitively know whether these expressions are destructive but as time passes in my dreams they seem more illusory to me. Yet, the disquiet only multiplied after experiencing the illusion with my own eyes.[48]

The photobook was not just about the war and the nuclear aftermath. Kawada also included images from contemporary life, taken from television news broadcasts that recorded Japan's emergence as an economic power, thereby linking the war experience with 1960s Japan.[49]

After the events in Fukushima, Kawada embarked upon his most recent series of photographs, *Phenomena*. Enamored of the possibilities afforded by digital photography, Kawada has produced images of moments of tension, confrontation, and anxiety in black and white as well as in saturated colors. Lurid orange clouds overwhelm a somber Tokyo skyline; phosphorescent ivy creeps over dark trees in a forest; and the moon appears in eclipse (pls. 103, 107, 104). In this series, Kawada once again grounds the eerie, unsettling images with shots from news broadcasts: the Syrian people's uprising as seen on Al-Jazeera, and cesium cancer cells and X-rays as presented by NHK. Kawada has said of this technique: "Electronic montages are a way to discover several random chances. Violence and crime, or when a dictator transforms his face, the negative and positive images whisper to us. A blurred photo and a fuzzy photo too, they inform us about the enigmatic fringes."[50] In producing *Chizu* and the *Phenomena* series, Kawada is fully aware that he is creating images that can be characterized as sublime. Indeed, they simultaneously proclaim beauty and originate from fear and pain.

When the earthquake struck and the nuclear reactors at Fukushima automatically shut down, Daisuke Yokota was immersed in preparations for a new photobook, *Backyard*. He took the images of figures and trees that he had shot in color and transformed them into black-and-white apparitions, which he then rephotographed multiple times while intentionally introducing processing imperfections. In this way he hoped to introduce an element of extended time, which photography as a discipline often denies. Yokota's pictures provide a vehicle for him to explore the hazy recollections, rather than the precise details, that are central to memory. He believes that the "effects of delay, reverb, and echo (in photographic terms, developing the film 'badly' and so on) might be a way to alter the sensation of time in a visual way."[51]

Yokota has never said that he produced *Backyard* or his similar subsequent books such as *Site*, *Nocturnes*, and *Site/Cloud* in response to the events at Fukushima. Yet, post-3/11 audiences, reminded more than ever of what the Japanese call *mujō*, the transience of life, find them compelling.[52] The photographs with their ghostly figures also resonate with other images from Japan's nuclear past—the shadow of a soldier remaining on the wooden wall of the Nagasaki military headquarters, documented by Eiichi Matsumoto (fig. 13), or the shadow of a victim on the steps of a bank in Hiroshima—and those taken more recently, such as Kikuji Kawada's *Tokyo, Shadow in Shadow* (2011, fig. 14). Born in 1983,

Figure 13. Eiichi Matsumoto, *Shadow of a Soldier Remaining on the Wooden Wall of the Nagasaki Military Headquarters (Minami Yamate-machi, 4.5 km from Ground Zero)*, 1945

Figure 14. Kikuji Kawada, *Tokyo, Shadow in Shadow*, from the series *2011 Phenomena: Chaos*, 2011

Yokota, like Tatsuki and Takeda, is from a generation that never experienced the nuclear bombs nor participated in the debates about proliferation, but is part of a generation that still has had to contend with the nuclear legacy.

The events of March 11, 2011, have confronted Japan again with its nuclear past. The Nobel laureate Kenzaburō Ōe wrote in the *New Yorker* three weeks after the initial meltdowns at Fukushima Daiichi: "Therein lies the ambiguity of contemporary Japan: it is a pacifist nation sheltering under the American nuclear umbrella. One hopes that the accident at the Fukushima facility will allow the Japanese to reconnect with the victims of Hiroshima and Nagasaki, to recognize the danger of nuclear power, and to put an end to the illusion of the efficacy of deterrence that is advocated by nuclear powers."[53] Photographers in Japan have never lost sight of the catastrophic impact of the atomic bombs; indeed, they have ensured that the experiences remain part of the national collective memory. Since the 3/11 disasters they have drawn connections in the visual realm between the devastation in Hiroshima and Nagasaki and the nuclear meltdowns in Fukushima. They recognize that the nuclear contamination that has blighted the countryside is long-lasting. The artists whose work is included in this exhibition are the first group who have responded to the disaster; they are the first group who have used their cameras to document and to give expression to this new source of societal anxiety. It is certain that these photographers will continue to return to the subject whether explicitly or implicitly, and other generations of artists will surely follow.

Notes

1 Hiromi Kitazawa, "Araki Nobuyoshi: Interview," *ART iT,* January 6, 2010, www .art-it.asia.

2 Satō Dōshin, *Modern Japanese Art and the Meiji State: The Politics of Beauty,* translated by Nara Hiroshi (Los Angeles: Getty Research Institute, 2011), 238.

3 See Timon Screech, *The Western Scientific Gaze and Popular Imagery in Later Edo Japan: The Lens within the Heart* (New York: Cambridge University Press, 1996), 56, and Terry Bennett, *Photography in Japan: 1853–1912* (North Clarendon, Vt.: Tuttle Publishing, 2006), 35.

4 See Gennifer Weisenfeld, *Imagining Disaster: Tokyo and the Visual Culture of Japan's Great Earthquake of 1923* (Berkeley: University of California Press, 2012), 5.

5 Samuel C. Morse, ed., *Reinventing Tokyo: Japan's Largest City in the Artistic Imagination* (Amherst, Mass.: Trustees of Amherst College, 2012), 97.

6 Among them are Robert Adams, Nicholas Nixon, and Frank Gohlke. See William Jenkins, *New Topographics: Photographs of a Man-Altered Landscape* (Rochester, N.Y.: International Museum of Photography at George Eastman House, 1975), 4.

7 Conversation with Tomoko Nagakura, May 23, 2014.

8 Artist's website, keizokitajima.com.

9 Conversation with the authors, March 12, 2014.

10 Ishida Tetsurō, "An Interview with Rinko Kawauchi: Obsession with Time and Memory," in *Rinko Kawauchi: Illuminance, Ametsuchi, Seeing Shadow* (Kyoto: Seigensha, 2012), 125.

11 Hatakeyama's description of Rikuzentakata appeared in Christopher Phillips and Noriko Fuku, *Heavy Light: Recent Photography and Video from Japan* (New York: International Center of Photography; Göttingen: Steidl Publishers, 2008), 31.

12 Naoya Hatakeyama, "Lime Works," in *Setting Sun: Writings by Japanese Photographers*, ed. Ivan Vartanian (New York: Aperture, 2006), 112.

13 "'My house used to be here.' 'I had my portrait taken by the owner of the photography shop that used to be here (He also died).' The reminders of one's personal history have vanished from this world and one can only describe the reality of one's past through words; one cannot show them to people using visual means. . . ." Naoya Hatakeyama, "Dare ka o koeta nani monoka ni, kono dekikoto zentai o hokoku shitakute shashin o totte iru," *AsahiCamera* (September 2011): 77.

14 Hatakeyama, "By Way of Postface" in *Kesengawa*, trans. Marc Feustel (Madeleine, France: Éditions Light Motiv, 2013).

15 Stephan Berg, "Down to the Waterline," in *Naoya Hatakeyama* (Ostfildern-Ruit, Germany: Hatje Cantz, 2002), 11.

16 Conversation with the authors, March 14, 2014.

17 Conversation with Tomoko Nagakura, May 28, 2014.

18 Hatakeyama, "By Way of Postface."

19 This and the following quotations are from an unpublished manuscript by Lieko Shiga titled "The Spiral Shore."

20 Hatakeyama, *Kesengawa*, n.p.

21 Kaori Fujino, "A.'s Secret, Our Secret," in Nobuyoshi Araki, *Ōjō Shashū: Photography for the Afterlife* (Toyota: Toyota Municipal Museum of Art, 2014), 325.

22 The title of this book makes a play on the sobriquet "Old Man Crazy about Painting" (*Gagyō rōjin*) used by the nineteenth-century painter and printmaker Katsushika Hokusai. Araki's approach to the photographs in the book is described in Hitoshi Suzuki, "Nega e no sokō," in Nobuyoshi Araki, *Shakyō rōjin nikki* (Tokyo: Waizu shuppan, 2011), 212–13.

23 For an excellent discussion of the legacy of the atomic bombs on the Japanese consciousness, see John W. Dower, *Ways of Forgetting, Ways of Remembering* (New York: The New Press, 2012).

24 David Lochbaum, Edwin Lyman, Susan Q. Stranahan, and the Union of Concerned Scientists, *Fukushima: The Story of a Nuclear Disaster* (New York: The New Press, 2014), 39.

25 Dower, *Ways of Forgetting*, 142.

26 Many of the Fukushima photographs are included in the series *Yoyo no kagami* (Mirrors in Our Nights, 2011), and those of *Daigo Fukuryūmaru* are part of the series *Hyaku no taiyō aratakarete* (Exposed in a Hundred Suns, 2012). See Rei Masuda and Reiko Nakamura, eds., *Shashin no genzai 4: Sono toki no hikari, sono saki no kaze* (Photography Today 4: In Their Persistent Endeavors to Meet the World) (Tokyo: National Museum of Modern Art, 2012), 66–83, and Mami Kataoka, Hitomi Sasaki, and Shinichi Uchida, eds., *Roppongi Crossing: Out of Doubt* (Tokyo: Mori Art Museum, 2013), 44–48.

27 Lyle Rexer, in *Photography's Antiquarian Avant-Garde: The New Wave in Old Processes* (New York: Abrams, 2002), 25, discusses the late-1970s movement in the United States led by Jerry Spagnoli, who has been highly influential on Arai's work.

28 Geoffrey Batchen, *Forget Me Not: Photography and Remembrance* (Amsterdam: Van Gogh Museum; New York: Princeton Architectural Press, 2004), 8.

29 Rei Masuda, "Interview: Arai Takashi," trans. Christopher Stephens, in Masuda and Nakamura, *Shashin no genzai*, 133.

30 Ibid.

31 See, for instance, *Sniper View—View from Serbian Sniper Position Overlooking the City of Sarajevo*, 2004; *Sniper View—View from Christian Sniper Position Overlooking No Man's Land, Beirut*, 2004; and *Railway Track—Overlooking the Location Where the Japanese Army Fabricated a Bombing to Create a Reason to Invade Manchuria, Shenyang, China*, 2007, from the series *Scene*.

32 These photographs are reproduced in *Yoneda Tomoko: Owari wa hajimari* (An End Is a Beginning) (Tokyo: Hara Museum of Contemporary Art, 2008), pls. 29, 35, 37.

33 Satomi Fujimura has commented: "Cumulus clouds are the fleecy ones typically drawn by children. When cumulus clouds develop, however, they become cumulonimbus clouds and remind us of midsummer, which may also remind us of the atomic bombings and the end of World War II. In Latin, the word cumulus also means heap or pile. By piling up image upon image, Yasukuni Shrine, Peace Memorial Park in Hiroshima, Iitate Village in Fukushima Prefecture—Yoneda reminds us of the reality of the date March 11, 2011." Satomi Fujimura, "Beyond the Light," in *Yoneda Tomoko: Yami naki tokoro de mukaereba* (Tomoko Yoneda: We Shall Meet in the Place Where There is No Darkness) (Tokyo: Tokyo Metropolitan Museum of Photography, 2013), 168.

34 Andre Maerkle and Natsuko Odate, "The Multiple Lives of Images," *ART iT*, February 15, 2012, www.art-it.asia.

35 Ibid.

36 Najih Imthihani and Mariko Yanai, "Media Coverage of the 2011 Fukushima Nuclear Power Station Accident: A Case Study of NHK and BBC WORLD TV Stations," *Procedia Environmental Sciences* 17 (2013): 940.

37 Ishu Han, correspondence with Tomoko Nagakura, June 12, 2014.

38 For an important examination of photographs taken right after the bombings in Hiroshima and Nagasaki, see Ryūichi Kaneko, *Kaku: Hangenki/The Half-Life of Awareness: Photographs of Hiroshima and Nagasaki* (Tokyo: Tokyo Metropolitan Museum of Photography, 1995), 23–25.

39 Peter B. Hales, "The Atomic Sublime," *American Studies* 32, no. 1 (Spring 1991): 16.

40 Many of the photographs have been published in his photobook, *Sono mori no kodomo* (Mushrooms of the Forest; Tokyo: Blind Gallery, 2011).

41 Masato Seto, *Cesium: 137 Cs* (Tokyo: Place M, 2013), n.p.

42 Corey Keller, in "Sight Unseen: Picturing the Invisible," *Photography and the Invisible, 1840–1900*, ed. Corey Keller (San Francisco: San Francisco Museum of Modern Art; New Haven, Conn.: Yale University Press, 2008), 19–35, discusses the camera's ability to record that which exceeds human vision.

43 Seto, *Cesium*.

44 Charlotte Cotton, *The Photograph as Contemporary Art*, 2nd ed. (London: Thames & Hudson, 2009), 207.

45 "Japanese Artist Uses Radiation's Effects to Show Contamination Spread," www.Ntd.tv/en/news/world/asia-pacific/20140428/134159-japanese-artist-uses-radiation39s-effects-to-show-contamination-spread.html, accessed May 28, 2014; Takashi Morizumi, "AutoRadiography," *Morizumi Takashi no fōto burogu* (Takashi Morizumi's Photo Blog), April 11, 2014, http://mphoto.sblo.jp.

46 Yoshirō Fukukawa, ed., *Shashin ni nani ga dekiru ka—Shikō suru shichi nin no me* (Is There Something that Photography Can Do?—The Eyes of Seven Individuals Who Think) (Tokyo: Madosha, 2014), 164.

47 Shimpei Takeda, *Trace: Cameraless Records of Radioactive Contamination* (n.p.: Shika Inc., 2012).

48 Kikuji Kawada, "The Illusion of the Stain," in *Chizu* (The Map, 1965; reprint, Tokyo: Getsuyosha/Nazraeli Press, 2005), n.p.

49 Kyoko Jimbo, "Celestial Residue," in *Sekai gekijō* (Theatrum Mundi) (Tokyo: Tokyo Metropolitan Museum of Photography, 2003), 56.

50 Kikuji Kawada, "2011-Phenomena," trans. Kevin L. Dunn, *PGI Letter*, no. 233 (Tokyo: Photo Gallery International, 2012).

51 Dan Abbe, "Shoot, Print, Repeat: An Interview with Daisuke Yokota," *American Photo*, July 11, 2012, www.americanphotomag.com.

52 Haruki Murakami, in "Speaking as an Unrealistic Dreamer," trans. Emanuel Pastreich, *The Asia-Pacific Journal: Japan Focus*, vol. 9, issue 29, no. 7 (July 18, 2011), characterizes the expression as meaning "there is no steady state that will continue forever in life.... We cannot find anything to rely on that will not change or decay."

53 Kenzaburo Oe, "History Repeats: Tokyo Postcard," *The New Yorker*, March 28, 2011, www.newyorker.com/talk/2011/03/28/110328ta_talk_oe.

Reframing the Tragedy: Lessons from Post-3/11 Japan

Michio Hayashi

The multitude of responses by photographers and other visual artists to the tsunami and subsequent nuclear disaster belies the notion of a unified Japanese voice, let alone the possibility that a single critic could somehow encompass it. Some of the photographers presented in this book were not even in Japan on March 11, 2011; others were immediate victims of the events. But, in one way or another, in their artistic responses they all cautiously and self-reflexively address their various forms of distance—spatial, temporal, or psychological—from the incident. Their awareness of and responsiveness to a distance that proves either too near or too far are what make their works so engaging. An essential problem in representing trauma is the impossibility of establishing a "proper" distance from the experience to be represented.[1]

The attempt to identify a proper distance naturally entails the question of what constitutes authenticity in representations of traumatic events: who has the right—and to what degree—to represent the experience of 3/11. The answer to this question is often translated into a simple formula of a concentric hierarchy declining steadily from the disaster's epicenter to its outer margins. Voices from the epicenter are seen as the most authentic, therefore to be unconditionally respected and trusted, while voices from the margins are seen as secondary, and therefore suspect, in direct proportion to their distance from the center.

But locating the epicenter of 3/11 as a social, rather than geological, phenomenon is not so simple. Yes, we have to respect the voices of survivors, rescuers, and those who lost loved ones. Their lives were the most deeply affected. But the effects of 3/11 took innumerable forms, whose qualitative differences cannot be quantified as degrees of comparable distance. There were and still are multiple "centers" to this disaster, leading us to gauge the sense of authenticity, or sincerity, on different scales.

If we acknowledge the qualitative differences among centers—inside and outside Tōhoku or, for that matter, inside and outside

Japan—then we recognize how they deconstruct the concentric hierarchy of representational voices. Doing so is especially necessary in response to the surging nationalistic sentiment after 3/11.[2] This nationalism tends to both flatten out the complexity of the multidimensional network of voices in order to simulate a sense of collective unity, and to suppress or foreclose voices that speak from a distance. As Judith Butler has pointed out in an insightful essay on the Abu Ghraib photographs, this flattening of the discursive field leads to the "framing" of the space of representability—delimiting what should be or can be represented as well as who has the right to do so—and by doing so offers the majority of viewers an easily identifiable perspective.[3] The resulting space of natural, or "naturalized," understanding and compassion excludes the noise of unwanted voices.

In an influential newspaper article written two months after 3/11, the philosopher Yoshimichi Nakajima criticized the mass media representation of victims for repeatedly focusing on ordinary—to be read as "normal"—people who had lost family members or friends.[4] It was as if people who are out of the ordinary had never lived in the area: there was no coverage of, say, members of gay or otherwise different couples who lost their partners, or loners who had severed their ties to society before the disaster. In this way the coverage of 3/11 tended to portray the affected communities, both before and after the incident, as harmonious and ideal by excluding unwelcome images from the frame of representation. The mass media repeated images of ideal families, friendships, or communities with an emphasis on the type of mourning that evokes generalized mass sympathy. Although Nakajima doesn't mention it, foreign nationals who lived in the area were also virtually excluded from the initial media coverage.[5]

Such criticism does not take anything away from the suffering of individuals portrayed in the media. The problem lies with the representational strategy of the reporting: through the selection of victims and editing of recorded data, the media seem to have defined who should represent the experience of 3/11 and what the scenario of suffering should be. Nuanced differences among those at the center of the disaster were suppressed to make their situation more relatable for those outside its immediate experience; and this relatability engendered a more abstract (and possibly narcissistic) compassion for the victims' sufferings. Such denial of internal degrees of distance was a precondition for abridging external distance and for producing a flattened-out image of unified national sentiment.[6]

The emergence of this constructed scenario of mourning opens up questions of the relationship between reality and fiction that have been raised, critically or uncritically, by many artists, writers, playwrights, filmmakers, and others after 3/11.[7] The creation of such a scenario—and, by extension, its theatrical nature—is closely related to the idea of framing that Butler proposes. She argues that the medium of photography, which appears to be able to transcend ideological determination, is nonetheless deeply embedded in the battlefield of representation: "in framing reality, the photograph has already determined what will count within the frame—and this act of delimitation is surely interpretive, as are, potentially, the various effects of angle, focus, light, etc." The function of various framings employed in post-3/11 representational practices cannot, however, be fully comprehended if seen only as delimiting. The story is more complex.

To understand this complexity, we need to look further at the issue of distance. Any representation of the experience of the 3/11 triple disaster inevitably incorporates its own distance from the initial site and moment. Even first-person accounts by victims occur at a temporal and spatial distance from the actual event. This separation makes it possible for them not only to talk about the experience in the first place, but also to frame that account in an available narrative format. Seen this way, theatrical framing should not be dismissed as false or secondary but seen as a condition for re-presentation. For example, Lieko Shiga's photographic response to 3/11 consists entirely of images artificially composed before and after the disaster. She chose to stage exhibitions of these "fictional" images in a dark labyrinthine structure with theatrical lighting, so viewers can experience her works as if in a dream (or a nightmare). With almost all the photographs shot at night against an eerie unfathomable darkness, the images go beyond the purely optical realm to evoke a confusing amalgam of multisensory stimuli—tactile, visceral, visual, kinesthetic, as well as implied smells and sounds—that causes viewers to lose the sense of their position in the space. The theatrical framing, distanced from the initial experience, paradoxically conjures up that experience's heightened sensory confusion and lack of analytical distance.

Such framing has a dual and often contradictory function of cleaving open a passage of representation and, at the same time, restricting it. Much of the difficulty that artists have faced after 3/11 in fact arises from this contradictory aspect of framing as a quasi-theatrical condition of representation. In some cases, artists invent a new framing to expose the delimiting and naturalizing function of an old framing, which in turn creates its own fissures. Others deploy a new framing that takes the form of a complete fiction—one that nonetheless succeeds in conveying the reality of the post-3/11 situation better than a straight documentary, by virtue of its theatrical artificiality.

A notable example of the struggle to establish a frame, which recursively problematizes the very act of framing, is the controversial documentary film *311*, codirected by two film directors (Yoju Matsubayashi, Tatsuya Mori), one journalist (Takeharu Watai), and one film producer (Takuji Yasuoka). They visited Tōhoku just two weeks after the incident, without proper professional filmmaking equipment and lacking a specific plan for recording the aftermath of the earthquake. Like many other journalists, they decided they needed to see what was really happening there with their own eyes (that is, their cameras). Partly frustrated by the initial mass-media coverage (or framing) of the situation, the four decided to close the distance between themselves and the actual sites. Their approach was separated from other typical journalistic coverage by almost excessive awareness of their own position as outsiders or intruders. In the documentary film, they do not make their presence transparent, nor do they disappear behind the camera. On the contrary, they appear in the camera frame and expose their own fears, excitement, guilty consciences, and conflicts as they approach the nuclear power plants in Fukushima carrying Geiger counters and wearing protective suits, or enter local villages where searches for tsunami victims were still ongoing.

In a disturbing but memorable scene toward the end of the film, Tatsuya Mori—himself in the frame, recorded by another member of the crew—directs the camera to the corpse of a child found in a search and laid out on the ground by the local Self-Defense Force. Suddenly, one of the residents throws a piece of wood at him and tells him not to take pictures of the body. (The camera had captured just a glimpse of the child's face.) Mori and his colleagues, however, continue recording the scene, saying rather awkwardly that they have to report it. In a later essay on the production of the film, Mori states that the crew members were often harshly criticized not only by local residents but also by fellow journalists for their lack of respect for the deceased and for the survivors' feelings.[8] Journalists and documentarians had an unspoken agreement to avoid photographing the deceased. Mori and his crew crossed this implicit boundary and intruded into the local residents' space of grief and mourning. They did this knowingly, despite feeling tremendously guilty and shameful about it. The ambivalence about their own actions is apparent not only in the film but also in the subsequent essays that each of them wrote and published as an anthology after the production of the film.[9] At the core of this ambivalence is the impossibility of hearing the voices of the deceased, who are absolutely distanced from all of us at the epicenter of the tragedy. The victims' closest survivors are, in that regard, no different from outsiders. While it seems to be the duty of the living to remember those who perished and to recall their voices, this ethically correct act itself inevitably sets in motion various conflicts of representation.

Knowing that it is impossible to represent the deceased, the four directors chose to make a theme of the film their own internal conflict between guilt and duty, sympathy and curiosity, must and must not. This can appear as an ethically questionable act: spotlighting themselves and exploiting the scenes of disaster and tragedy as a mere backdrop, while using their guilty consciences and simulated sincerity to appeal to the consumers of the film. However, their internal conflict, which they tried to foreground in the film, is not simply personal; its condition is derived from the socially normalized morality deeply and widely shared by each one of them and also by us, the viewers. Whether we admire or are disgusted by the

film's relentless pursuit of the traces of the disaster, we cannot avoid becoming conscious of our complicity with the intrusive gaze of the directors. This gaze challenges and exposes the naturalized frame of representation (which excludes death, ugliness, dirtiness, and so on) but also possibly disrupts the relationship among the involved parties. As it audaciously intrudes into our comfort zones and nears the object of representation, thereby minimizing the distance from it, the gap between the film's subjects and viewers seems to widen proportionally. The viewers become part of this dialectic without synthesis and are left with essential questions about what it means to be an observer of a traumatic event. So many art projects and visual representations dealing with the disasters of 3/11 aimed at alleviating the pain of the survivors, reemphasizing community spirit—which often comes dangerously close to nationalistic narcissism, exemplified by abuse of the term *kizuna* (bond)—or offering audiences more hopeful visions of the future. The documentary *311* is one of the rare cases in which fundamental issues regarding the triangular relationship among the viewer, the producer, and the subject are laid bare as a problem to be reckoned with.[10]

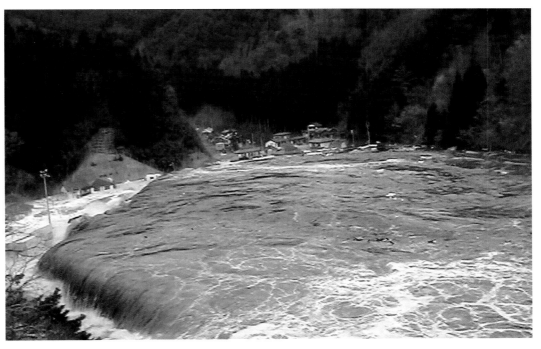

Figure 15. Hashime Seto, still from video footage in *3.11 Tsunami 2011*, 2011

Another documentary project that engages these questions in a very different way is a set of three video pieces produced by the photographer Ryūji Miyamoto. Unlike the *311* directors, Miyamoto waited several months to go to the city of Kamaishi, in the Tōhoku area, and he went there not as a photographer but to search for local residents who had captured the tsunami attack with their own recording devices. He was able to contact three of them and interviewed them separately in their home villages, creating videos of each interview.[11] In the interviews, Miyamoto asked the persons who recorded the tsunami attack to retrace their steps, explaining what they saw and how they captured it as they made their way to higher ground, and also asked them to describe local everyday life before 3/11. With their permission, Miyamoto then combined these with fifteen minutes of tsunami footage taken by each of the interviewees, without any editing or alterations. At the end of each video, Miyamoto added, as a sort of visual epilogue, two extended still shots of local landscapes that underwent the destruction of 3/11 (fig. 15).

What makes Miyamoto's case critically interesting is that his method this time is diametrically opposed to one he employed back in 1995. Miyamoto is the photographer who, probably more than any other, helped publicize the images of the massive damage done by the Great Hanshin Earthquake that occurred in Kobe on January 17, 1995. He went to the site immediately after the event and took many black-and-white photographs of destroyed buildings, houses, and streets with a pan-focused large-format camera that renders images focused across the full depth of the scene. Taking full advantage of his long experience as a photographer of architecture and ruins, Miyamoto produced eerily serene images that vividly conveyed the dehumanizing power of the earthquake.[12] Those photographs were then enlarged and displayed in the Japanese Pavilion at the 1996 Venice Architecture Biennale, as part of a collaboration to allegorically reconstruct the ruins in Kobe, with two architects, Yoshiaki Miyamoto and Osamu Ishiyama. Miyamoto's photographs were integrated into the installation by being enlarged and hung

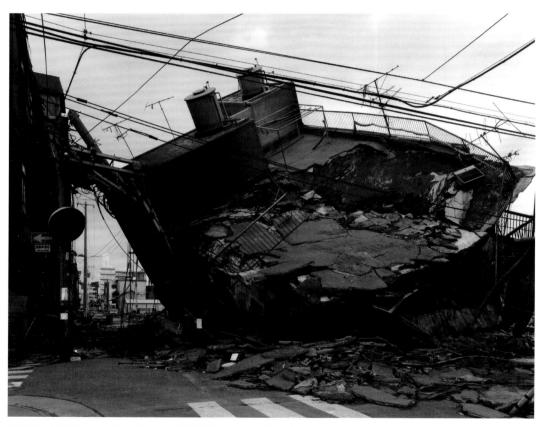

Figure 16. Ryūji Miyamoto, from the series *KOBE 1995 after the Earthquake*, 1995

from the ceiling (figs. 16, 17). The project, directed by the architect Arata Isozaki, won the Golden Lion Award. After the Biennale, the set of enlarged photographs traveled to many venues all over the world to visually represent the damage done to the city of Kobe by the earthquake.

Among the factors involved in Miyamoto's choice of a contrasting method to approach the atrocities of 3/11 is the changing media environment and its ethical challenges. YouTube did not exist yet when Miyamoto took pictures of Kobe and exhibited them in a hyper-theatrical manner in Venice. In 2011, tsunami footage inundated YouTube and other sites immediately after the incident and is still circulating online. In less than fifteen years' time, the media environment changed to make it possible for anyone and everyone to distribute images online, after making them sensational and

consumable through ad hoc editing. Miyamoto's decision to combine unedited video footage with interviews of the persons who took them is clearly a critical response to—a reframing of—the rapid and unstoppable spectacularization of 3/11. Miyamoto also carefully avoided making the final products his works, instead presenting them as collaborative efforts in which he functioned not as an author or director but as a sort of mediator who let both the video footage and the interviewees speak for themselves. Behind this sensitive positioning of himself lie Miyamoto's self-reflective musings on his distance from the original site(s) and the limitations and possibilities of being distanced.

This sense of distance that Miyamoto ascetically maintained as a primary condition of his production induced several forms of internal distance within the video pieces. His neutral posture throughout the interviews seems to have created a comfortable space between Miyamoto and his subjects. Moreover, the decision to leave the interviewees' footage unedited illuminates the

Figure 17. Installation view of the Japan Pavilion, Venice Architectural Biennale, 1996

temporal distance between the original moment of witnessing the disaster and the later moment of the speakers' subsequent representation. Their initial responses are speechless or excessively repetitive, while their reenactment and re-narration of what they did and saw is more articulate in terms of the flow of logic, rhetoric, and gesture. Two different registers of experience are inscribed in the same video piece, and their unmediated juxtaposition draws attention to an unseen interstitial period of time when the transformation occurred.

Thus, Miyamoto's pieces realize not only the unimaginable power and scale of the tsunami, but also the ontological aspect of temporality itself: that is, time as the very medium of deconstruction as well as construction of being, understood as a state of constant becoming. This impression is confirmed and magnified by the

two extended "photographic" stationary shots of the local land-scape at the end of each piece. Inserted abruptly without a clear narrative context and as such not absorbed into the filmic time, these stationary shots quietly refer to ruined landscapes in their existential temporality, marking the irreversible passing of time after March 11, 2011.

Photography has a peculiar relationship to time, noted by numerous writers since Roland Barthes, who termed it the tempo-rality of "this-has-been."[13] Unlike film, which viewers tend to expe-rience as an unfolding present, photography baffles us with a dual temporality of the past disjointedly but persistently existing in the present. The relationship between the photographed past and the viewing present determines the semantics of photography. After a disastrous incident such as 3/11, innumerable personal photo-graphs that were dormant in private households suddenly awaken in the present with an acute sense of dislocation and irreparable loss. Rescuers and volunteer groups immediately started collecting found photos in the detritus of the tsunami even as they searched for survivors. These "found photographs" were gathered, cleaned,

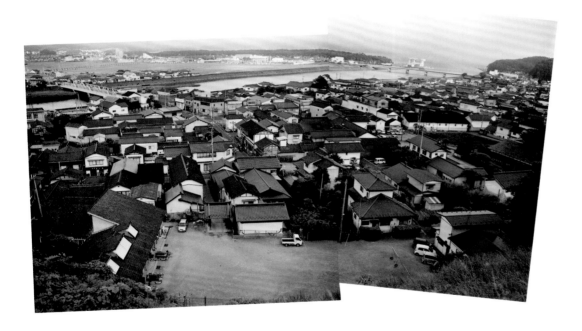

Figure 18. Naoya Hatakeyama, *2004.7.24, Imaizumi, Kesen-chō*, 2004

restored, and displayed in numerous designated sites so they could be claimed by their previous owners. Many of them acquired special significance as the only extant prints of lost loved ones.[14]

Naoya Hatakeyama's decision to include his pre-3/11 pho-tographs along with post-3/11 ones in his photobook *Kesengawa* (Kesen River) can be seen as a response to this "awakened" state of pre-disaster photographs. The calm mundane details of those land-scapes are clearly imprinted on the material surface of the prints but, as Hatakeyama's post-3/11 photographs imperturbably testify, they were all wiped out. The almost surgical coolness of his pho-tographs reflects Hatakeyama's methodical distancing of himself from the tragedy (in his case, a personal tragedy)—demonstrated by his frequent use of compositions with wide and deep perspec-tive. This coolness brings out the duality of photographic tempo-rality, making the gap between past and present painfully tangible (figs. 18, 19).

Miyamoto's insertion of the still "photographic" shots at the end of his video pieces and Hatakeyama's calm but methodically

willed distance seem diametrically opposed to the baroque the-
atrical approach that Shiga takes in her photo-installations. But
ultimately they are two contrasting responses to the temporality
of photography, constantly fluctuating between the past and the
present with no apparent signs of the future, and producing the
side effect of what might be called "photographic melancholy." If
Hatakeyama calmly and sharply delineates this melancholy with
surgical precision, Shiga enucleates it as the ever-absent center of
her theatrical spiral—which, because of its failure to capture the
"truth" of her experience, stirs us with its dark and unfathomable
effects. Photographers such as Keizō Kitajima and Rinko Kawauchi
also produced calmly powerful images that evoke this photographic
melancholy: Kitajima in the form of single prints of deserted land-
scapes taken with his signature even-and-sharp grayish tone and
analytical tranquility, and Kawauchi finding accidental details of
the debris as fragile existential markers of her own being in the inhu-
manly vast wasteland. Nobuyoshi Araki continuously registered his
anxiety about the post-3/11 situation by physically damaging his
negatives' surface to mark the frustrating spatio-temporal distance

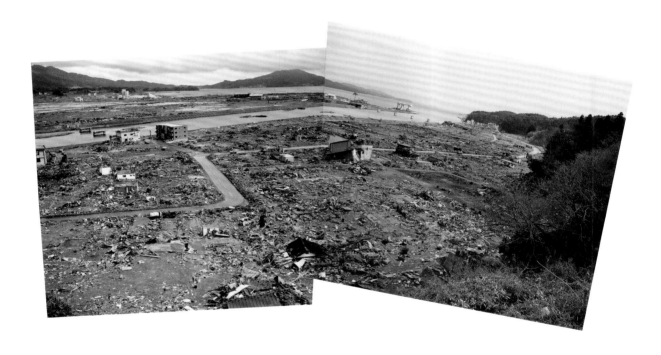

Figure 19. Naoya Hatakeyama, *2011.4.4, Imaizumi, Kesen-chō*, 2011

from the time and place of the disaster. Takashi Homma employs an
allegorical approach by taking pictures of mushrooms found in the
restricted area in Fukushima, intertwining memories of Hiroshima
and Nagasaki with their rather comical and possibly distorted fig-
ures. As he indicates in an essay on the series, each mushroom sud-
denly loses its natural particularity and begins to present itself as a
signifier to be deciphered, or as a visual emblem that summons up
an entanglement of multiple historical forces.

These photographers' works activate the dialectical fluctua-
tion between the fundamentally melancholic nature of our linear-
time-specific ontology and the possibility of weaving this linear
time into a tangled temporality in which the various unrepresent-
able "losses" are repeatedly reawakened, or relived, and (re)inte-
grated into the present. Such possibility does not necessarily mean
that the past is subsumed into the present; instead, we confront the
impossibility of doing so as the work keeps the dialectics-without-
synthesis alive while refusing to succumb either to the allure of
melancholic inertia or to the erasure of loss by filling it with socially

Figure 20. Shimpei Takeda, *Trace #7, Nihonmatsu Castle*, 2012

Figure 21. Shimpei Takeda, *Soil Sample at Nihonmatsu Castle*, 2012

ensured meanings. The task for us as viewers is to experience the actuality and the melancholy of these photographs, or to continuously reawaken them, while preventing the images from becoming "out of date" as consumed spectacles or turning into visual data to be absorbed into the pragmatic sociopolitical discourse. As we look at these photographs, we are continuously challenged to keep them mournfully alive in the space between inertia and symbolization.

A particularly difficult problem for photographers attempting to record evidence of the nuclear disaster is that the life-threatening rise in radiation remains entirely and eerily invisible. As the photographer Yasuhiro Ohara testified when he visited Fukushima, there is nothing visible to photograph in the landscape of the contamination zone.[15] The only aspects of the scene that could be captured were the absence of humans in the rural landscape, or the presence of workers scraping the surface to remove radioactive soil. Shimpei Takeda is one of the photographers who resorted to the material process of the medium to capture the effects of radiation. He began to take "pictures" of radiation by placing contaminated soil collected in various locations around Fukushima on photographic paper wrapped in a plastic sleeve. As the soil sits on the plastic surface, traces of radiation begin to appear on the paper. These beautiful traces, which look like miniature galaxies, evoke not so much the past as the ongoing present: although produced at a particular moment, these images remind us of the invisible and hazardous levels of radiation in the vicinity of the Fukushima nuclear plant that will persist for decades to come (figs. 20–22). And by extension, they also suggest the continuous presence of both manmade and naturally occurring radiation, however minimal, across the globe. Takeda's use of online media to disseminate these images echoes the transgressive nature of radiation in its uncontrollable spread beyond the immediate area of Fukushima. His booklet *Trace*, distributed to those who funded it with online pledges and consisting of forty pages of these prints, added another material dimension—with its printed rather than onscreen images—to the invisible but real presence, and constant spread, of radiation.

Figure 22. Shimpei Takeda, *Nihonmatsu Castle*, 2012

The duality played out in Takeda's work is not so much between the past and the present as between visibility and invisibility. His use of a radiographic process to make invisible things visible undermines our confidence in the fixed divide between them, reminding us that it is based on arbitrary conditions of human physiology. The beauty of the radiation traces also brings us back to the issue of framing: the "galaxies" in these images are aesthetically pleasing precisely because they are neatly framed within the rectangular format of the photographic paper. But the random distribution of the soil and the contingency of the composition remind viewers that this framing does not include the pervasive presence of radioactive effects beyond the edges of the print. The contemplative viewing subject constructed by the framed beauty is unsettled by the notion that we are constantly being exposed to radiation.

It is tempting to compare this convergence of epistemological pleasure and ontological fear to the aesthetics of the sublime, which typically relies on the perception of a thin boundary between the experiencing subject and a phenomenon of overwhelming power or scale. The initial fear of, say, a storm can be turned pleasurable, as long as the person experiencing it is safely protected behind a wall or shelter. Taking a photograph of the scene or event from a distance provides a further aesthetic framing. But photography such as Takeda's can also suggest a breach of this thin boundary by

laying bare the arbitrariness of its own framing and revealing the fearful possibility of exposure to an imminent danger.

Takashi Arai also plays with the concept of exposure, both literally and metaphorically. He places the Fukushima radiation in a larger historical context going back to Hiroshima and Nagasaki and continuing with exposure to civilian and military nuclear power after the war in both Japan and America. By photographing places and objects related to, or exposed to, nuclear radiation, including the Atomic Dome in Hiroshima, the *Daigo Fukuryūmaru* fishing boat, and nuclear plants in Japan and California, he points to a network of events and sites that provide a critical perspective for understanding the Fukushima disaster as one incident in the larger history of nuclear energy. His use of the "primitive" technique of the daguerreotype embodies the theme of radiation exposure. Because the daguerreotype image is literally inscribed by light onto its material surface through prolonged exposure, it usually turns out to be filled with accidental details and tends to have varying undulations of light and focus—brighter and sharper at the center, and darker and blurred at the margins. Each daguerreotype, unique and irreproducible and created by the direct action of light, is in a sense a primal scene of photography. It very effectively draws our attention to the poignant link between the kind of exposure represented within it and the exposure imprinted on its surface. However, this clear mirroring between the signified (what is depicted in the image) and the signifier (the materiality of the image) can make Arai's work appear restricted in its readings. The aesthetic effect and the political content often congeal too nicely into a unitary meaning, with "exposure" as its master code, creating a prescribed pattern rather than productive resonance.

The theme of the invisibility of radiation is deeply entangled with a historical invisibility that has operated deep within the structure of postwar Japanese society and its collective psyche.[16] Although anxiety about nuclear weaponry has sporadically surfaced in mass culture imagery, the construction of numerous nuclear power plants across Japan after the 1960s as well as the continual presence of American nuclear aircraft and submarines remained largely out of sight—in some cases intentionally concealed by the government—despite the perseverance of a few anti-nuclear movements.[17] The economic recovery of the postwar period, the oil crisis of the early 1970s, the resurgence of the economy again in the late 1980s, and the increasing gap in wealth between the provinces and the cities all contributed to cloud the Japanese people's evaluation of the risks of nuclear plants and the necessity for taking precautions against possible catastrophes. For instance, fundamental ethical and ecological questions about nuclear waste went unanswered in favor of an unfounded optimistic belief in future technologies.

This invisibility or willful blindness leads us back to the flattened unity of national sentiment. Although the issue of the historical invisibility of nuclear issues and the accumulated discourses on tsunami in general cover a much larger field than the representation of the 3/11 victims, the central logic of framing out unwanted noise remains consistent and derives from a similar predilection toward the imagined solidarity of the nation as a collective subject. At the center of this imagined national solidarity is a fictively (and performatively) assumed communal spirit, invoked to downplay the differences among involved parties and, by integrating all actors into a complicit relationship, to diffuse responsibility

for the disaster into the post-3/11 air. The concept of the *kizuna* bond, which could function as a comforter in some contexts, has been misused to block perception of the history that brought the nation to the present situation, as well as to erase differences and dissonances among involved parties including the community of victims and survivors. It is not impossible to discern some similarities between this structural blindness and propaganda during the fascist period in Japan, with its lack of objective logistical analysis and its promotion of *kokutai* (the unified character of the state) and *yamato* (Japanese) spirit.

The post-3/11 situation has both confirmed the enduring lure of this nationalistic impulse and exposed and deconstructed its ideological deceitfulness. Many artistic practices, including the works of photographers assembled in this volume, strive to break the hold of this drive by prying open the dominant frame of representation. Their attempts at "de-framing" or "re-framing" include, in Arai's case, summoning traces of the past to make visible the structural blindness of recent history; Shiga, Hatakeyama, Araki, and Kawauchi make us aware of the difficulties in talking about a unified 3/11 experience by emphasizing the aspects that are unique to each individual. Still others attest to the importance of paying close attention to particularities that refuse to be sublimated into a generalized and often sentimentalized compassion.

In fact, nothing can be more treacherous than the illusion of "understanding" events such as the 3/11 disaster. The more we are exposed to the forms it took through the specificities of photographic images—with their unique material and formal details—the less confident we become about our own capacities to understand what we see, as we are made aware of distance from the victims and among ourselves as witnesses. Testimony from and conflicts among the immediate victims and survivors show that they too register irresolvable differences among themselves, as each experiences different forms and degrees of hardship.[18] These particularities always slip through the cracks of an abstract frame of understanding.

The power of photography is that it distinctively inscribes traces of individual situations and actions. While it is possible to absorb photographic images into a generalized sentiment or a hegemonic ideological frame, they also carry their own singular differential markers—sometimes apart from the photographers' intentions, as in the case of lost and found photographs. Although photography can be embedded in a larger visual-discursive machine, it is very difficult for it to be totally absorbed without leaving any residue or distortions. And whereas the making of photographic images is technologically inseparable from the practice of framing in its optical sense, the medium always has the potential to resist or deviate from ideological or discursive framing precisely because of its inexhaustible existential singularity. The photography produced in response to the post-3/11 situation in Japan exemplifies these different registers of framing, placing it on the front line of the dialogue between absorption and resistance.

Notes

1 The concept of distance, or the impossibility of finding a proper distance, also plays an important role in Atsushi Sasaki's sensitive and provocative readings of many films, novels, or theatrical pieces produced after 3/11. See his *Situations: Igo o megutte* (Situations: About "Post-"; Tokyo: Bungei shunju, 2013). Naoya Hatakeyama also points out the importance of distance for differing responses by people, inside and outside Japan, to 3/11 in his interview. See "Sekai to ato: Nobi chijimi suru kyokai" (The World and Art: The Border That Stretches), interview by Aki Kusumoto, in *REAR* 31 (February 28, 2014): 102–10.

2 Tetsuya Takahashi suggested "Japan narcissism" or "Japan fetishism" instead of "nationalism." But I would like to use the concept here to suggest the continuity between the general mass sentiment of the post-3/11 and the surge of the exclusivist discourse and movements, consciously or unconsciously, against foreigners, especially other Asian peoples, and the rapid political reforms advanced by the current Shinzo Abe government. See *Gisei no shisutemu: Fukushima, Okinawa* (The System of Sacrifice: Fukushima and Okinawa; Tokyo: Shūeisha shinsho, 2011), 151.

3 Judith Butler, "Torture and the Ethics of Photography: Thinking with Sontag," in *Frames of War: When Is Life Grievable?* (New York: Verso, 2009), 63–100.

4 "Ima koso bidanga oou shinjitsu mo aru" (There Are Also Truths That Heroic Tales Conceal), *Tokyo shimbun*, May 17, 2011. Please note the date of this article, which is about two months after 3/11. The situation is now slightly different with a gradual increase of non-mainstream representations of victims or survivors (especially in fictions including films and comics).

5 Although there were occasional episodic reports on foreigners as victims of 3/11, overall the amount of media coverage of what happened to large communities of foreigners in the Tōhoku area—Chinese, Koreans, Filipinos, Brazilians, Thai, and so on—has been, and continues to be, disturbingly small. The emphasis on catchphrases such as "Japan as one" or "Go Japan" clearly clouded media and collective vision on the issue. The following website is useful for looking into the problem of underrepresentation of social minorities in relation to 3/11: http://risetogetherjp.org.

6 Although this overemphasis on relatability to the survivors and the victims of 3/11 seems diametrically opposed to the discrimination against the refugees from Fukushima in other areas of Japan, they may be seen as two sides of the same coin—as long as those two contrasting attitudes share the same emphasis on and expectation of the normalcy of the object of compassion and hate.

7 Some of the memorable works that addressed the experience of 3/11 are fictitious. For example, the novel *Sozo rajio* (Imagined Radio), by Seiko Itō (2013), very effectively dealt with the issue of how to represent the voices of the dead. The movie *Kibo no kuni* (The Land of Hope, 2012), directed by Shion Sono, depicts the tragic fate of two families in situations that resemble post-3/11 Fukushima; the film uses professional actors, while much of the shoot was conducted in the actual disaster-stricken areas.

8 Tatsuya Mori, "3-11 igo" (After 3/11), in Yoju Matsubayashi, Tatsuya Mori, Takeharu Watai, Takaharu Yasuoka, *311 o toru* (The Making of 311; Tokyo: Iwanami shoten, 2012), 1–36. See especially pp. 30–31 for the criticism they received from fellow journalists. The taboo on the visual representation of the dead is not unique to 3/11; it has always been a taboo for various reasons, throughout the history of photographic journalism. See Susan Sontag, *Regarding the Pain of Others* (New York: Farrar, Straus, and Giroux, 2003). In the context of 3/11, while visual (cinematic or photographic) representation of the dead still remains a taboo, verbal representation of them began to circulate in the form of reportage or documentary literature. The most notable example in the field is Ishii Kota, *Itai: Shinsai, tsunami no hate ni* (The Remains: After the Earthquake and the Tsunami; Tokyo: Shinchōsha, 2011).

9 Kota, *Itai*.

10 That many so-called *aato purojekuto* (art projects) and museum exhibitions organized after 3/11 are focused on the theme of consolation and encouragement is understandable in light of the fact that they were "public" events. However, I heard from various sources that decisions about what to include and exclude from those events were often made or influenced by the municipal government and authorities, to preclude any conflicts or complaints from the public. Nothing is

wrong with those themes themselves, but if the critical function of those events was significantly subdued or overshadowed because of this general tendency, that is problematic. And that is unfortunately what I saw in some cases such as the first museum exhibit of post-3/11 art, held in the Contemporary Art Center, Art Tower Mito (October 13–December 9, 2012), titled "Artists and the Disaster: Documentation in Progress."

11 Three of the local residents Miyamoto contacted and eventually collaborated with to make the video pieces are: Hashime Seto, Moriko Ikeda, Kenzaburō Kobayashi.

12 Miyamoto started his professional career as a photographer for the magazine *Jutaku kenchiku* (Residential Architecture) in the 1970s. After becoming a freelance photographer, he continued to take pictures of various architectural structures, including contemporary ruins and cardboard houses built by homeless people in various major cities. See, for example, *Architectural Apocalypse*, with an essay by Arata Isozaki (Tokyo: Heibonsha, 2003), and *Cardboard Houses* (Kobe: Berlin, 2003).

13 See Roland Barthes, *Camera Lucida*, trans. Richard Howard (New York: Farrar, Straus, and Giroux, 1981), 79, 96.

14 In most of the cases, these found photographs were returned to and cherished by close relatives or friends of the deceased. But it is also notable that they were occasionally refused, because of the immeasurable pain that those images induce. In either case, there is no question that the found images acquired acute affective meanings after March 11. I would like to thank Prof. David Slater for information about the survivors' varied responses to found photographs.

15 See Ryō Isobe, *Projekuto Fukushima 2011/3-11–8.15: Ima bunka ni naniga dekiruka* (Project Fukushima 2011/3/11–8/15: What Can Culture Do Now?; Tokyo: K & B Publishers, 2011), 105.

16 Another historical invisibility that is structurally analogical to the case of the nuclear plants is the situation of Okinawa, where 74 percent of the American military presence in Japan is concentrated. The myth of Japan as a demilitarized peaceful nation was maintained throughout the postwar period mainly through the sacrificial function of Okinawa. Books or articles published after 3/11 that point out this parallel invisibility include: Tetsuya Takahashi, *Gisei no shisutemu: Fukushima, Okinawa* (The System of Sacrifice: Fukushima and Okinawa; Tokyo: Shūeisha shinsho, 2011); *Kono kuni wa doko de machigaeta no ka: Okinawa to Fukushima kara mita Nihon* (Where Did This Nation Make the Mistake? Japan Seen from Okinawa and Fukushima; Tokyo: Tokumashoten, 2012); *3-11 Igo nani ga kawaranai no ka* (What Has Not Changed after 3/11; Tokyo: Iwanami Shoten, 2013).

17 The movie *Godzilla* (1954) is a good example of mass cultural response to the nuclear anxiety in postwar Japan. Although it was later serialized, the original was released in the same year as the *Daigo Fukuryūmaru* incident. In the background of both lie a series of American nuclear tests in the South Pacific.

18 For example, there are many ongoing lawsuits between the family members of the victims and the relevant authorities, including the municipal government and TEPCO.

The End of the Line: Tōhoku in the Photographic Imagination

Marilyn Ivy

Most people outside Japan had never heard of Tōhoku before March 11, 2011. English-language media often refer to the Tōhoku earthquake and tsunami, yet the place-name Tōhoku is not nearly as familiar as that of Fukushima, which has come to stand in for the entirety of the triple disaster of March 11. "Tōhoku" means, literally, "northeast," but it also is the Japanese term for the six northernmost administrative districts (prefectures) of the main island of Honshu: *the* Northeast.[1] The term is far more than a neutral administrative designation or a simple directional signifier, however. For Japanese today, the mention of Tōhoku immediately conjures up a vast territory in the far north, riven by densely articulated mountain ranges and narrow valleys, a Pacific Ocean coastline that rivals Big Sur in its breathtaking headlands, and unrelenting winters, with some of the deepest snowfalls on the planet. Tōhoku, sometimes called "the Scotland of Japan," a place cursed in earlier times with recurrent crop failures and famines. Tōhoku, long considered a poverty-stricken backwater far from the centers of Japanese civilization to the southwest, and—like all backwaters—subject to more than its share of discrimination from the cultural centers. Tōhoku, an area of tenaciously distinctive and enduring local lifeways and forms, known for its superb horses, folk crafts, flamboyant festivals, shamanistic practices, and local dialects almost incomprehensible to outsiders. And, since March 11, 2011, Tōhoku connotes a world of unfathomable natural disaster, displacement, and nuclear poisoning, the site of the most widely photographed catastrophe in history.

In former centuries, the distant northeast was a zone only partially pacified and controlled by the ancient Japanese state centered in Kyoto, far to the south and west. Although there is ongoing debate among archaeologists and others about the original inhabitants of Tōhoku, local groups—the Siberian-linked Ainu, along with groups known from seventh-century texts as Emishi and later as Ezo—clashed with (and sometimes intermarried with)

Japanese military forces and migrants from the south. The region was increasingly brought under control by local lords loyal to the feudal government in the Tokugawa period, 1615–1868. A branch of the Kyoto imperial court even established its own northern mini-kingdom in the eleventh and twelfth centuries in Hiraizumi (located in today's Iwate Prefecture). Buddhist in aesthetic and religious culture, Hiraizumi was designated by UNESCO soon after 3/11 as a World Heritage Site, recognized for its Buddhist temples (one, at least, lavished with gold) and gardens left behind by the ruling Fujiwara clan.[2]

Yet despite this ancient high-cultural splendor, the perception of the Northeast as a dangerously if seductively undomesticated periphery persisted well into the modern period. "Tōhoku" is actually a twentieth-century designation that was not commonly used until the railways were extended into the region; after the Tōhoku Line was opened in 1909, the term took its place as the standard name for the entire region.[3] Before then, it was called (indicating either its entirety or its subregions) Ōu, Ōshū, Oku, or Michinoku, all names that denote the interior, metaphorically extended into the idea of the remote.[4] "Michinoku," for example, can be translated as "the end of the road" or, more emphatically, "the end of the line." Although *oku* literally means the "inside," the place-name Oku historically pointed ever-northward to regions far from the imperial court: the backcountry, the boondocks, the northeastern interior that extends to the Tsugaru Strait separating Honshu from the island of Hokkaido. Japan's most famous haiku poet—and the Japanese poet most famous worldwide—Matsuo Bashō (1644–1694), wrote his landmark work *Oku no hosomichi* as a prose and poetry travel diary of his pilgrimage to the far north, to Oku, in 1689. English translations of this work abound, with the title variously rendered as *The Narrow Road to the Deep North*, *Narrow Road to the Interior*, or *The Narrow Road to Oku*.[5] Commentators and translators always remind us that the "narrow road" (*hosomichi*) to the "interior" (*oku*) not only indicates the more than two-thousand-kilometer trek that the poet made on foot to the northern backcountry, but also alludes to a Buddhist-inflected journey to the interior of being, a trip to the "deep north" of existence, an existential peregrination to an origin that is as far away as it is ineffably intimate.

By Bashō's time, then, Michinoku or Oku described a destination for spiritual and poetic encounters both with the deep historical past and with celebrated landscapes, such as the sublime vistas of Matsushima. And there were other, more mysterious sites: sacred mountains as centers of Shinto-Buddhist asceticism, shamanism, and spirit mediumship. At Mount Osore (which translates as Mount Dread), on the farthest northern edge of Honshū, blind female spirit mediums gather to call down the spirits of the dead even today.[6]

With the overthrow of the Tokugawa shogunate and the founding of the Meiji state in 1868, Japan was radically transformed—and so was Tōhoku. The urbanization that began at this time and continued throughout the next century brought profound upheavals in the very foundations of rural life. As the countryside became not only the source of food for cities but also a source of factory labor, modernizing cities like Tokyo came to dominate the countryside. Peripheral areas, particularly Tōhoku in the north and the islands of Okinawa in the south, became veritable "sacrifice zones" serving the cause of industrial capitalism.[7]

From the early years of the twentieth century, caught in the perfect storm of perhaps the most rapid-fire industrialization in global

history, urban middle-class Japanese increasingly came to regard the far north as a stubborn repository of archaic Japanese traditions, a last holdout against the state's Westernizing mission to civilize and enlighten the population. Tōhoku signified a land where peasants kept the old ways, where recently discovered Jōmon pottery sites testified to the existence of indigenous Neolithic peoples who predated the conquering Yamato Japanese from the south; a land where, lore had it, ghosts appeared in the mountains along with hunters, woodcutters, and charcoal makers. The region's very poverty and distance from the urban centers of Japanese modernity helped sustain an aura of archaic cultural authenticity for city folk who had forgotten the ways of their rural forebears. Gradually (re)discovered by folklorists, arts and crafts enthusiasts, geographers, poets, artists, literary figures, intellectuals, reformist bureaucrats, and—not least—photographers, Tōhoku called forth an ambivalent nostalgia (and when is nostalgia not ambivalent?) for peasant villages as surviving sites of Japanese premodernity.[8]

In 1909, a young Tokyo government bureaucrat and aspiring literary scholar named Kunio Yanagita found himself in the Tōno basin, in the inland heart of Tōhoku. He came there on a pilgrimage of sorts, after having spent nights in Tokyo listening to storytelling by a Tōno native. Yanagita traveled to Tōno hoping to encounter the original landscapes and scenes of these tales. The following year, he self-published *Tōno monogatari* (*Tales of Tōno*), a retelling of local lore and legends along with his own reflections. The book received only scattered attention at the time, but within twenty years it had been recognized as a true masterpiece and the founding text of Japanese folklore studies (*minzokugaku*). In the century since it was written, the *Tales of Tōno* has acquired an almost fetishistic status among modern Japanese—including photographers—hoping to find a lost homeland (*furusato*) in the mountains, fields, and forests of Tōhoku. Beyond its recognition as the foundational text of Japanese folklore studies, the *Tales of Tōno* is universally considered a crucial work of Japanese literature and a landmark in modern Japanese thought, one that secured the legendary place of Tōhoku in the modern Japanese imagination.[9]

Photographers had captured Tōhoku's natural scenery and historical sites since the early days of the camera in Japan, and images of its village farm life and festivals were not rare in early twentieth-century newspapers and magazines outside the Tōhoku region. But Tōhoku consolidated its place in the Japanese photographic imagination only after the Second World War, with the dramatic surge in domestic travel enabled by the extension of the Japanese National Railways and, in particular, its tourism campaigns from the 1970s urging Japanese to "Discover Japan" before it was too late.[10] The massive dislocation and ruined cities of the war, followed by the post-1945 American-dominated Allied occupation, had already led many photographers, artists, writers, and intellectuals to turn yet again to the countryside and its villages for a sense of an enduring national identity. They saw stability in communal life and old traditions, along with the possibility of resisting, however fleetingly, the onslaught of Americanization centered in the cities. Tōhoku figured prominently in these postwar dreams of a return to Japanese tradition, preserved through the archival vocation of photography.[11]

Some photographers, not professionals but native to the region, captured Tōhoku life in images that were only later made public. Others with already established professional careers made

forays into Tōhoku with well-defined projects in mind. All these photographers, whether local or not, were drawn to the enduring rhythms of farming and fishing, the lingering texture of seasonal folk practices, the harshness of the terrain. Snow is everywhere in these photos—and if not snow, then mud; if not mud, then green expanses of rice or the sepia-colored aftermath of the harvested fields. Oceans and mountains form the boundaries of settled agricultural life. Hard labor is a universal given; children are ubiquitous.

With few notable exceptions, master photographers of the postwar decades rarely included local cities (Fukushima, Sendai, Morioka, Aomori, and others) in their thematic presentations of Tōhoku. It is as if cities did not exist in Tōhoku—or if they existed, they did not signify what photographers wanted to convey. The desire to portray Tōhoku as a region virtually unchanged since premodern times was in sharp opposition to the inexorable spread of American-style consumer culture throughout the archipelago. There is thus a conflict among three photographic desires in postwar photography of Tōhoku: the desire to document pristine survivals of an older Japan, often by recording ritual scenarios or domestic scenes without the intruding evidence of postwar modernity; an equally strong desire to portray the contemporary realities of Tōhoku life, pleasant or unpleasant, Japanese or foreign; and finally, a desire to capture Tōhoku as primarily an object of aesthetic appreciation through photography that accents the singular imagination of the photographer as much as the objective realities of Tōhoku itself.

Two Tōhoku-native photographers of the 1940s and 1950s generated some of the most elegiac yet unsparing photographs of a Tōhoku at the end of the line, a terminus where brutal scarcity and the possibilities of a better life tenuously coexisted. Teisuke Chiba (1917–1965), from Tōhoku's Akita Prefecture, began taking photographs as an amateur. Perhaps his most iconic image is *Driving Off Sparrows* (1943). Here, as in many so-called ethnodocumentary photographs capturing regional village life, children become an object of delicate observation and redemptive registration, operating as guarantees of continuity and the transmission of tradition. In this photograph they are recorded performing a timeworn folk agricultural practice—driving off birds with their songs—that is depicted as living on, even in the midst of wartime (fig. 23).

Ichirō Kojima (1924–1964) takes his place with Chiba as a pivotal midcentury Tōhoku-based photographer. With access to cameras from his family's store, Kojima took copious photographs after his return from the war and was active as a professional photographer only from 1954 to 1964, in a sadly foreshortened career. Some critics refer to Kojima as Japanese photography's Millet (referring to the mid-nineteenth-century painter of French rural life, Jean-François Millet), claiming that he romanticized peasant agricultural labor, particularly in his figuratively rendered photographs of small groups of workers and shots of solitary laborers.[12] Above these depictions of unremitting labor—with figures carrying or hauling heavy burdens—are the sublimely lustrous skies manifested by his artful printing. The snows glow with luminescence, yet his photographs reveal the realities of frontier desolation and hardscrabble survival. The settlement called Jūsan-mura, with its muddy road and wooden buildings, resembles nothing so much as a forlorn prairie town in an American Western (figs. 24, 25).

Two masters of realist photography of the 1950s–1970s, Hiroshi Hamaya and Ihei Kimura, made Tōhoku a crucial part of their oeuvre.

After the profound disruptions of the war, Japanese photographers sought to explore the uncertain contours of existence itself with newfound intensity. This form of realist photography (*riarizumu*) strove not just to record reality mechanically with the camera, but to shape it in terms of social vision and personal experience.[13] Ken Domon (1909–1990), who has been called Japan's most popular photographer, was central in the strenuous debates about realism, particularly when he held forth as a judge and commentator in amateur photography contests sponsored by hobby magazines. Two of his contemporaries found their footing as Japanese searching for reality in backcountry Tōhoku. Domon's internationally recognized photojournalist colleague Hiroshi Hamaya (1915–1999) is best known outside Japan for his lucid ethnodocumentary photographs of Japan's snowy western coast—including Akita and Yamagata, both prefectures in Tōhoku with coastlines on the Japan Sea. His

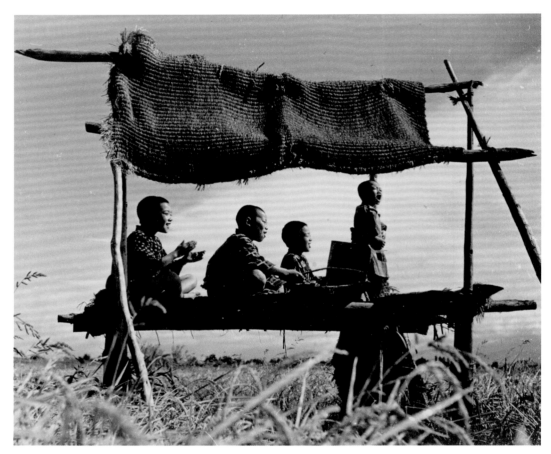

Figure 23. Teisuke Chiba, *Suzume oi (Driving Off Sparrows), Kitsunezuka, Taiyū Village*, 1943

influential mid-1950s photobook *Yukiguni* (Snow Country) presented seasonal rituals and rites with the attention to detail proper to a committed folklorist.[14] Hamaya found his antidote to the terrible upheavals of a Japan in war and recovery in the placid rhythms of communal life in the northeast country, even if it was an antidote that was dependent on poverty for its effectiveness.[15]

Ihei Kimura (1901–1974) emerged as a dominant commentator, pedagogue, and proselytizer for documentary photography in the 1950s and 1960s. Influenced by the French photographer Henri Cartier-Bresson's notion of the "decisive moment," Kimura based his practice on the *sunappu*, the distinctively Japanese conception of a candid, documentary photograph.[16] Using a handheld Leica, the favored camera of amateur and professional *sunappu* photographers, Kimura became internationally known for his photographs of Japanese literary figures, Tokyo street scenes, Kabuki actors,

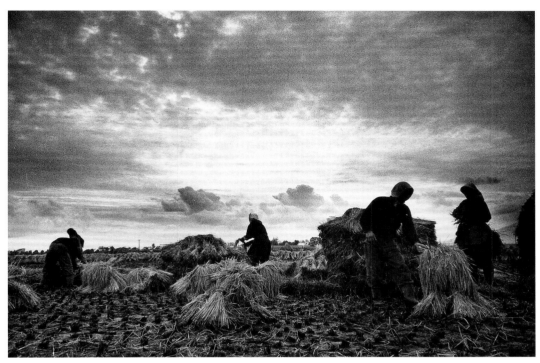

Figure 24. Ichirō Kojima, *Kizukuri, Tsugaru City*, 1958

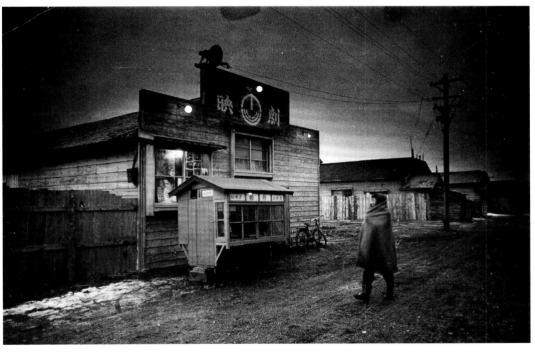

Figure 25. Ichirō Kojima, *Twilight (Jūsan, Goshogawara City)*, about 1957

and—famously—1950s Paris. After the mid-1950s, he transferred his focus to Tōhoku's Akita Prefecture, visiting the area more than twenty times in the production of photographs that are considered the apotheosis of his career.[17]

The period from the fifties to the seventies was also marked by experimentation in the arts, including avant-garde work deeply influenced by prewar German photography. Tarō Okamoto, a major modernist artistic and intellectual figure, was the first person to make a case to the Japanese public for the aesthetic brilliance of Jōmon pottery, often claimed to be the oldest fired clay pottery in the world (fig. 26). Tōhoku is the area noted for the greatest flourishing and final homeland of the Jōmon, and cultural theorists even today will claim that Tōhoku retains the primitive "spirit" of the Jōmon despite centuries of domination by later migrants to the islands.[18] This Jōmon legacy has continued to shape the popular perception of Tōhoku as the last redoubt of a primeval, indigenous hunting and foraging culture that existed in Japan for thousands of years.[19] An artist of expansive talents and energies, Okamoto is most renowned as a painter, sculptor, and writer rather than as a photographer. Yet his lengthy travels throughout the archipelago, documenting what he called "shinpitekina Nihon" (mysterious Japan) from Okinawa to Tōhoku, depended on his photography. This work is not simply documentary, instead representing a form of primitivist modernism—evoking the lineage of Japanese folkloric photography and the ethnographic tradition in European anthropology—while gesturing to surrealist and modernist influences that stimulated a rethinking of the primitive. For Okamoto, Tōhoku became the place where the still-vital origins of the Japanese could be found—and photographed.

Okamoto's modernist primitivism links him to the riveting mid-1960s photographs taken by Eikoh Hosoe (born in 1933), of the extraordinary avant-garde dancer and performance artist Tatsumi Hijikata (1928–1986) in rural Akita. Along with Kazuo Ohno, Hijikata is known as the founder of Japan's unparalleled modern dance form, *butoh* (also known as *ankoku butoh*, the "dance of utter darkness"). Hijikata's dances staged extravagant performances of creaturely life, miming the movements of animals, of crawling infants, of birds and insects, formed from his memories of the poverty, starkness, and earthiness of Akita, his birthplace in Tōhoku. In these images, collected in Hosoe's photobook *Kamaitachi*, Hijikata dances, plays, crawls in the mud, leaps and runs through the rice fields, terrifying (and charming) the local children, embodying the uncontained energy of the trickster *kamaitachi*: the "sickle weasel" of legend, a demon of the air that cuts with the sickle sharpness of a whirlwind (fig. 27).[20]

This experimental ethos took on yet another form with the dynamic photographers of the 1960s and 1970s who used the camera with a no-holds-barred physicality, speed, and proximity. Few contemporary photographers of Japan are as internationally renowned as Daidō Moriyama (born in 1938), a master of street photography. His pictures, rendered in a style known as *are bure boke* (grainy, blurry, and out of focus), are taken on the run and shot from the hip. Moriyama's sixth photobook is an unsparing photographic diary of his sentimental journey in 1976 to none other than Tōno, that Tōhoku epicenter of Japanese folklore studies.[21] In a rambling, revealing prefatory essay, alternately heartfelt and ironic, Moriyama writes of his sense of unsettledness and his desire to discover a true Japanese *furusato* (homeland) in Tōno. Part

Figure 26. Tarō Okamoto, *Jōmon Ware*, 1956

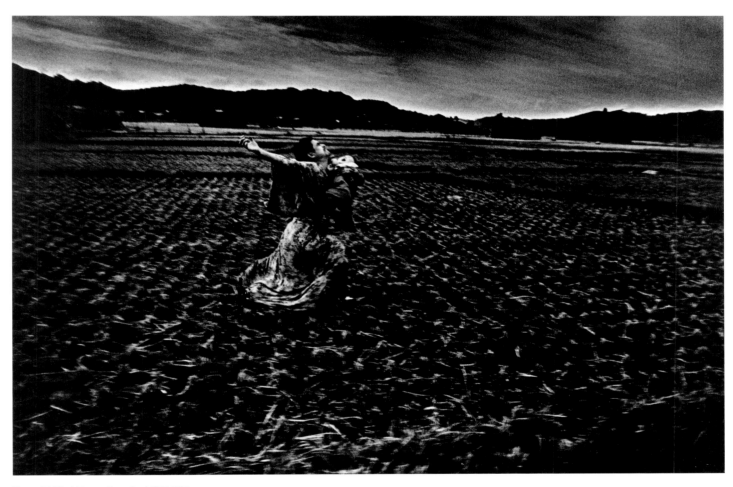

Figure 27. Eikoh Hosoe, *Kamaitachi #37*, 1965

Bashō's *Narrow Road to the Deep North*, part Kerouac's *On the Road*, Moriyama's *Tales of Tōno* does not record Tōhoku as a folkloric mystery nor as the setting for a primitivist reencounter with the earth, but as a place imbued with the familiar strangeness of everyday life in a Japan fully immersed in postwar economic growth. Moriyama cannot completely forgo images of masked folk dancers, mountain temples, reliquary tablets, and thatched roofs—iconic signifiers of rural Tōhoku—yet he gives equal attention to vending machines, coffee shops, streetlights, and railroad tracks, along with old trucks, chickens, cabbages, and electric fans (fig. 28).

By the time Moriyama made his 1976 trip to Tōno, his colleague Masatoshi Naitō (born in 1938) had been photographing Tōhoku for more than ten years, first coming to international attention with his startling photographs of the *baba* (old grandmothers) and female spirit mediums at Mount Osore and other sacred mountains.[22] Naitō consciously set himself apart from the *are bure boke* style of Moriyama, yet both photographers produce a sense of unsettling

Figure 28. Daidō Moriyama, from the series *Tales of Tōno*, 1974

estrangement from vision as usual—Moriyama with his ceaseless hunting for the unfathomably random, fractured singularities of the world, and Naitō by his photographic production of an immanent otherworldliness found on the margins of bourgeois urban culture. Naitō achieves his effects by use of uncensored flash, producing surrounds of blackness in his prints and leading one critic to describe his photographic cosmos as located in the "interior of darkness" (*yami no oku*, which could also be rendered as "heart of darkness").[23] His careful scholarship and devotion to folklore studies are evident in his photobook homage to Yanagita, *Tōno monogatari: Naitō Masatoshi shashinshū* (Tales of Tōno: The Photographs of Masatoshi Naitō), which—unlike the rhythms of chance embodied in Moriyama's street photography—orchestrates an ordered sequence of blackened photographs that paradoxically illuminate the "other world" of Yanagita's *Tales* (fig. 29).[24]

The publication of Naitō's work in the 1980s marked a certain culmination in the depiction of Tōhoku, a photographic genealogy reaching back to an earlier documentary tradition before the widespread use of digital cameras. Many others have photographed the Northeast since then, but two celebrated contemporary artists could be said to epitomize the last generation devoted to photographing Tōhoku before 3/11. Tatsuki Masaru's photobook *Tōhoku*, published soon after the tsunami, presents images worlds apart from the ethereal prints of Kojima, the deep blackness of Naitō's work, or the *are bure boke* shots of Moriyama. Tatsuki's photographs are outrageously technicolored spectacles of Tōhoku life, ranging from depictions of Mount Osore's blind mediums (again) to fishermen to masked festivals to deer hunting. Indeed, the bloody realities of hunting, the place of animals—dogs, deer, bear, horses, snakes—and their bones, antlers, and fur repurposed for ritual use make for the most piercing images in the collection. Red is the color that remains in memory: Tōhoku, red in tooth and claw, larger than

Figure 29. Masatoshi Naitō, *Ritual at Rokkōshi Shrine, Tōnoshi, Aozasa*, 1975

life, as far from black and white as can be imagined in these chromogenic prints (fig. 30). Although there is a shot of the unearthly perfection of Aomori apple orchards in still repose, not one image in the collection shows active agricultural labor, the work of settled village folk that made up the biggest part of Tōhoku photographs in the earlier postwar period. Tatsuki instead goes to the mountains and the sea, to worlds before and outside the rise of agriculture over two thousand years ago, to evoke the shamanic lineage of the Japan that Tarō Okamoto imagined, that of Jōmon hunters and gatherers.[25]

The everyday unconscious and unseen life on the margins, death and the body, a Tōhoku village on the Pacific coast, the ocean and its beaches, the earth and trees, the enigma of photography itself (perhaps above all)—these are recurring motifs in the extravagant work of Lieko Shiga. In her *Rasen kaigan (Spiral Shore)*, the

legacy of several years of living in a small community in the region, she offers uncannily dark and deeply premeditated photographs of the people and the land—images often cross-processed, double-exposed, scarred with bursts of light, awash in unlikely fluorescent colors, and always penumbral.[26] At times, they recall the abyssal blackness of Naitō's photography of Tōhoku, with their nocturnal obsessions and use of flash, particularly in the bleached-out illumination of faces and objects eerily floating up from the dark.[27] Here, the elderly natives of the coastal village of Kitakama are photographed performing (and performing they are) strange, theatricalized activities, night labors, and collective rites. We see them sweeping the sand with branches, inscribing patterns not unlike crop circles on the beach, digging what could be graves (are they?), funereally carrying a long white shroud, dragging what look like body bags out of the ocean (fig. 31). In the hindsight of 3/11, these photographs appear as elaborately synchronized stagings of preemptive mourning work. This is a folkloric home, a *furusato*, an uncanny one, full of nocturnal, repetitive labors that seem to

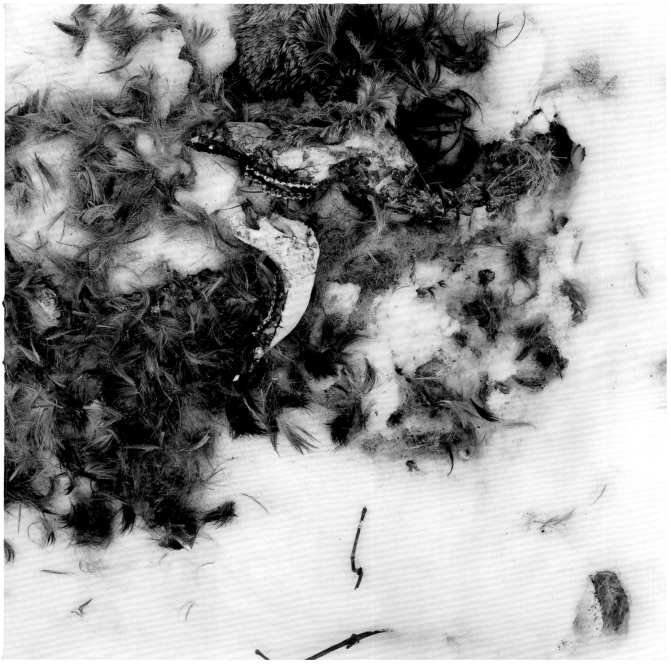

Figure 30. Masaru Tatsuki, *Deer Bones, Kamaishi, Iwate Prefecture*, from the series *Tōhoku*, 2009

mimic the old agricultural rhythms. *Rasen kaigan* has multiple photographs of stones, painted white, as if they were faces or mirrors; they recall the centrality of stones—markers, memorials, Buddhist stupas, magical tokens—in the folklore of Tōhoku. The elaborate spiraling exhibition of this work in the city of Sendai in 2012—immense photographs mounted on a forest of easels, backlit by the natural light streaming through the glass-enclosed gallery space of the Sendai Mediatheque—seemed to function, one and a half years after the disaster, as an encircling array of memorial markers for the dead, doubling the memorial function of the photograph itself in its capture of a reality long departed, now ghostly.[28]

After Tatsuki and Shiga, the photography of Tōhoku—indeed, Japanese photography in general—has irrevocably moved into a long-term engagement with catastrophe's aftermath. The destruction of the coastal settlements, the ruins of the Fukushima Daiichi nuclear power plant and its ominous, evacuated exclusion zone, the unseen powers of radiation, and the disrupted lives of people lodged in interminably temporary housing: these are the defining

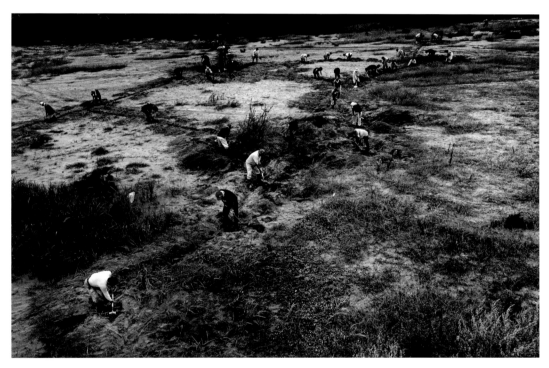

Figure 31. Lieko Shiga, *Rasen kaigan (Spiral Shore) 47*, 2008

images of Tōhoku that photographers struggle to capture today. The disasters have made more evident than ever the enduring powers of vernacular photography, cell-phone pictures, and family photo albums; indeed, the recovery of family photographs took on a memorial function sometimes second in importance only to the recovery of the dead themselves.[29] Tōhoku is now another name for historical catastrophe, although superseded for many by that of Fukushima, which—taking its place alongside Hiroshima and Chernobyl—may end up being promoted first and foremost as a destination for a morbid "dark tourism."[30]

Yet one more Tōhoku photographer, Naoya Hatakeyama, brings the story of photography before the flood to a coda. Hatakeyama, who lost his mother in the tsunami, was not a photographer of Tōhoku, or even a photographer of Japan as such. Instead, his work focused on extraordinary scenes of human intervention into the fabric of nature, extending the reach of the camera into landscapes

that dwarf the human presence and appear to be the result of gargantuan forces unbound. His series *Ciel tombé* (Fallen Sky), for example, looks at underground quarries and their fallen ceilings in France, resembling nothing so much as the cliff dwellings of the Anasazi, with suffused light seeming to radiate down to illuminate the red stone underneath. His celebrated *Blast* series is devoted to the violent poetics of open-air explosions, improbably punctuated with the aesthetic surplus of dust plumes, constellations of airborne rocks, and starbursts of debris. Hatakeyama's work has been engaged with the catastrophe of modern technologies, of gigantic transformations of the earth, scenarios where the human presence is sharply attenuated. His thought and practice are explicitly drawn to the limits of representation, to the enduring problematic of the sublime and photography's capacity to approach it.

After the catastrophe, Hatakeyama photographed the destruction in Rikuzentakata, producing uncompromisingly stark yet strangely serene images.[31] But alongside those photographs he has also shown a collection of personal "commemorative photographs" (*kinen shashin*) that he took as early as 2000. As he says about these photographs in an afterword to the photobook *Kesengawa* (Kesen River), written after the tsunami: "Because I had been traveling so globally, maybe I began to see my hometown in a new light, as a 'corner of the world.' Or maybe it was because I had really begun to feel my age, within the entire life of a place that I had believed was continuous, unchanging. Sometimes I would print out these photographs in the darkroom, affixing them to the wall, gazing at them absentmindedly, not particularly pointing them out to anyone. I put them away in a box I had labeled 'un petit coin du monde' [a little corner of the world]. These photographs weren't ones taken as 'aids to memory,' but I thought they were wonderful as 'aids to imagination,' as clues for reflecting on my life and times."[32] He says that after 3/11 he came to understand for the first time the naïve desire to capture a vanished moment through the medium of the photograph: "Not considering the photograph '*as* a photograph,' but *from* a photograph, I wanted to confirm what was over there, what kind of face that person had, the sky of that moment, the color of the water.... For human beings, isn't this confirmation the paramount reason for taking photographs, when we really think about it? Like my mother, facing the Kesen River and its reflection of the evening sky, preparing to use her little camera" (fig. 32).[33]

Here are tranquil, resolutely undramatic scenes of local life, tenderly and hesitatingly taken from a box labeled "un petit coin du monde" to affirm the power of photographs that were nothing but personal. Only perhaps in the wake of a catastrophe on the order of 3/11 could the intimate non-sublimity of Hatakeyama's photographs of his little corner of the world in Tōhoku become the occasion for rethinking the future of photography and its capacity for bearing witness to life and death at the end of the line.

Figure 32. Naoya Hatakeyama, *2003.08.23, Kesen-chō*, 2003, illustrated in *Kesengawa*, 2012

Notes

1 The prefectures are Fukushima, Miyagi, Yamagata, Iwate, Akita, and Aomori.

2 See Nathan E. Hopson, "Tōhoku as Postwar Thought: Regionalism, Nationalism and Culturalism in Japan's Northeast" (PhD diss., University of Pennsylvania, 2012), and Mark Hudson, *Ruins of Identity: Ethnogenesis in the Japanese Islands* (Honolulu: University of Hawaii Press, 1999), for careful analyses of the ongoing debates about the early history of Tōhoku.

3 Hopson states that the renaming of the national railways' Ōshū Line as the Tōhoku Line "was the critical turning point in nationwide public recognition of the new name for the Northeast." Hopson, "Tōhoku as Postwar Thought," 4.

4 Ibid., 3. These designations did not necessarily correspond seamlessly with the six prefectures that comprise Tōhoku today, and they were used with some variation. For example, Ōu often designated a larger area of today's Tōhoku than Ōshū or Michinoku did.

5 Four widely available translations are: *The Narrow Road to the Deep North and Other Travel Sketches*, trans. with an introduction by Nobuyuki Yuasa (London: Penguin Books, 1966); *Narrow Road to the Interior and Other Writings*, trans. Sam Hamill (Boston: Shambhala, 2000); *Bashō's Narrow Road: Spring and Autumn Passages*, trans. with annotations by Hiroaki Sato (Berkeley: Stone Bridge Press, 1996); and *The Narrow Road to Oku*, trans. Donald Keene (Tokyo: Kodansha International, 1996).

6 See "Recalling the Dead on Japan's Mt. Osore," in Ivy, *Discourses of the Vanishing: Modernity, Phantasm, Japan* (Chicago: The University of Chicago Press, 1995), for a description of the blind female mediums (*itako*) at Mount Osore. For an analysis of the practices and lives of spirit mediums, see Ellen Schattschneider, *Immortal Wishes: Labor and Transcendence on a Japanese Sacred Mountain* (Durham: Duke University Press, 2003).

7 "Sacrifice zones" refers most generally to economically disadvantaged places that become the sites of waste facilities, dumps, radiation processing plants, military bases, and nuclear reactors in order to service wealthier areas. The critic Tetsuya Takahashi has theorized postwar economic growth in Japan as predicated on a "sacrificial system" (*gisei no shisutemu*), in which Fukushima in the north and Okinawa in the south operate as the most egregious examples of exploited zones. Tetsuya Takahashi, *Gisei no shisutemu: Fukushima, Okinawa* (The Sacrificial System: Fukushima, Okinawa) (Tokyo: Shūeisha, 2012). Following the analyses of many Japanese historians, Nathan Hopson explores the designation of Tōhoku as Japan's "internal colony" in his "Systems of Irresponsibility and Japan's Internal Colony," *The Asia Pacific Journal* 11, no. 52, 2 (Dec. 31, 2013), http://www.japanfocus.org/-Nathan-Hopson/4053.

8 Kim Brandt, in *Kingdom of Beauty: Mingei and the Politics of Folk Art in Imperial Japan* (Durham: Duke University Press, 2007), cogently unfolds the history of the discovery of "folk arts" (*mingei*) in the prewar period, in which Tōhoku became the object of state-sponsored attempts at rural uplift and reformation through government support of local arts and crafts. These attempts were part of a larger political strategy of promoting national unity by pointing to the unbroken artistic traditions of the Japanese "folk" (a strategy not unlike the appropriation of the "folk" for nationalist ends in Europe during the same period).

9 *Tōno monogatari* has been translated into English as *The Legends of Tono* by Ronald A. Morse, with an introduction by Richard M. Dorson (Tokyo: Japan Foundation, 1975).

10 See Ivy, "Tradition and Difference in the Japanese Mass Media," *Public Culture* 1, no. 1 (1988): 21–29, for a discussion of the "Discover Japan" campaign in the 1970s and its sequel, "Exotic Japan."

11 I do not claim that my selection of photographers of Tōhoku is exhaustive. For a focused overview of Tōhoku photographers, including some not considered in this essay, please consult Kōtarō Iizawa, *Tohoku through the Eyes of Japanese Photographers* (Tokyo: The Japan Foundation, 2012).

12 A major retrospective exhibition of Kojima's work at the Aomori Prefectural Museum of Art in 2009 helped resituate him in the pantheon of important postwar photographers and, in particular, photographers of Tōhoku; this exhibition was followed in August 2011 (shortly after the disaster) by a solo gallery show at Taka

Ishii Gallery in Tokyo. Accompanying the Aomori exhibition was the publication of *Kojima Ichirō shashin shūsei* (The Photographs of Ichirō Kojima), edited by the Aomori Prefectural Museum of Art (Tokyo: Inscript, 2009).

13 See Julia Adeney Thomas's acute examination of the "realism" debates in photography in the late 1940s and early 1950s in "Power Made Visible: Photography and Postwar Japan's Elusive Reality," *Journal of Asian Studies* 67, no. 2 (May 2008): 365–94. She argues that at the very core of these debates in the unsettled aftermath of the war lay the question of power and how it was to be photographically revealed. In her analysis, the realism debates were thus not centrally about documentation as such.

14 The "snow country" Hamaya photographed is primarily the prefecture of Niigata which, while in the north, is not formally part of Tōhoku as it is constituted in the modern period. In his photobook *Ura Nihon*, published the year after *Snow Country*, sites in Tōhoku's Akita Prefecture were highlighted along with other areas farther south. Hiroshi Hamaya, *Ura Nihon* (Japan's Back Coast) (Tokyo: Shinchōsha, 1957).

15 Jonathan M. Reynolds has written in detail about Hamaya's *Snow Country* portfolio and the ethnographic sensibility that he brought to this project. See "Hiroshi Hamaya's Snow Country: A Return to 'Japan,'" in *Japan's Modern Divide: The Photographs of Hiroshi Hamaya and Kansuke Yamamoto*, ed. Judith Keller and Amanda Maddox (Los Angeles: J. Paul Getty Museum, 2013), 17–29.

16 See Yoshiaki Kai, "*Sunappu*: A Genre of Japanese Photography, 1930–1980," (PhD diss., City University of New York, 2012).

17 For Kimura's Tōhoku photography, see *Kimura Ihei no Akita* (Ihei Kimura's Akita), ed. Takeyoshi Tanuma (Tokyo: Asahi Shinbun Shuppan, 2011).

18 For example, the eminent photography critic Kōtarō Iizawa's introductory essay in the catalogue for the touring exhibition *Tōhoku through the Eyes of Japanese Photographers* is entitled "Recovery of the Jōmon: Introducing *Tōhoku through the Eyes of Japanese Photographers*." Iizawa asserts that there is a particular kind of mystical, synthetic thinking that he terms "Jōmon thinking," a relationship to the world that still has particular force in Tōhoku, with its history of oppression and marginalization.

19 The archaeologist Junko Habu states that the Jōmon people inhabited Japan as long as 14,500 years ago. See her *Ancient Jomon of Japan* (Cambridge: Cambridge University Press, 2004), 3.

20 The photographs were published in Japan as a limited-edition photobook in 1969. In 2009 the Aperture Foundation published a new English-language edition redesigned by Ikko Tanaka (the original book designer), which included four previously unpublished images and an introduction by Shūzō Takiguchi, preface by Donald Keene, poem by Toyoichirō Miyoshi, and afterword by Eikoh Hosoe: *Kamaitachi* (New York: Aperture Foundation, 2009).

21 Daidō Moriyama, *Tōno monogatari* (Tokyo: Asahi Sonorama, 1976), was reissued in a trade edition (Tokyo: Kōbunsha bunkō, 2007). There is also an English translation: *Tales of Tōno*, trans. Lena Fritsch, afterword by Simon Baker (London: Tate, 2012).

22 In the late 1960s, Masatoshi Naitō began to shoot a series of photographs of blind female spirit mediums and "grannies" (*baba*) who were religious practitioners. This series culminated in his photobook *Baba: Tōhoku no minkanshinkō* (Grannies: The Folk Religion of Tōhoku) (Tokyo: Asahi Sonorama, 1979). His photographs of Tōno were collected in *Tōno monogatari: Naitō Masatoshi shashinshū* (Tales of Tōno: The Collected Photographs of Masatoshi Naitō) (Tokyo: Shunseisha, 1983).

23 Kōtarō Iizawa, "Yami no oku e—Naitō Masatoshi no shashin uchū" (Toward the Interior of the Dark—Masatoshi Naitō's Photographic Cosmos), in *Naitō Masatoshi*, Nihon no shashinka 38 (Tokyo: Iwanami shoten, 1998), 3.

24 For an extended discussion of Masatoshi Naitō's photographic techniques—particularly his use of the flash—and his folklorist's vision of Tōno, see Ivy, "Dark Enlightenment: Naitō Masatoshi's Flash," in *Photographies East: The Camera and Its Histories in East and Southeast Asia*, ed. Rosalind Morris (Durham: Duke University Press, 2010), 229–57. Naitō draws close to Tarō Okamoto in sensibility; it is no accident that Naitō was chosen to print Okamoto's negatives for a posthumous collection of his photographs whose title translates as *Mystery*. Masatoshi Naitō and Toshiko Okamoto, *Okamoto Tarō: Shinpi* (Tarō Okamoto: Mystery), with text and photographs by Tarō Okamoto and prints by Masatoshi Naitō (Tokyo: Nigensha, 2004).

25 Norio Akasaka, "'You, What Do You Think You Know about Me?' Mutters a Voice," in Masaru Tatsuki, *Tōhoku* (Tokyo: Little More, 2011).

26 See Lieko Shiga, *Canary* (Tokyo: Akaakasha, 2008), and *Lilly* (Tokyo: Artbeat Publishers, 2007).

27 The photography critic Marcus Bohr has also noted this implicit evocation of Naitō's Tōhoku work in his essay "Dreamscapes: The Fantastical Photographs of Lieko Shiga," in the "Out There" section of *Time*'s online photography site "Light Box," May 7, 2013; http://lightbox.time.com/2013/05/07/dreamscapes-the-fantastical-photographs-of-lieko-shiga/#1.

28 The art critic Minoru Shimizu initiated a vigorous debate about the production of fantasy effects in Shiga's photographs, likening them to "B-grade horror" techniques. This assessment was countered by the critic Aki Kusumoto, who drew attention to Shiga's nuanced evocation of the "spirit photographs" of photography's formative decades. Shimizu's critiques were published in his ongoing column "Critical Fieldwork: Observations on Contemporary Art in Japan," *Art It*, at http://www.art-it.asia; Kusumoto's review of the exhibition *Rasen kaigan* was published on her blog, February 18, 2013, http://curatory.exblog.jp.

29 The anthropologist David Slater is working on photograph recovery and the significance of family photograph albums in the economy of mourning after 3/11: "The Work of the Visual in Mourning the Dead in Post-Tsunami Japan," public presentation at the conference "Reframing 3.11: Cinema, Literature, and Media after Fukushima," University of California, Berkeley, April 6, 2014.

30 The contemporary critic Hiroki Azuma has written widely about the possibilities of "dark tourism" to Fukushima. Drawing on the legacies of Chernobyl, Azuma theorizes ways to ensure that the lessons of Fukushima are not forgotten, while developing tourism as a viable source of income for the areas around the reactor zone. See, for example, two special issues of the journal *Shisō chizu* (which Azuma edits): *Cherunobuiri dāku tsūrizumu gaido* (Chernobyl Dark Tourism Guide), *Shisō chizu* 4, no. 1 (July 2013), and *Fukushima daiichi genpatsu kankōchika keikaku* (Tourizing Fukushima: The Fukuichi Kankō Project), *Shisō chizu* 4, no. 2 (November 2013).

31 Hatakeyama's major solo exhibition *Natural Stories* ran from October 1 to December 4, 2011, at the Tokyo Metropolitan Museum of Photography. See *Naoya Hatakeyama: Natural Stories* (Tokyo: Sankei shinbun, 2011).

32 Naoya Hatakeyama, *Kesengawa* (Tokyo: Kawade shobō, 2012), "Atogaki ni kaete" (By Way of Postface). Translation mine.

33 Ibid., translation mine.

Artist Biographies

Tomoko Nagakura

新井卓 **Takashi Arai**
Born in 1978

Takashi Arai first encountered photography while he was a university student of biology. In an effort to trace photography to its origins, he encountered the daguerreotype, and after much trial and error mastered the complex technique. Arai does not see daguerreotype as a nostalgic reproduction of a classical method; instead, he has made it his own personal medium, finding it a reliable device for storing memory that is far better for recording and transmitting interactions with his subjects than modern photography. Beginning in 2010, when he first became interested in nuclear issues, Arai has used the daguerreotype technique to create individual records—micro-monuments—of his encounters with surviving crew members, and the salvaged hull, of the fallout-contaminated *Daigo Fukuryūmaru* fishing boat, records that touch upon the fragmented reality of events in the past. This project led him to photograph the deeply interconnected subjects of Fukushima, Hiroshima, and Nagasaki. Arai's work has appeared in numerous exhibitions, at the Mori Art Museum and the National Museum of Modern Art, Tokyo, among other Japanese venues, as well as abroad. In 2014, he received the Source-Cord Prize, sponsored by a contemporary photography magazine in England. His works are held in the collections of the San Francisco Museum of Modern Art, Tokyo Metropolitan Museum of Photography, and Musée Adrien Mentienne, in France, among others.

荒木経惟 **Nobuyoshi Araki**
Born in 1940

Nobuyoshi Araki is known worldwide for photographs that bring a touch of pathos to themes of eros and thanatos (sex and death), through subjects such as the female body, as well as flowers, food, human faces, his housecat, and street scenes in his native Tokyo. The artist calls his work *shi-shasin* ("I" photographs), in a play on the autobiographical Japanese literary genre *shi-shōsetsu* ("I" novel). He records his daily life, revealing even private aspects of it such as love and sex. Among the most celebrated examples are the self-published photobooks *Sentimental Journey* (1971), a record of his honeymoon with his beloved wife, Yoko, and *Sentimental Journey/ Winter Journey* (1991), which combines selections from the first book with images of her final days. Araki studied film and photography at Chiba University and then worked at an advertising agency from 1963 until 1972. *Satchin*, photographs of children in his neighborhood, received the prestigious Taiyō Award in 1964, launching his career. Araki's important solo exhibitions include the retrospective *Ōjō shashū: Photography for the Afterlife—Faces, Skyscapes, Roads*, Toyota Municipal Museum of Art (2014); *Nobuyoshi Araki: Self, Life, Death*, Barbican Art Gallery, London (2005); and *Suicide in Tokyo*, at the Italian Pavilion of the Venice Biennale (2002). He is also known for his more than four hundred published photobooks.

潘逸舟 **Ishu Han**
Born in 1987

Born in Shanghai, China, Han moved to Aomori Prefecture, in northern Japan, with his family when he was nine years old. After graduating from a high school for the arts, he moved to Tokyo to pursue a master's degree at the highly selective Tokyo University of the Arts. He works mainly in video, photography, and performance,

exploring the primary theme of his double identity as both Chinese and Japanese. Following his proposition that "maybe one can find a new identity from a different landscape," Han has found opportunities to broaden his expressive range and further investigate the idea of identity through experiences in artist-in-residence programs outside Japan. The photography-based work titled *Australia*, created while he was in residence at the Victoria College of Arts, employs multiple gray-shaded images of the Australian five-cent coin—which bears Queen Elizabeth's face—to make a composite representation of the country's iconic eucalyptus forest landscape, revealing the hidden social and economic power structure of this former colony. This concept forms the basis of Han's subsequent work on 3/11, *Life Scan Fukushima*, using a Japanese coin image in the same manner. He assumes an artist residency in New York in 2015, sponsored by the Asian Cultural Council.

畠山直哉 **Naoya Hatakeyama** PAGES 47–61, 172, 173, 192
Born in 1958

Naoya Hatakeyama was born in Rikuzentakata, in Iwate Prefecture. He completed graduate studies in 1984 at Tsukuba University, where he studied with Kiyoji Ōtsuji, a well-known surrealist photographer. Since then, he has been based in Tokyo; exploring the contrast between that city and his native Tōhoku region, he has developed a body of work concerned largely with the cyclical relationship between nature and urban development. His austerely detached images, created through a conceptual approach to subjects such as quarries, mines, and factories in series including *Limeworks* (1996) and *Underground* (2000), gained Hatakeyama an international reputation. Among his numerous solo and group shows are the retrospective *Natural Stories* at the Tokyo Metropolitan Museum of Photography (2011) and the San Francisco Museum of Modern Art (2012); and a collaborative project with the architect Toyoo Itō at the Japanese Pavilion of the Venice Architecture Biennale in 2012, which captured the transformation of his hometown in the wake of 3/11. Hatakeyama's photographs are in collections including the National Museum of Modern Art, Tokyo; Tokyo Metropolitan Museum of Photography; International Center for Photography, New York; J. Paul Getty Museum, Los Angeles; La Maison Européenne de la Photographie, Paris; and the Tate Gallery, London.

ホンマタカシ **Takashi Homma** PAGES 95–99
Born in 1962

By choosing to spell his artist's name in the phonetic *katakana* system (used mainly for foreign words), rather than in the symbolic and traditional Chinese-character *kanji*, Homma conveys his defiant stance toward a sense of belonging, historically or geographically. In his photographs he expresses his free spirit and his frustration with traditional values, typified by the early series *Tokyo Suburbia* (1998). Homma received a prestigious Kimura Ihei Memorial Photography Award for emerging artists for this body of work, in which he presented the new mode of life in a suburban area of Tokyo in the 1990s where he himself had lived as a young adolescent. Its airy images of a rootless existence based on urban consumption, which could be found in any suburb in the world, were received by many viewers, both nationally and internationally, as reflecting their own reality. Homma began his professional career as a

photographer of advertising in Tokyo in the mid-1980s. After two years in the early 1990s in London, where he contributed to youth culture magazines such as *i-D*, he returned to Tokyo. He is prolific not only in photography but also in writings on photography theory and in organizing workshops and teaching at schools including Tokyo Zōkei University. A solo exhibition in 2011 that introduced Homma's theory of "New Documentary," summing up his work to that point, was shown at the Opera City Gallery in Tokyo and the 21st Century Museum of Contemporary Art, in Kanazawa.

川田喜久治 **Kikuji Kawada** PAGES 129–35, 159, 161
Born in 1933

Kawada was a member of the photography club while a student at Rikkyō University, in the Department of Economics. After graduation he took a position in 1955 as staff photographer for Shinchōsha Publishing Company, where he remained for four years. In 1959 he joined his contemporaries Eikoh Hosoe, Shōmei Tōmatsu, and others to found the independent photography agency Vivo. Opposing the mainstream realist photography movement of the time, they pursued a more subjective form of expression. Kawada's *Chizu* (The Map), released in 1965, captured the memory of wartime insanity from an incisive new perspective and secured his status as a photographer. Among other major projects are *The Last Cosmology* (1980–97), which combines various aspects or phases of celestial bodies with the end of the Shōwa era, and *Car Maniac* (1996–98), a collection of images of the urban landscape as seen from the driver's seat of the artist's own car. Over the course of more than sixty years, the artist has continued to reveal the moments of catastrophe and chaos in the everyday and present the absurdity of this world, while actively adopting digital technology.

川内倫子 **Rinko Kawauchi** PAGES 41–45
Born in 1972

Rinko Kawauchi became known in the wake of the "girly photo boom" of the mid-1990s. This fresh and provocative movement was led by women photographers in their twenties who brought a new approach and new subjects to the traditionally male-dominated photography milieu in Japan. Kawauchi has been recognized since the beginning of her career for her keen sensibility to the ephemeral nature of birth and death incarnate in everyday life. She captures this transience in both still photography and video, in softly colored images of microcosms, people, and landscapes. In the 2012 project *Ametsuchi* (whose title, meaning "Heaven and Earth," is taken from an ancient Japanese poem), she broke new ground in conveying a strong sense of cyclical life and connectivity in settings beyond her territory of the everyday—associating seemingly unrelated scenes of land, spiritual moments such as the traditional seasonal rituals of open incineration on the Aso plain of Kyushu, the Western Wall in Jerusalem, and the constellations in planetariums. Following her solo show at the Tokyo Metropolitan Photography Museum in 2012, this work went on to be shown internationally. Rinko Kawauchi first gained worldwide recognition with the Infinity Award in Art from the International Center of Photography in New York (2009) and with numerous solo shows at institutions including Fondation Cartier in Paris (2005) and the São Paulo Museum of Modern Art, Brazil (2007).

北島敬三　　　**Keizō Kitajima**　　　PAGES 35–39

Born in 1954

A leading figure in the rise of Japanese photography in the 1970s and 1980s, Kitajima first came to be known for his grainy black-and-white shots of people on the streets of Tokyo, at an American military base in Okinawa after the end of the Vietnam War, and in New York. Daidō Moriyama, with whom Kitajima first studied photography, praised his talent as a gifted snapshooter by calling him "a street killer in broad daylight." Kitajima's Image Shop CAMP, set up in the bustling Shinjuku area in 1976 in collaboration with Moriyama, was a pioneering experimental space for photographers before the gallery system was established. In his legendary experimental series *Photo Express* (1979), Kitajima photographed people at bars and on the streets in Shinjuku at night right outside the CAMP, converted the gallery into a darkroom to make wall-sized prints as a public performance event, and even published the images as an instant booklet. Through these processes of delivering images immediately, the artist explored the ways that time affects photography in terms of documentation, record, and memory. Later in his career, the street snapshots bifurcated into portraits and landscapes—subjects became independent of their background (his *Portraits* series), and the background developed into its own unpopulated landscape (his *Place* series). The *Untitled Record* series that Kitajima launched after 3/11 can be seen as a culmination of the *Place* series and of his extended investigation into time and documentation in photography.

三好耕三　　　**Kōzō Miyoshi**　　　PAGES 27–33

Born in 1947

Kōzō Miyoshi is recognized for his meticulous monochrome prints capturing landscapes, people, and objects, taken with large-format cameras (up to 16 x 20 inches). Since his time as a photography student at Nihon University in Tokyo, his work has always involved travel, with his camera as his passport: on a long road trip in the Tōhoku area, or even on a day trip to a familiar place within his native Tokyo, he photographs as an outsider. Beginning with his first trip to the United States in 1972, Miyoshi has found inspiration in the comparatively young American nation. Following a residency at the Center for Creative Photography in Tucson, Arizona, in 1991, he remained in the United States for six years. On road trips across America, he produced many series capturing the landscape, including *South West* (1994), *Cacti* (1995), and *In the Road* (1997). His works have been collected by institutions around the world, including the Museum of Fine Arts, Houston; the Princeton University Art Museum; and the Queensland Art Gallery, in Brisbane, Australia.

瀬戸正人　　　**Masato Seto**　　　PAGES 83–87

Born in 1953

Seto was born to a Japanese father and a Thai-Vietnamese mother in Udon Thani, a Thai town near that country's border with Laos, where his father had established a local photography studio after serving as a Japanese soldier in Laos during World War II. In 1961, when Seto was eight years old, the family returned to his father's hometown in Fukushima Prefecture, where his father continued in the photography business. Although he had grown up with photography, Seto's eyes were opened to its possibilities during

studies with Daidō Moriyama in Tokyo. His *Bangkok, Hanoi 1982–1987* (1989), which captured Vietnamese and Thai street life during trips to his birthplace, received the Rookie of the Year Award from the Photographic Society of Japan. Subsequent works include the *Heya–Living Room Tokyo* series (1996), portraits of Tokyo residents of various nationalities posing in their homes; and the *Binran* series (2008), portraits of women confined in small glass-walled stands selling *binran* (betel nuts) in the nightlife districts of Taiwan. The artist's interest in people and their spaces brings to traditional portraiture issues of identity, dislocation, memory, and Asian history, rooted in his personal history of finding himself in Thailand, Vietnam, and Japan. Seto's autobiography, titled *Tooi and Masato* (1998), was awarded the Arts and Sciences Prize of the Shinchōsha Publishing Company and has been followed by the publication of novels and critical essays.

志賀理恵子 **Lieko Shiga**
Born in 1980

PAGES 8–9, 63–77, 152, 191

First intrigued by photography as a high school student in Okazaki City, in Aichi Prefecture, Shiga went on to study at the Chelsea College of Arts in London. After graduating in 2004, she began working as an artist and in 2007 returned to London for a year with a program sponsored by Japan's Agency for Cultural Affairs. The resulting series, *Lily*, featured residents of her London neighborhood; upon her return to Japan, a commission from the Sendai Mediatheque featuring residents of cities including Sendai and Brisbane produced the experimental fieldwork-based series *Canary*. The two series garnered Shiga the Kimura Ihei Memorial Photography Award in 2008, and the following year, she received an Infinity Award from the International Center of Photography, New York. Few of these photographs are straightforward depictions of their subjects, but rather they unfold in a mesmerizing, phantasmal jumble of real and imaginary worlds. Beginning in 2008, Shiga spent four years as a resident photographer in the community of Kitakama, in Miyagi Prefecture. The time she spent deepening her connections to this community through photography, and the images that she collaborated with its residents to create, culminated in the series *Rasen kaigan (Spiral Shore)*, which premiered in 2012 at the Sendai Mediatheque to great critical acclaim.

武田慎平 **Shimpei Takeda**
Born in 1982

PAGES 89–93, 174, 175

Shimpei Takeda was born in Fukushima, his parents' hometown, and raised in Chiba. After moving to New York City in 2002, Takeda collaborated with composers and sound artists on video works. His more recent work uses camera-less photographic techniques to capture interactions of materials and electromagnetic waves outside the visible light spectrum, as in the series *Trace* that exposes film to radioactive soil. Takeda has also experimented with other materials, using the same minimal camera-less technique, to explore abstract aesthetics in conceptual photography. In 2014 he relocated to Japan, where he continues to pursue his projects. His works have been featured in exhibitions such as *A Different Kind of Order: The ICP Triennial*, International Center of Photography, New York (2013), and *Survive: The Towada Oirase Art Festival*, Towada Art Center, Aomori Prefecture (2013).

田附勝 **Masaru Tatsuki** PAGES 101–5, 190
Born in 1974

Masaru Tatsuki has been traveling to the Tōhoku area since 2006. Encountering the powerful and raw lifestyle of the people of the region, he captured their coexistence with nature and their awe of its force in projects that include *Tōhoku* (2011), which received the Kimura Ihei Memorial Photography Award. Tatsuki responded to 3/11 by focusing on the long tradition of deer hunting, in *Is the Blood Still Red?* (2011) and *Kuragari* (2013). *Never Again.* (2014) documented its demise, caused by radiation contamination. Tatsuki entered the film industry when he was eighteen, and then set out on his own with his first project, *Decotora* (2007), photographs of highly decorated long-distance trucks taken between 1998 and 2006. His travels with the drivers, many of whom were from the Tōhoku region, led him to begin visiting the area.

横田大輔 **Daisuke Yokota** PAGES 139–45
Born in 1983

Yokota came to be known in Japan after receiving awards in popular photography competitions organized by companies such as Canon, Epson, and the advertising and publishing conglomerate Recruit. In 2014 he made his debut in Europe with the solo show *Daisuke Yokota: Site/Cloud* at the Foam Photography Museum in Amsterdam, as one of the winners of the 2013 Foam Talent Call. Yokota's image making involves manipulating the original color images both manually and digitally by rephotographing, photocopying, layering, using Photoshop, and other processes. The resulting seemingly smooth surface of his photographic images, in subtle monotone with a hint of color, evokes a distant time that seems to have congealed beneath it in layers and that rises up as dreams and memories. Besides making prints, Yokota explores different forms of photography such as staging performance events where he gives live demonstrations of his image production, or creating self-produced limited-edition photobooks, made with simple reproduction techniques like photocopiers and inkjet printers.

米田知子 **Tomoko Yoneda** PAGES 121–27, 154
Born in 1965

Tomoko Yoneda was introduced to photography as a student in the United States. She went on to study photography at the University of Illinois, Chicago, and at the Royal College of Art, London, where she received her MA in 1991. Since then she has been based in London. Her interest in journalism is evident in her consistent themes of history and memory. Yoneda photographs sites of historical events, often wars and conflicts, to capture them in the present; for instance, an image of a quiet field bears the title *Path to the Cliff Where Japanese Committed Suicide after the American Landings of World War II, Saipan*. The artist's work challenges viewers about what we do and don't see, or what we pretend not to see—history and memory. Yoneda's first subjects were in Europe, but later she explored the modern history of Japan in Asian countries such as Taiwan and Korea. The series *Cumulus* connects this history with post-3/11 Japan. Yoneda's solo show toured the country in 2013–14, following its opening at the Tokyo Metropolitan Museum of Photography. She has also participated in numerous international exhibitions, including the Venice Biennale (2007) and the Gwangju Biennale, in South Korea (2014).

List of Illustrations

Plates

Nobuyoshi Araki

1–6

From the series *Shakyō rōjin nikki*
(Diary of a Photo-Mad Old Man), 2011
Gelatin silver prints
Each 101.6 × 152.4 cm (40 × 60 in.)
© Nobuyoshi Araki
Courtesy of Taka Ishii Gallery

Kōzō Miyoshi

7–11

Nos. 1, 3, 4, 10, and 11 from the series
*Northeast Earthquake Disaster Tsunami
2011 Portfolio*, 2011
Gelatin silver prints
Each 50.8 × 61 cm (20 × 24 in.)
© Kōzō Miyoshi

7
*2011:04:02, Minamisanriku, Motoyoshi,
Miyagi Prefecture*
40.6 × 50.8 cm (16 × 20 in.) image

8
*2011:04:03, Nishiminato, Kesennuma,
Miyagi Prefecture*
40.6 × 50.8 cm (16 × 20 in.) image

9
*2011:04:02, Minamisanriku, Motoyoshi,
Miyagi Prefecture*
43.2 × 53.3 cm (17 × 21 in.) image

10
*2011:05:03, Hiyorigaoka, Ishinomaki,
Miyagi Prefecture*
43.2 × 53.3 cm (17 × 21 in.) image

11
*2011:05:05, Higashimae, Kamaishi,
Iwate Prefecture*
40.6 × 50.8 cm (16 × 20 in.) image

Keizō Kitajima

12–15

From the series *Untitled Records*,
2011–12, ongoing
Pigment-based inkjet prints, 2014
Each 90 × 112.5 cm (35 ⅜ × 44 ¼ in.)
© Keizō Kitajima

12
April 25, 2011, Yamada, Iwate Prefecture

13
*October 17, 2011, Ōfunato,
Miyagi Prefecture*

14
*April 19, 2012, Minamisōma, Fukushima
Prefecture*
Museum of Fine Arts, Boston,
Museum purchase with funds donated
by Leslie and Sandra Nanberg

15
*October 11, 2011, Kesennuma,
Miyagi Prefecture*

Rinko Kawauchi

16–35

Digital slide show from the series
Light and Shadow, 2011
© Rinko Kawauchi

Naoya Hatakeyama

36–50

From the series *Rikuzentakata*, 2011–14
(ongoing)
Chromogenic prints
Each 50.8 × 61 cm (20 × 24 in.)
© Naoya Hatakeyama

36
2011.5.2, Takata-chō, 2011

37
2011.6.15, Kesen-chō, 2011

38
2012.2.25, Takata Matsubara, 2012

39
2012.2.25, Takata Matsubara, 2012

40
2012.3.24, Takekoma-chō, 2012

41
2012.3.24, Kesen-chō, 2012

42
2013.3.31, Takata Matsubara, 2013

43
2013.5.11, Kesen-chō, 2013

44
2013.5.12, Takata Matsubara, 2013

45
2013.5.14, Kesen-chō, 2013

46
2013.6.16, Takata-chō, 2013

47
2013.6.16, Takata-chō, 2013

48
2013.9.25, Takata-chō, 2013

49
2013.10.20, Kesen-chō, 2013

50
2014.5.18, Takata Matsubara, 2014

Lieko Shiga

51–62

From the series *Rasen kaigan
(Spiral Shore)*, 2008–13
Chromogenic prints
© Lieko Shiga

51
Rasen kaigan (Spiral Shore) 46, 2011
120 × 180 cm (47 ¼ × 70 ⅞ in.)

52
Meat Is Meat, Fish Is Fish, 2010
180 × 120 cm (70 ⅞ × 47 ¼ in.)

53
Rasen kaigan (Spiral Shore) 28, 2012
120 × 156.3 cm (47 ¼ × 61 ½ in.)

Figures

16. Ryūji Miyamoto
From the series *KOBE 1995 after the
Earthquake*, 1995
Gelatin silver print
50.8 × 61 cm (20 × 24 in.)
© Ryūji Miyamoto

17. Ryūji Miyamoto, photographer;
Osamu Ishiyama and Yoshiaki
Miyamoto, architects
Installation of the Japan Pavilion,
Venice Architecture Biennale, 1996
Photograph © Ryūji Miyamoto

18. Naoya Hatakeyama
2004.7.24, Imaizumi, Kesen-chō, 2004
Illustrated in Naoya Hatakeyama,
Kesengawa (Tokyo: Kawade shōbō,
2012)
© Naoya Hatakeyama

19. Naoya Hatakeyama
2011.4.4, Imaizumi, Kesen-chō, 2011
Illustrated in Toyoo Itō, Kumiko Inui,
Sou Fujimoto, Akihisa Hirata, and
Naoya Hatakeyama, *Architecture.
Possible here? "Home for All"* (Tokyo:
TOTO, 2013)
© Naoya Hatakeyama

20–22
Shimpei Takeda
From the series *Trace*, 2012
© Shimpei Takeda

20. *Trace #7, Nihonmatsu Castle*
Gelatin silver print
50.8 × 61 cm (20 × 24 in.)

21. *Soil Sample at Nihonmatsu Castle*
Pigment-based inkjet print

22. *Nihonmatsu Castle*
Polacolor print
8.5 × 10.8 cm (3 ¼ × 4 ¼ in.)

23. Teisuke Chiba
*Suzume oi (Driving Off Sparrows),
Kitsunezuka, Taiyū Village*, 1943
Gelatin silver print
25.4 × 30.3 cm (10 × 12 in.)
Tokyo Metropolitan Museum of
Photography
© Teiko Chiba

24. Ichirō Kojima
Kizukuri, Tsugaru City, 1958
Gelatin silver print
16.6 × 24.2 cm (6 ½ × 9 ½ in.)
Private collection on deposit at
Aomori Museum of Art
© Hiroko Kojima

25. Ichirō Kojima
Twilight (Jūsan, Goshogawara City),
about 1957
Gelatin silver print
16.1 × 24.6 cm (6 ⅜ × 9 ⅝ in.)
Private collection on deposit at
Aomori Museum of Art
© Hiroko Kojima

26. Tarō Okamoto
Jōmon Ware, 1956
Digital scan from negative film
Collection of Taro Okamoto Museum
of Art, Kawasaki
© Tarō Okamoto Memorial Museum

27. Eikoh Hosoe
Kamaitachi #37, 1965
Gelatin silver print
22.5 × 29.5 cm (8 ⅞ × 11 ⅝ in.)
The Museum of Modern Art, New
York, NY, Gift of the photographer
Image © Eikoh Hosoe, reproduced
with permission of the artist and
Studio Equis
Photograph © The Museum of Modern
Art, Licensed by SCALA, Art Resource,
New York, NY

28. Daidō Moriyama
From the series *Tales of Tōno*, 1974
Gelatin silver print
35.6 × 43.2 cm (14 × 17 in.)
Shimane Art Museum
Illustrated in *Tōno monogatari*
(Tales of Tōno), 1976
© Daidō Moriyama

29. Masatoshi Naitō
Rokkōshi jinja no sairei, Tōnoshi, Aozasa
(Ritual at Rokkōshi Shrine, Tōnoshi,
Aozasa), 1975
Gelatin silver print
40.6 × 50.8 cm (16 × 20 in.)
Tokyo Metropolitan Museum of
Photography
Illustrated in *Tōno monogatari*
(Tales of Tōno), 1983
© Masatoshi Naitō

30. Masaru Tatsuki
Deer Bones, Kamaishi, Iwate Prefecture,
from the series *Tōhoku*, 2009
Chromogenic print
80 × 80 cm (31 ½ × 31 ½ in.)
© Masaru Tatsuki

31. Lieko Shiga
Rasen kaigan (Spiral Shore) 47, from the
series *Rasen kaigan (Spiral Shore)*, 2008
Chromogenic print
© Lieko Shiga

32. Naoya Hatakeyama
2003.08.23, Kesen-chō, 2003
Chromogenic print
27.9 × 35.6 cm (11 × 14 in.)
Illustrated in Naoya Hatakeyama,
Kesengawa (Tokyo: Kawade shobō,
2012)
© Naoya Hatakeyama

Acknowledgments

It has been an extraordinary experience to spend concentrated time with the images that were made by Japanese photographers in response to the traumatic events of March 11, 2011. Numerous individuals during the course of this study have been of invaluable assistance. We appreciate foremost all the artists whose insightful works stimulated us to take on this project. Our sincere thanks for all our conversations, for participating in our project, and for lending their works to the exhibition.

A number of the photographers have dealers who facilitated on their behalf. We thank Alison Bradley; Junko Shimada (Gallery Side 2); Naoko Hatta (G/P Gallery); Yurika Kōno; Nick Haymes (Little Big Man Gallery); Sayaka Takahashi (Photo Gallery International); Nao Amino; Satoko Ōe and Shūgo Satani (ShugoArts); Takayuki Ishii, Yutaka Kikutake, and Elisa Uematsu (Taka Ishii Gallery); and Masako Hosoi, Shino Ozawa, and Tarō Nasu (Taro Nasu Gallery). We also consulted along the way the photographers Tetsugo Hyakutake, Katsumi Ohmori, Q. Sakamaki, Keiko Sasaoka, and Kishin Shinoyama. In addition, we give special thanks to the collectors Leslie and Sandy Nanberg, who aided the Museum in the acquisition of a photograph by Keizō Kitajima. For the beautiful prints in the exhibition, we thank the artists' printers in Japan, and also the staff at Color Services LLC, especially Marc Elliott.

We thank a number of other lenders to our exhibition, including Bryn Geffert and Michael Kelly at the Amherst College Library; Adam Fuss; Yishay Garbasz; Takahiro Kondō (and Joan Mirviss); Yasusuke Ōta; and Munemasa Takahashi (and Annette Booth, Aperture, New York). We also thank Tsunehiko Hatakeyama at Nippon Hōsō Kyōkai (NHK), and we are grateful to Kōdansha Ltd. for making it possible to present in the exhibition the *3/11 Tsunami Photo Project* app.

Many individuals made themselves available for consultation: Akihito Nakanishi (US Embassy in Japan); Masanobu Itō (Japan Foundation); Henry Ng (World Monuments Fund); Fumiko Nakamura (Aichi Prefectural Museum of Art); Shihoko Iida and Hiroko Kikuchi (Aichi Triennial 2013); Taka Kawachi (Amana Holdings, Inc.); Samuel C. Morse (Amherst College); Toshihiro Asai (Art Tower, Mito); Ivan Vartanian (Goliga Books); Theodore and Victoria Bestor (Harvard University); John W. Dower and Nasser Rabbat (Massachusetts Institute of Technology); Florence McKenzie and Michael Hoppen (Michael Hoppen Gallery); Lisa Sutcliffe (Milwaukee Art Museum); Yasufumi Nakamori (Museum of Fine Arts, Houston); Hisako Hara (Osaka Electro-Communication University); Priska Pasquer and Ferdinand Brueggemann (Priska Pasquer Gallery); Sandra Phillips (San Francisco Museum of Modern Art); Keiko Toyoda (Shiseido Gallery); Michiko Kasahara and Yoshiko Suzuki (Tokyo Metropolitan Museum of Photography) and Martha Tepper Takayama. We also thank the collector David Solo; and Sylvan Barnet, editor, collector, and friend.

We thank the Museum of Fine Arts donors who have offered enthusiastic support, in particular Mrs. Estrellita Karsh, who with her husband Yousuf Karsh has been committed to the photography program at the MFA and who offered to underwrite a symposium in relation to our exhibition. We are also very grateful to Rena Koopman for her gracious and generous support of the Museum's Rad Smith Program in Japanese Art. The Museum is grateful to the Art Mentor Foundation Lucerne for its support of the exhibition; additional support was provided by the Ishibashi Foundation, Brian J. Knez, and the Barbara Jane Anderson Fund. Supporting sponsorship was provided by Shiseido Co., Ltd. Generous support for this publication was provided by the Andrew W. Mellon Publications Fund.

We thank our contributors, Marilyn Ivy and Michio Hayashi, for their eloquent and insightful essays in this book, as well as our imaginative book designer, Daphne Geismar. For rights of reproduction, in addition to the artists and their agents, we thank Teiko Chiba, Marc Feustel (Studio Equis), Ayano Hirasawa (Tokyo Metropolitan Museum of Photography), Hiroko Kojima, Risa Murata (Akita Senshu Museum of Art), Masanori Ōkura, Hidenori Sasaki (Tarō Okamoto Museum of Art, Kawasaki), Hashime Seto, Shigemi Takahashi (Aomori Museum of Art), Yoshio Takahashi (Tarō Okamoto Memorial Museum), Yasuko Tōmatsu, Noriko Tsuruya (Shimane Art Museum), and Yumi Ueda (Yokohama Archives of History).

We are grateful to many colleagues at the MFA, especially Malcolm Rogers, Ann and Graham Gund Director, and Katie Getchell, Deputy Director. We are very grateful for the collaboration of our close colleagues in the department of Art of Asia, Oceania, and Africa, and those in Prints, Drawings, and Photographs, with special thanks to James Leighton. We appreciate the efforts of the staffs of Contemporary Art, Design, Education, Exhibitions, Intellectual Property, MFA's William Morris Hunt Library and the School of the Museum of Fine Arts Library, Marketing, Paper Conservation, Publications, Public Relations, and Registration.

Finally, we are inordinately grateful to Tomoko Nagakura, Research Fellow in Japanese Art at the MFA, who has been involved in every aspect of this exhibition and book. This project would not have been possible without her tireless efforts.

Anne Nishimura Morse
William and Helen Pounds Senior Curator of Japanese Art

Anne E. Havinga
Estrellita and Yousuf Karsh Senior Curator of Photographs

Contributors

Anne E. Havinga is Estrellita and Yousuf Karsh Senior Curator of Photographs, Museum of Fine Arts, Boston.

Michio Hayashi is Professor of Art History and Visual Culture, Sophia University, Tokyo.

Marilyn Ivy is Associate Professor of Anthropology, Columbia University, New York.

Anne Nishimura Morse is William and Helen Pounds Senior Curator of Japanese Art, Museum of Fine Arts, Boston.

Tomoko Nagakura is a Research Fellow for Japanese Art, Museum of Fine Arts, Boston.

BOSTON

MFA Publications
Museum of Fine Arts, Boston
465 Huntington Avenue
Boston, Massachusetts 02115
www.mfa.org/publications

Published in conjunction with the exhibition *In the Wake: Japanese Photographers Respond to 3/11*, curated by Anne E. Havinga and Anne Nishimura Morse and organized by the Museum of Fine Arts, Boston, from April 5 to July 12, 2015.

Exhibition presented with generous support from Art Mentor Foundation Lucerne. Additional support from the Ishibashi Foundation, Brian J. Knez, and the Barbara Jane Anderson Fund. Supporting sponsorship from Shiseido Co., Ltd.

∫HI∫EIDO

Generous support for this publication was provided by the Andrew W. Mellon Publications Fund.

Artist statement by Kōzō Miyoshi on p. 27 adapted from *North East Earthquake Disaster Tsunami 2011 Portfolio* (Tokyo: Photo Gallery International, 2012).

Artist statement by Tomoko Yoneda on p. 121 adapted from *Yami-naki tokoro de aereba* (If We Could Meet in a Place with No Darkness; Tokyo: Heibonsha, 2013).

Artist statement by Kikuji Kawada on p. 129 adapted from an essay in the magazine *Kaze no tabibito* 45 (Kyoto: Kazetabi-sha, 2012).

Artist statements translated by Maiko Behr.

Front cover: Lieko Shiga, *Rasen kaigan (Spiral Shore) 46*, 2011 (detail, plate 51)
Back cover: *Shimpei Takeda, Trace #9, Asaka Kunitsuko Shrine*, 2012 (detail, plate 70)

ISBN 978-0-87846-827-0
Library of Congress Control Number: 2014953802

The Museum of Fine Arts, Boston, is a nonprofit institution devoted to the promotion and appreciation of the creative arts. The Museum endeavors to respect the copyrights of all authors and creators in a manner consistent with its nonprofit educational mission. If you feel any material has been included in this publication improperly, please contact the Department of Rights and Licensing at 617 267 9300, or by mail at the above address.

While the objects in this publication necessarily represent only a small portion of the MFA's holdings, the Museum is proud to be a leader within the American museum community in sharing the objects in its collection via its website. Currently, information about more than 330,000 objects is available to the public worldwide. To learn more about the MFA's collections, including provenance, publication, and exhibition history, kindly visit www.mfa.org/collections.

For a complete listing of MFA publications, please contact the publisher at the above address, or call 617 369 3438.

Edited by Jennifer Snodgrass
Proofread by Kathryn Blatt
Designed by Daphne Geismar
Typeset by Julie Allred, BW&A Books, Inc.
Production by Terry McAweeney
Production assistance by Anne Levine
Printed on 150 gsm Perigord and bound at Graphicom, Verona, Italy

Distributed in the United States of America and Canada by
ARTBOOK | D.A.P.
155 Sixth Avenue
New York, New York 10013
www.artbook.com

Distributed outside the United States of America and Canada by
Thames & Hudson, Ltd.
181A High Holborn
London WC1V 7QX
www.thamesandhudson.com

FIRST EDITION
Printed and bound in Italy
This book was printed on acid-free paper.